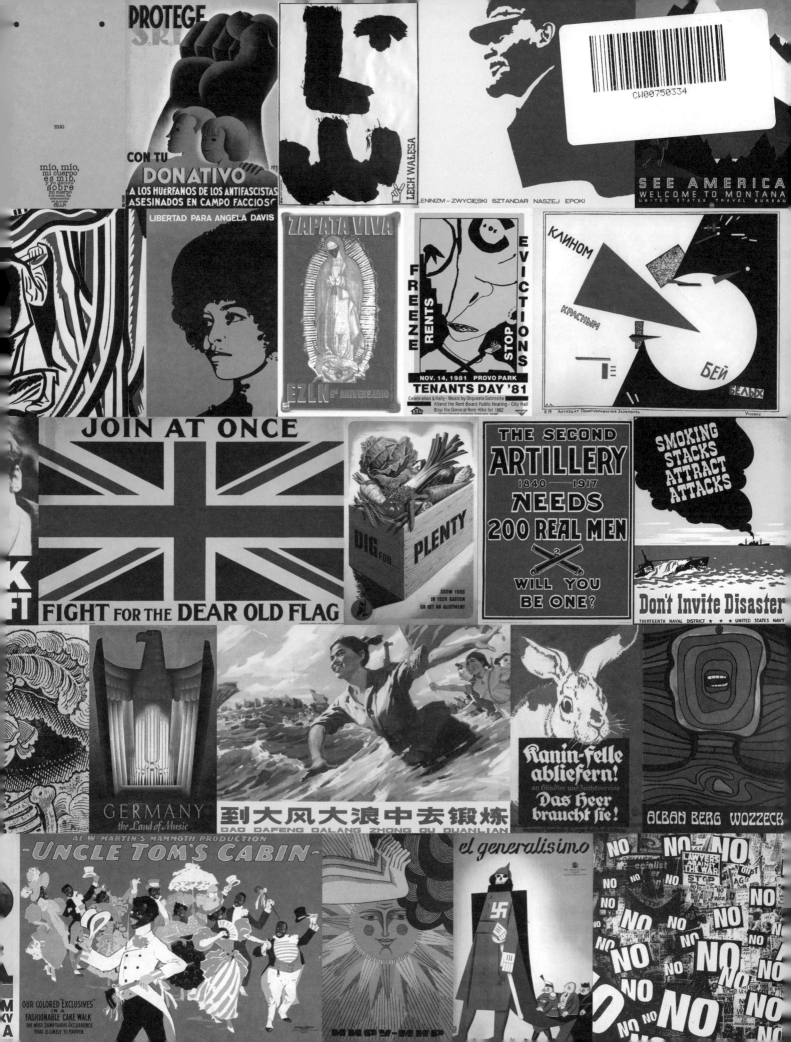

PROPAGANDA PRINTS

D. Minkler

Art is not a mirror held up to reality , but a hammer with which to shape it .
Mayakovski

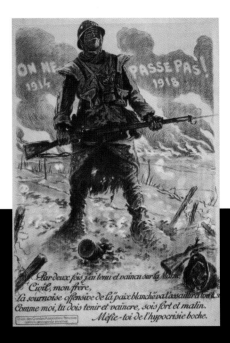

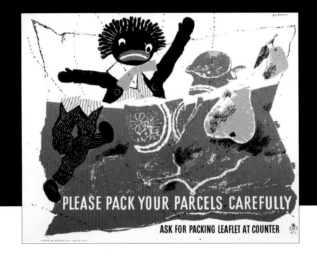

PLEASE PACK YOUR PARCELS CAREFULLY

ASK FOR PACKING LEAFLET AT COUNTER

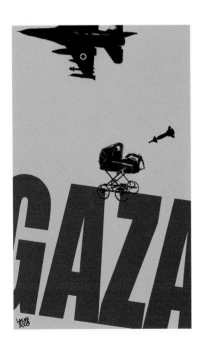

GAZA

NO

war on Iraq
axis of oil
brute force
friendly fire
body bags
blood price
collateral
smart bombs
orphans
imperialism
hypocrisy
heroics
quick fix

COLIN MOORE

PROPAGANDA
PRINTS

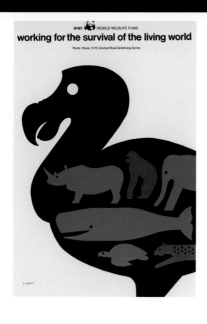

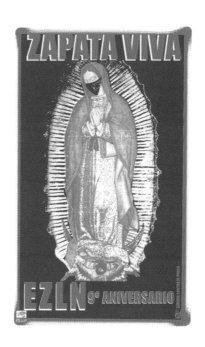

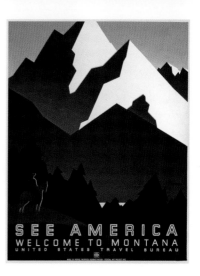

Of the 300 illustrations in here, 85 are attributed to
unknown artists. This book is dedicated to them.

First published in Great Britain in 2010
A&C Black Publishers Limited
36 Soho Square
London W1D 3QY
www.acblack.com

ISBN: 978-14081-0591-7

Reprinted 2011

Book design by *Gabriella Le Grazie*
Cover design by *Sutchinda Rangsi Thompson*
Commissioning editor: *Susan James*
Copyeditor: *Julian Beecroft*

Printed and bound in Singapore

A&C Black uses paper produced with elemental chlorine-free pulp, harvested from managed sustainable forests.

pg 1
DOUG MINKLER
Mayakovski, National Lawyers Guild,
Reproductive Rights Taskforce, USA, 1985.
Offset. Courtesy of the artist.

pg 2 from left to right, top row
JAMES GILLRAY
Sans-culottes feeding Europe with the Bread of Freedom, Britain, 1793. Hand-coloured etching.

HANS ARNOLD ROTHHOLZ (1919–2000)
Please pack your parcels carefully, Post Office, Britain, 1956. Lithograph, 74 x 92cm (29 x 36in.), © Royal Mail.

MAURICE NEUMONT
They shall not pass, Devambez, Paris, 1917. Lithograph, 115 x 80cm (45 x 31in.). Library of Congress LC-USZC2-3936.

Bottom row
CARLOS LATUFF
Gaza, 2000. Digital image. Courtesy of the artist.
Download from fileflyer.com/view/Ho03ZB7

DAVID GENTLEMAN
Placard for Stop the War coalition, Britain, 2003. Offset. Courtesy of the artist.

DOUG MINKLER
Demand protection, National Lawyers Guild, Reproductive Rights Taskforce, USA, 1982. Offset. Courtesy of the artist.

pg 3
TOM ECKERSLEY (1914–1995)
Working for the survival of the living world World Wildlife Fund, Britain, 1982. Offset, 76 x 50cm (30 x 19in.). © WWF, image courtesy of the Eckersley Archive, University of the Arts London.

ANDRÉS RAMIREZ
Zapata viva, Multiforo Alicia (publisher), Mexico, 2007. Digital image. Courtesy: the artist.

MARTIN WEITZMAN
See America. Welcome to Montana, Federal Art Project, New York, USA, 1939. Screenprint. Library of Congress LC-USZC4-4241.

Contents page
TOM ECKERSLEY (1914–1995)
Cyclists, make sure you are seen, Royal Society for the Prevention of Accidents, Britain, printed by Loxley Bros, 1939–45, Offset, 76 x 50cm (30 x 19in.). © RoSPA, image courtesy of the Eckersley Archive, University of the Arts London.

Contents

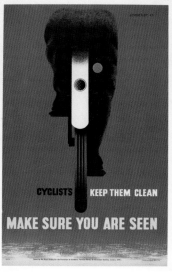

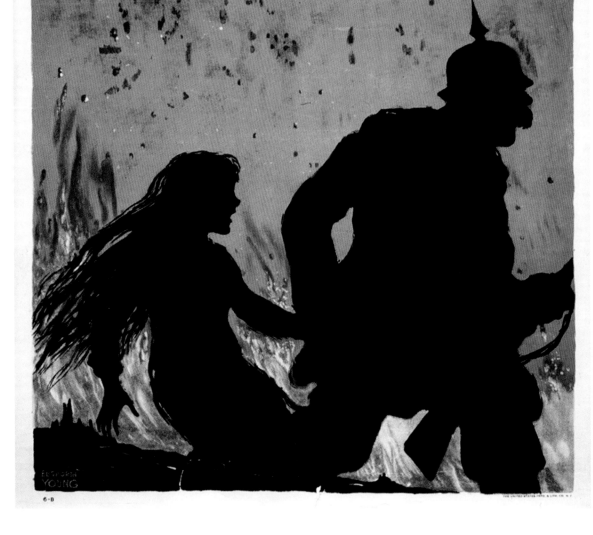

Introduction

1. ELLSWORTH YOUNG (1866–1952)
Remember Belgium, United States Printing and Lithography Co., NY, USA, 1918. Lithograph, 51 x 28cm (20 x 11in.).
Library of Congress LC-USZC4-12086.

The suffering of women and children was a common theme in WWI propaganda but this explicit portrayal of the abduction of a young girl must have been shocking at the time. The twin stereotypes of defenceless little Belgium and the bestial Hun are graphically superimposed on an apocalyptic landscape and a ghastly green sky. By taking this direct and unalloyed approach to the subject, and avoiding unnecessary detail, the artist has created a memorable and impactful image.

Throughout history people have used art to influence the beliefs and behaviour of others. From the earliest times the leaders among us have known that a good picture, song, sculpture or building can get our attention and maybe change our minds. Art has been used to educate us, to mould our opinions, to confirm us in our nationhood and to persuade us of the existence of many gods. We have cheerfully marched away to kill people who not long before had not been our enemies, and, true to fashion, have adopted attitudes and styles which were incomprehensible to our parents. We have been persuaded to brush our teeth regularly, to grow vegetables in time of need and, in this modern age, to consume a staggering diversity of branded goods and services. The art created for these purposes - art in the service of social and political change - is propaganda art.

In 1622 the word 'propaganda', which comes from the Latin *propagare* meaning to 'sow or propagate', was adopted into the title of a new committee of cardinals, the *Sacra Congregatio de Propaganda Fide*, created by the Catholic Church to promote the faith in mission territories. Part of the apparatus of the Counter-Reformation, this organisation was viewed with suspicion in the Protestant countries of the north, and the word propaganda was to become tainted by association with it. Until the end of the 19th century, however, it was not a common word in English and could still enjoy a neutral, even positive, meaning. An early Oxford English Dictionary, for example, offers the following unheated definition, still true to its Latin root: 'Any association, systematic scheme, or concerted movement for the propagation of a particular doctrine or practice'.

Comparison with the current entry - 'information, especially of a biased or misleading nature, used to promote a political cause or point of view' - clearly demonstrates that our view of propaganda changed during the course of the 20th century.

The First World War saw unprecedented investment, particularly by the Allies, in the deliberate control of information. Deploying modern media for the first time, and insights into human cognition provided by the new social sciences, agencies on both sides of the Atlantic achieved such spectacular success in the manipulation of public opinion that the practice of propaganda would be treated

from then on as indispensable to the health of both government and business. But the word 'propaganda' fared less well. Partly due to the Allied practice of referring to enemy communications as 'propaganda' and partly to an emerging realisation on the part of the general public of the extent to which their opinions had been manipulated during the war, the popular view of propaganda hardened, and the publicists, keen to dissociate their worthy services from it, encouraged the narrowing of its definition to exclude advertising and public relations. Later association with the despotic regimes of Stalin and the Nazis confirmed the trend, and propaganda's descent into infamy was complete.

Now it is a word with a poor image. Its message is unreliable. It calls up hidden persuasion, half-truths and distortions. The people who produce it are untrustworthy and unaccountable. Its ends are used to justify its dubious means. We do not indulge in it. Our enemies do. Propaganda is now associated with political indoctrination, and its essential commonality with social and commercial forms of persuasion is ignored. But, like it or not, we are all involved. Even the propagandee is complicit. In his book *Propaganda: the Formation of Men's Attitudes*, Jacques Ellul asserts that propaganda is not something perpetrated by evil propagandists on a helpless society. 'One can lead a horse to water but cannot make him drink; one cannot reach through propaganda those who do not need what it offers … To understand that propaganda is not just a deliberate and more or less arbitrary creation by some people in power is therefore essential. It is a strictly sociological phenomenon, in the sense that it has its roots and reasons in the need of the group that will sustain it.' (Ellul, p.121)

So propaganda is a reciprocal activity, a continuous dialogue between the giver and receiver, long recognised by historians as a faithful and sensitive index to the changes which occur in society. An applied art, like architecture and design, it imposes constraints which under a totalitarian regime can be suffocating; however, in opposition the artists can be free, and the best of their work reflects this freedom. In fact it can be argued that some of the most enduring and effective images of the 20th century were produced for the purpose of social, political and commercial propaganda, and though we may not be accustomed to viewing the output of these diverse sources together, in appreciation of the qualities which they all share, it is the purpose of the present work to do so.

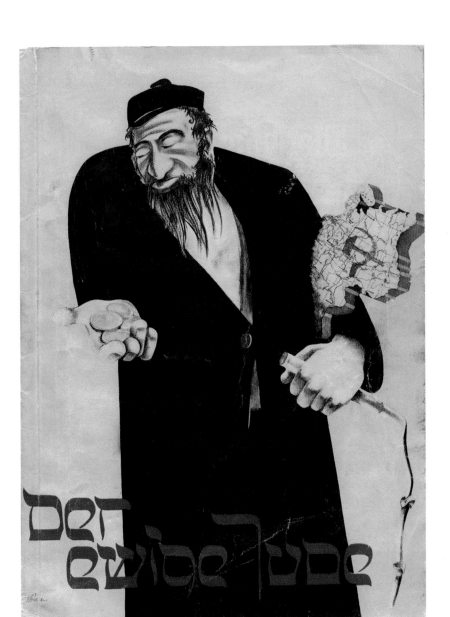

2. ARTIST UNKNOWN
The eternal Jew, Munich, Germany, 1937.
Lithograph. Courtesy of Library of Congress
LC-USZC4-779

By the late 1930s, the increasingly fanatical tone of Nazi propaganda reflected the growing radicalisation of the regime's anti-Semitic policies. The Jewish stereotypes shown in such propaganda served to reinforce anxieties about contemporary developments in political and economic life, without questioning the reality of the Jewish role in German society.

In November 1937 'The Eternal Jew' exhibition opened in Munich, running until 31 January 1938 and claiming to show the 'typical outward features' of Jews and their allegedly Middle Eastern and Asiatic characteristics. The exhibition also attempted to 'expose' a worldwide 'Jewish–Bolshevik' conspiracy.

This striking poster for the exhibition contrasted Jewish individualism and 'self-seeking' with the Nazi ideal of a 'people's community'. It did this by revealing an 'eastern' Jew – wearing a kaftan, and holding gold coins in one hand and a whip in the other. Under his arm is a map of Germany, with the imprint of the hammer and sickle. The apparent ideological contradiction in this image does not seem to have troubled its sponsors. The exhibition attracted 412,300 visitors, over 5,000 per day. The Secret Police reports claimed that it helped to promote a sharp rise in anti-Semitic feelings, and in some cases violence against the Jewish community.

In his seminal work of political science *Public Opinion*, Walter Lippmann threw light on how we form our ideas about things. Summarised in the memorable phrase, 'The world outside and the pictures in our heads', his model suggests that we humans have a limited capacity to apprehend reality directly. There is too much of it and we are too easily distracted. To cope we are forced to select and categorise, a process which brings in our habits of thought, our cultural baggage and our emotions. The result is what Lippmann calls a 'pseudo-environment', in which our opinions are formed. Unfortunately, the actions which result do not return to the 'pseudo-environment' but to the real one, with often unforeseen consequences. This explains why we all see things differently, and while it lies beyond our scope to speculate on whether Lippmann found here the source of all human conflict, it seems likely that this 'pseudo-environment', rich in stereotypes and potent symbols, is the natural field of the propaganda artist. His goal is to change our opinions. He could do it by advancing rational arguments. That would be persuasion. But playing on our emotions is more effective, and that is propaganda.

The stereotype, a preconceived and oversimplified idea of something, is a common device of the propagandist. By introducing a well-turned stereotype and consistently communicating it in every available medium, he will eventually overcome the natural diversity of public opinion. The common stereotype will replace individual reality even when it grossly deviates from it, and people will not complain, because the stereotype is so convenient, so much easier to use than an objective opinion based on the facts. Eventually the stereotype assumes a life of its own. In this way, the portrayal of the German soldier as the cruel and bloodthirsty Hun by Allied propagandists during the First World War galvanised the American public into action. Rumours of the murder of Belgian children were given substance by their portrayal in posters, and horrific reports of their little hands being chopped off and nailed to barrack walls as trophies, which would have met with shocked incredulity at the beginning of the war, were provided with a context which admitted the possibility, however remote, of their having occurred. Whether or not such stories were true was of no consequence in any case. Their provenance was unknowable and the whole thing was taking place, not in Belgium, but in the collective 'pseudo-environment' of the propagandees. The result, the political object of the exercise, was to propel a peace-loving and self-absorbed nation into war. No amount of talk about 'national interest' could have achieved this. It took a direct and systematic appeal to people's sense of moral outrage to move them. (Fig. 1)

Twenty years later, in Nazi Germany, a potent campaign of manipulation taught normal Germans not to see the neighbour who happened to be Jewish, but to see the Jew, 'The Eternal Jew', the one with the big nose, sloping forehead and shifty foreign appearance, even when the individual bore no physical resemblance whatever to this grotesque invention. Thus the stereotype, a creature of the 'pseudo-environment', is free from the need to conform even to the most basic observable components of the real world. (Fig. 2)

Once established, the stereotype can be supported by symbols which stand for it. With great graphic economy symbols can transcend language to summarise a whole set of values or evoke quite abstract concepts. Flags and standards have been used for this purpose from time immemorial, and to this day are a common feature of propaganda material. (Fig. 3)

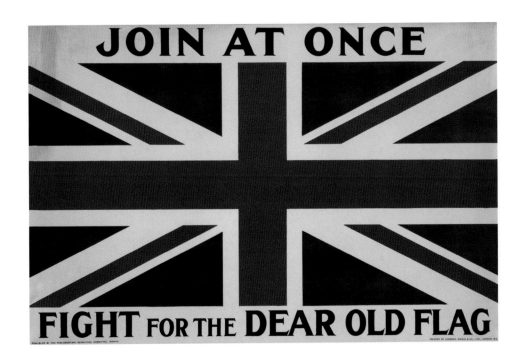

JOIN AT ONCE

FIGHT FOR THE **DEAR OLD FLAG**

3. ARTIST UNKNOWN
Join at once. Fight for the dear old flag.
Parliamentary Recruiting Committee, London,
1915. Lithograph, 74 x 50cm (29 x 19in.).
Library of Congress LC-USZC4-11045.

So too is a whole range of visual abbreviations which have been developed over time to represent religions, political systems and, in our time, all sorts of facilities and commercial products. The American sportswear manufacturer Nike, for example, as a result of a consistent programme of brand development since 1972, can now confidently assume that its 'swoosh' symbol will evoke in many people's minds not only the company name and its products, but an attitude to life based on self-fulfilment through physical exercise. For this reason a Nike T-shirt will sell at a premium to even the most disadvantaged in places remote from the Nike heartland. The consumer may not know where his next meal is coming from but he is wearing the symbol which he has learned to associate with success.

In *Mein Kampf* Adolf Hitler noted that 'Only constant repetition can finally bring success in the matter of instilling ideas into the memory of the crowd. The most important thing is to paint your contrasts in black and white.' This advice, to rely on repetition and to keep it simple, lies at the heart of every successful propaganda campaign, political or commercial. Repetition is natural to us. We repeat things to commit them to memory, to confirm ourselves in our beliefs and to establish a familiarity which will provide comfort: a fixed point in an otherwise baffling world. Again, this lesson has been well learned in the world of advertising, as anyone who has sat through an evening of commercial TV will testify. Repetition, constant repetition, overwhelms our indifference and leaves its mark.

In the end, though, good propaganda art, like any good art, is more than the sum of its parts. There is more to it than stereotypes and symbols, more than colours and shapes and language. It is culture, history, and sometimes it provides the key to our understanding of the people who produced it.

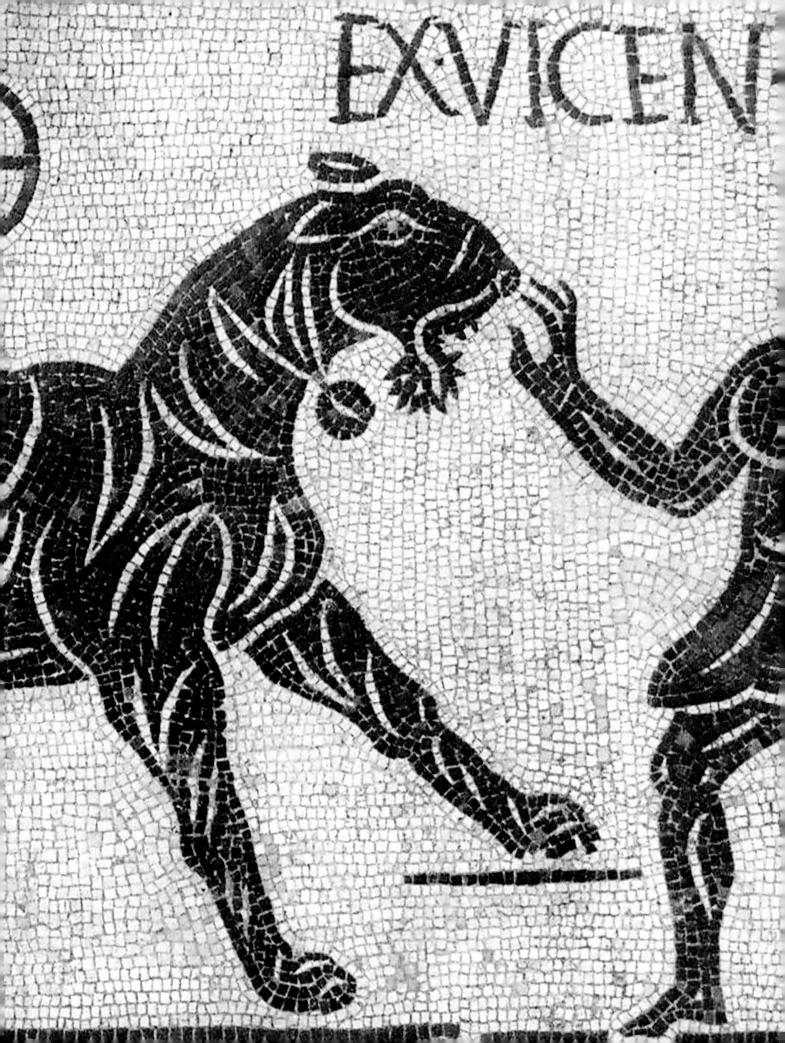
EXVICEN

1

The Ancient World

ARTIST UNKNOWN
Detail: *Gladiators fighting a tiger*, Colosseum,
Rome, c.2nd century AD. Mosaic, (approx.) 50 x
150cm (19 x 59in.). Photograph by the author

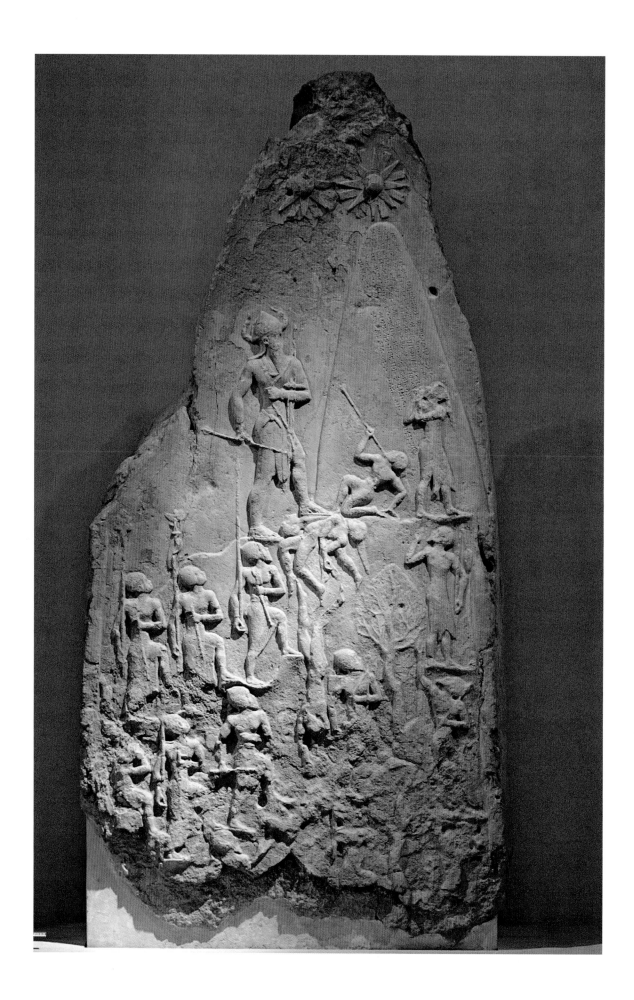

The very beginning

4. ARTIST UNKNOWN
Victory stele of Naram-Sin, Mesopotamia, now in the Louvre, Paris, c.2250BC. Limestone stele, 2 x 1.5m (79 x 59in.). Wikimedia Commons.

There is a case to be made for beginning an account of propaganda art with the First World War, which destroyed so much of the past and hurried in the new science and media of the modern world. But if we begin in 1914 we would have to ignore Napoleon, the great propagandist. We would have to dispense with the Counter-Reformation, the Reformation itself and the glories of the Renaissance. And casting further back, we would neglect the Medieval world, not to mention the Romans, the Greeks and the Egyptians.

So how far back do we go? If we believe that the urge to persuade others is an essential human trait, perhaps we should turn to the invention of language to find the first propaganda, and even then, perhaps language itself came about to serve that urge. We do not know. The cave paintings of our ancient ancestors are tempting subjects, but we don't know much about them either. Therefore, to find reliable evidence of propaganda, we have to look to the first settled communities of the ancient world, to the remains of the Mesopotamian civilisations, where men first lived in towns, built temples to their gods and were ruled over by kings who were careful to leave their stories for us to find.

Around 3000BC, in the land between the Tigris and Euphrates rivers, the ancient Sumerians lived and built cities. They had public buildings, organised trade and a strict rule of law. They developed a kind of writing on clay tablets, known as cuneiform, the earliest surviving record of social communication.

Isolated from each other by swamp and desert, these city states grew independently. They fought with each other for centuries, without any significant outcome, until a king called Eannatum of Lagash managed to unify them for a brief period around 2550BC. After his victory over the people of Umma he erected a limestone slab, the so-called Stele of the Vultures now in the Louvre. Almost two metres high when erected, the now fragmented stele was covered in relief carvings which record the story of the battle. One part depicts the king at the head of his troops, trampling the enemy. Another shows the vultures devouring the dead. In graphic detail the stele not only commemorates the great victory; it glorifies the god of Lagash in whose name the battle was fought, confirms Eannatum in his supremacy and sends a warning to his enemies, and to his subjects, of the fate which awaits those who oppose him. This is most certainly propaganda.

Around 2250BC the Akkadian king Naram-Sin erected a stele to celebrate his victory over the Lullubi in the mountainous region of Zagros, east of the Tigris. Unlike the stele of Eannatum, which was divided into panels or registers to depict different aspects of the story, this beautiful relief sculpture is rendered by its artist as one image. Taking full advantage of the shape of the stone, it shows the king, twice as big as everyone else and wearing the horned helmet of the gods, leading his troops up one side of the mountain, while his enemies, dismayed and trampled, beg for mercy on the other. Naram-Sin ascends towards the sun and moon at the moment of his victory, now himself a god and 'King of the Four Quarters of the World'. (Fig 4)

These examples show that some idea of propaganda did exist in the ancient kingdoms of Mesopotamia, as it also did in Egypt, but it was not until the emergence of Greek civilisation, a more structured society, that we can see a methodical approach to propaganda in the conduct of war and politics. By the 8th century BC the Greek city states were locked in competition with each other, a struggle for cultural and commercial domination which not only produced the legends and myths that are part of the bedrock of European culture, but a proliferation of propaganda in the form of temples, monumental sculpture, art and literature. Over time, however, the Greek peoples were weakened by their inability to form effective alliances, leaving them vulnerable to threats from outside. In the end it took an outsider to unite them.

Alexander

When he died in 323BC, aged 32, Alexander III of Macedon, better known as Alexander the Great, ruled over an empire of his own making which stretched from Greece to India. His exploits profoundly altered the course of history, leading to the flourishing of Hellenistic culture in the Middle East and Central Asia and a shift in the focus of power to the Mediterranean, a situation that would endure for 800 years.

Despite the huge body of literature dedicated to him, Alexander's character and the details of his personal life are still the subject of speculation. No contemporary accounts have survived and the many commentators of later periods have cast him in a mould suited to the values of their own times. But there can be no doubt that he was special. He was tutored by Aristotle, who steeped him in Greek culture and encouraged him to share it with the 'less fortunate' people of the world. This he seemed destined to do. He came to power at the age of 20, embarked on a series of military campaigns over a 12-year period, and never lost a battle. To this day he is considered one of the greatest military commanders of all time.

He also seems to have understood instinctively that it was just as important to win hearts and minds as it was to win battles. He inspired loyalty in his Macedonians, who would, and did, follow him anywhere. He destroyed the Persian Empire, which before his own was the greatest the world had seen, and entered Babylon a hero. Everywhere the people he conquered learned to respect him, and nobody ever forgot about him. Though he died young, he forged a personal image which has endured, and in doing so contributed more to the art of propaganda than anyone in history.

He has featured prominently in both Greek and non-Greek literature. To the Greeks he became a legendary hero in the tradition of Achilles, an individual born of the union of a god and a mortal, possessed of superhuman qualities. People of many other cultures, inspired by the numerous reports of his personal bravery, indeed of the persistent disregard for his own safety that was so vexatious to those close to him, have celebrated his courage as a man and his breathtaking vision as a leader. After his death, a number of the tales and legends surrounding him were drawn together into the Alexander Romance, a story which grew and changed with the telling and eventually found its way into

every major Middle Eastern and European language to provide the basis of the Alexander legend we are familiar with today.

In his own lifetime Alexander encouraged the creation of the cult surrounding him. Following his success in Egypt he accepted the title of 'Son of Zeus', and if this can be interpreted as the typical megalomaniac delusion of someone in his position, it does seem unlikely that he would not have appreciated its propagandistic advantages: though he could not be everywhere at once in the great expanse of his empire, the idea of his divinity could be. Faced with the difficulty of communicating, and of ruling, across half the world, Alexander devised a system which used propaganda as a substitute for himself and his authority. Throughout the empire, his presence was evoked on statues, buildings, paintings and pottery, while the coins struck in his name, and showing the head of a god, found their way to the ends of the earth. (Fig. 5)

Alexander, military genius and charismatic leader, provided future leaders with the model to follow. All of them, from Hannibal to Napoleon, owe him something, but none, not even Julius Caesar, who wept at the sight of his statue in Spain, can quite compare to him, such is the power of his story to move us.

5. ARTIST UNKNOWN
Alexander the Great coin – silver tetradrachm, Macedonia, c.336–326BC. ©Trustees of the British Museum.

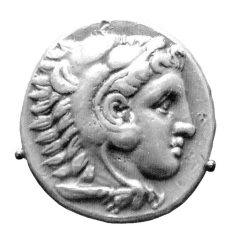
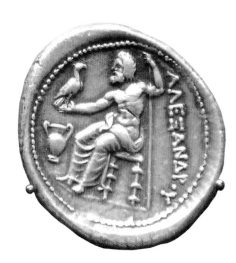

Pax Romana

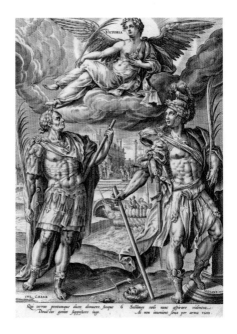

6. AFTER MARTEN DE VOS
Virtues, Netherlandish, c.1581. Engraving, 28.3 x 20.7cm (11 x 8in.). ©Trustees of the British Museum.

The personification of Victory, holding a palm, sits on a cloud above the figures of Julius Caesar (left) and Alexander the Great, an image which would surely have met with Caesar's approval.

Caesar was not the only Roman to revere Alexander. His life and legend so clearly reflected Roman ideals that he was widely admired, particularly by ambitious young men whose advancement depended on their military achievement. Republican Rome, a society structured to produce zealous commanders and willing soldiers, thrived in an atmosphere of war, convinced of its own superiority and its manifest destiny. Such motivation, combined with a talent for organisation and engineering, produced the greatest war machine the world had ever seen. (Fig. 6)

Julius Caesar was a great military commander, and a master propagandist with a natural talent for communication and self-promotion. Like Alexander before him, he took care to create a bond of loyalty with his men and to motivate them both emotionally and materially. Unlike Alexander, who is said to have envied Achilles for having had Homer to immortalise him, Caesar acted as his own historian. Writing the accounts of his own military exploits, he ensured that history, as well as the people at home, would be provided with his version of events. With every successful campaign his fame grew, and he reached out not only to his soldiers but to the people of Rome, dispensing gifts and staging mock battles and games for their amusement, all the while gathering power and prestige to himself. The Roman Triumph, originally a religious procession to give thanks for a victory, was, in Caesar's hands, transformed into the propagandistic climax of his campaigns and an orgy of personal glorification.

In time he came to be treated like a god by the common people, an evolution which he was careful neither to encourage nor prohibit but which proved to be his undoing. The envy of the aristocrats and the fear of the Senate that his popularity would undermine its authority fostered the conspiracy which led to his murder. However, the cult of personality which Caesar had built around himself contributed to a permanent shift away from Republican ways. He was succeeded by his great nephew and adopted son Octavian who, after a bloody civil war, became Augustus, the first Emperor of Rome.

As the empire expanded under Augustus, so did the audience for the organs of state propaganda. Rome now spoke not only to Romans but to a polyglot assembly of conquered peoples that stretched from Britain to the Middle East. Faced with the same challenge as Alexander, of maintaining order over a vast

area, the Romans developed a worldview of peace and prosperity for all, the Pax Romana, which offered protection from barbarian outsiders, and a role, even Roman citizenship in some circumstances, for those willing to collaborate. Vast sums were expended in the construction of public buildings and monumental architecture. Rome itself was virtually rebuilt under Augustus, and in the provinces roads, aqueducts, bridges and ports appeared, all of which, beside their practical benefit, provided the concrete symbolic expression of the might of Rome: infrastructure as propaganda.

Those who were not yet adopted by the empire, the Barbarians, were habitually depicted as pitiful, poverty-stricken creatures, excluded from the benefits of belonging. They lived in darkness, ignorance and terrible insecurity, vulnerable to the attacks of neighbours as miserable as themselves. As for those who opposed Rome, the message was clear: expect no mercy. The Pax Romana was underpinned by a culture of cruelty and violence.

The central propaganda message, the idea which drove the Roman Empire, concerned its role in the world. While Rome was quite willing to acknowledge the cultural accomplishments of subject peoples, the Greeks in particular, it was made clear that Rome's was the right and obligation to govern. In *The Aeneid*, written during the reign of Augustus, Virgil dedicates a celebrated passage to this idea:

Others shall hammer forth more delicately a breathing likeness out of bronze, coax living faces from the marble, plead causes with more skill, plot with their gauge the movements in the sky and tell the rising of the constellations.

But you, Roman, must remember that you have to guide the nations by your authority, for this is to be your skill, to graft tradition onto peace, to spare those who submit, but to crush those who resist.

This essential propaganda message was repeated endlessly to justify the empire and to reconcile the individual with his role in it.

Augustus, careful not to repeat the mistakes of his predecessor, avoided divine status for himself but, by perpetuating and elaborating the myth of Caesar, established a dynastic system which endured for centuries. Although he claimed to be acting to restore the republic, in reality, from now on Rome would be ruled by a monarch, and the Senatus Populusque Romanus (SPQR, the motto of the

7. ARTIST UNKNOWN
Emperor Augustus of Prima Porta, Museo Chiaramonte, Vatican, Rome, 20BC. Marble statue, 2.04m (6ft 8in.) high. Wikimedia Commons.

The Augustus of Prima Porta, now in the Vatican Museum, defines the Augustan ideal. The figure is in a Greek style, young and elegant, in the pose of an orator to establish the emperor as cultured and wise. His breastplate, with its decorative references to imperial victories, expresses his strength and military capacity. But he is also barefoot, an unusual state for a soldier, and supported by a cupid sitting on a dolphin, in reference to Venus, the mythical ancestor of his adopted father Julius. Designed as an instrument of government propaganda, this sculpture provides an idealised personification of Imperial Rome - noble, wise, strong and favoured by the gods.

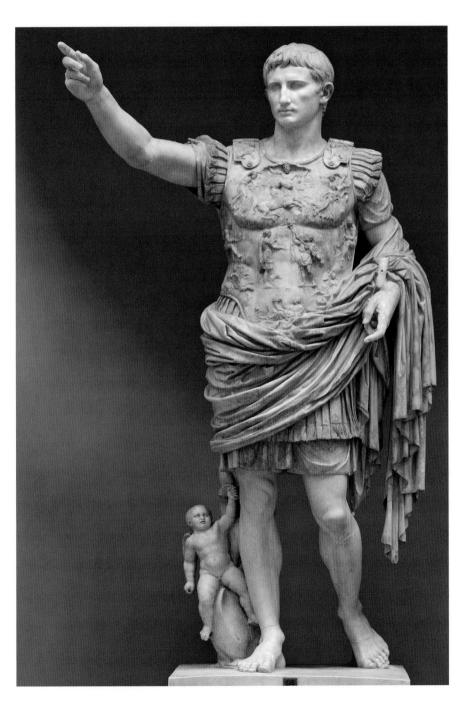

Roman Republic) would become just another symbol of his power.

Key to the new order was the figure of the emperor himself, which was projected throughout the empire by means of monumental statuary. (Fig. 7)

Augustus also expanded the practice of issuing coins, not only to consolidate his image but to celebrate military and diplomatic achievements and even to broadcast key messages such as his 'Peace and Victory' manifesto issued after the civil wars. As we shall see, the history of propaganda is bound up with the history of printing, and in a way these coins are the first propaganda prints of our story - prints on metal instead of paper - an important reproducible propaganda medium which carried the message of imperial prestige throughout the world.

By the time of the Emperor Hadrian the aggressive wars of expansion had ceased and the empire had entered a phase of consolidation. A most peripatetic emperor, Hadrian travelled around his dominions and wherever he went he built in the name of Rome. On the frontiers he built walls and towers which spoke to those outside of the power within. In the cities he built temples, arenas, theatres,

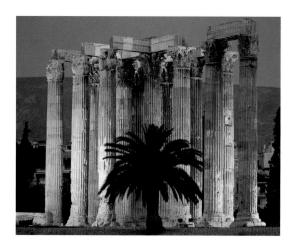

8. ARTIST UNKNOWN
Temple of Olympian Zeus, Athens, Rome, completed 2nd century AD. Courtesy of Google images

bathhouses - all the apparatus of civilisation. For the Rome of Hadrian was no longer a mere war machine. It was a way of life, custodian of a civilisation held in trust for the commonwealth of nations it protected. (Fig. 8)

Nevertheless, the barbarity continued. In the arenas, gladiators fought to the death in re-enactments of old victories. Dissidents and criminals were eaten alive by wild beasts, roasted and torn to bits, all of which provided the audience not only with an addictive form of entertainment but also continuous exposure to imperial policy in the form of dramatised propaganda. (Fig. 9)

Among the victims of the arena were the members of a small religious cult, one of scores which thrived in the generally tolerant religious atmosphere of Imperial Rome. Drawing its members from the empire's teeming underclass - slaves, outcasts - the cult came to the attention of the authorities because of the stubborn refusal of its members to recognise any authority before their god - their one and only god. In the eyes of the state this was subversion. The Christians, as they were called, were outlawed and driven underground by state persecution. But the cult survived, thriving, it seems, on adversity. Something about its message of equality, brotherly love and redemption was irresistibly attractive to the disenfranchised masses at the bottom of the imperial pile. The cult's symbol of the sign of the fish, two intersecting curves, began to appear in public places. As the 3rd century advanced, and the empire was increasingly racked by political and economic crisis, Christianity flourished and eventually broke out of the underclass, invading every level of Roman society.

The Romans had always taken a pragmatic view of religion. They developed a polytheism designed to support their warlike ambitions and were quite happy to adopt the gods of subject peoples, often adapting their message to derive a propaganda advantage from them. This approach served the republic well, allowing flexibility and religious tolerance in dealing with other cultures. It did not, however, provide a unifying religious ideology, and the Roman Empire of the late 3rd century, already showing signs of the failure of morale which would eventually destroy it, was ready for something new to believe in. When the Emperor Constantine adopted Christianity in 312, he no doubt did so for political reasons. But the consequences for the empire were immense. From now on the Roman legions would be fighting, not for the Senate and the Roman people, or

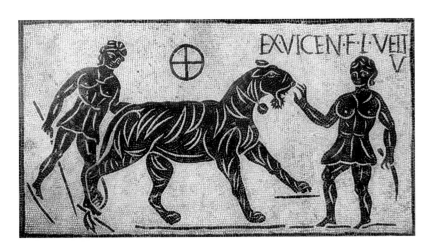

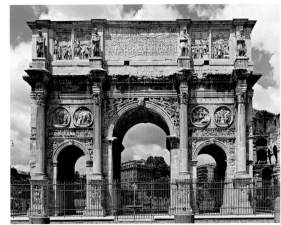

9. ARTIST UNKNOWN
Gladiators fighting a tiger, Colosseum, Rome, c.2nd century AD. Mosaic, (approx.) 50 x 150cm (19 x 59in.). Photograph by the author

Above right
10. ARTIST UNKNOWN
The Arch of Constantine, Rome, 315AD. Marble with marble-faced brick attic, h. 21m (69ft), w. 25.7m (84ft), d. 7.4m (24ft). Courtesy of Google images

for the emperor, but for the glory of God. Within a hundred years Christianity was established as the state religion, a mutually beneficial alliance of church and state, sometimes referred to as Christendom, in which the priests would preach loyalty to the government, the state would pursue the enemies of God, and the people as always would suffer the consequences.

This ideological revolution significantly affected the content and appearance of state propaganda in the Roman Empire. In the early days, the Christian message had circulated at grassroots level, a form of agitation based on personal contact. Its propaganda would be simple, opportunistic and mostly ephemeral. By the 4th century the stuff of daily life - coins, jewellery, frescoes and mosaics - began to reflect the influence of the new religion, and the important public works of the time, concerned as much with continuity as with change, showed a careful grafting of new onto old.

The Arch of Constantine, for example, erected by the Senate in 315 to commemorate the Emperor's victory over Maxentius at the Battle of the Milvian Bridge, carries a decorative programme designed to place him among his illustrious predecessors - Trajan, Marcus Aurelius and Hadrian. By using material from earlier monuments and making careful reference to the past in the new sections, the builders emphasise the legitimacy of Constantine's rule. (Fig. 10)

Nothing, however, could arrest the fall of Rome. By 476 the Western Empire was effectively finished, the emperor deposed by Germanic mercenaries. However, though confusion was to reign throughout Europe, the legacy of Rome endured, a legacy so deeply embedded in every aspect of European culture that we are scarcely aware of it today. In terms of propaganda, the Romans demonstrated that it was only possible to maintain control of huge areas of territory by winning over the people, which they did by combining the material benefits of belonging to the empire with something to believe in. This big idea, the glory that was Rome, was created as much by the systematic manipulation of public opinion through art, entertainment, architecture and religion as it was by military might.

2

The Middle Ages

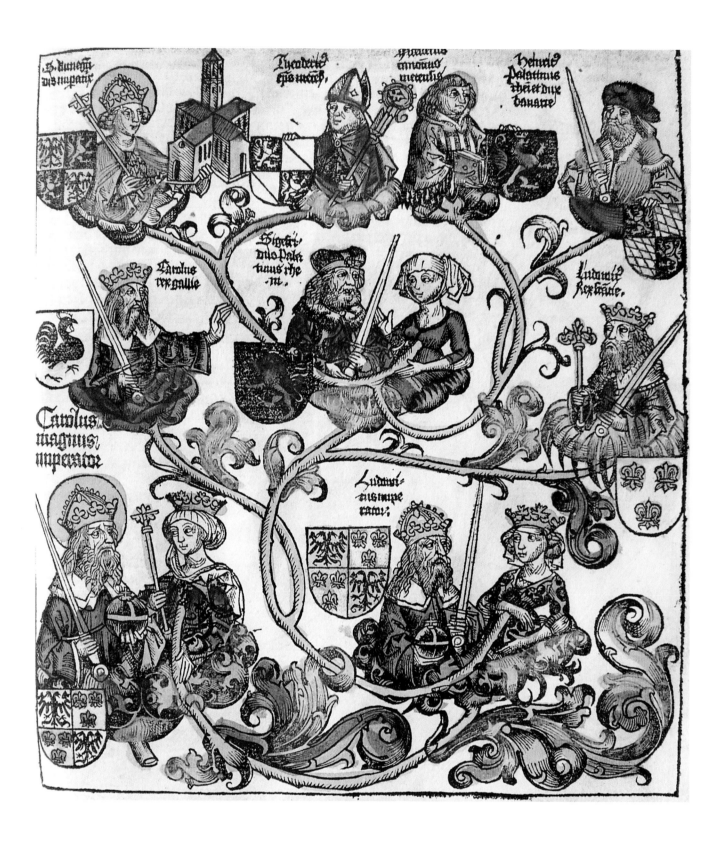

The Dark Ages

Fig. 11. MICHAEL WOHLGEMUT (1434–1519) *Charlemagne's family tree*, from the Nuremberg Chronicle, Germany, 1493. Hand-coloured woodcut. © Benoit University.

As the Roman Empire collapsed in the West, Christianity grew and in doing so drew into itself a world of symbols and stories - simple symbols like the *chi-rho* and the cross, and powerful graphic metaphors like the lily of the field and the seeds on stony ground. Lions and lambs, angels and devils, heaven and hell were combined with the stories of men, miracles, the acts of apostles and, most of all, the love of Jesus in a world thrown into chaos. From the beginning, Christianity maintained a distance from all other beliefs but also a useful facility for adopting their ideas. All of it would later find full expression in the great medieval public works of church and state. In the meantime, between the 4th and 8th centuries, the church fought to impose, by force of arms, propaganda and a ruthless attitude to the barbarian faiths, a cultural coherence to replace that of Rome as the successor states struggled to emerge and redraw the map of Europe.

In 800, Charles, King of the Franks, was crowned Charlemagne, Holy Roman Emperor, by the Pope, in recognition of his work to consolidate the Christian sphere of influence. In 30 years he had conquered the Saxons, the Huns and the Lombards, had contained the Muslims in Spain and established himself as the protector of the Christian faith. By uniting most of Western Europe for the first time since the Romans, and by encouraging a renewed interest in learning and literature, he advanced the emergence of a European identity and is considered the father of Europe by many today. Unlike most empire builders, he made no attempt to create an imperial myth around himself, and in fact little is known, beyond his insistence on Christian practice, of his propagandistic activities. After his death, however, the first Holy Roman Emperor became the stuff of legend, and his reign a model for those who followed him. (Fig.11)

When Charlemagne died, western civilisation again fell into chaos, threatened from the south by the Muslims and from the north by Vikings who, emboldened by the break-up of the Carolingian Empire, began to raid coastal areas of Britain and Western Europe. One group of these 'Nor'men' was given land around Rouen in 911, the basis of what would later become the Duchy of Normandy. They settled, in time adopting the religious and feudal ways of their neighbours. But the restless spirit of their ancestors would not be denied and in 1066 they invaded England.

The Norman Conquest

The invasion of England in 1066 by William, Duke of Normandy, almost failed at the Battle of Hastings. One of the most celebrated and controversial encounters of the Middle Ages, it was, according to the popular story, a close-run thing which was only decided after a whole day of desperate fighting by the death of the Saxon King Harold, shot in the eye by an arrow. William, now the Conqueror, moved quickly to crush all further opposition in the South, and by 1072, after a brutal campaign of repression in the North and having virtually eliminated the Saxon aristocracy, he was in full possession of England and its presumably hostile population. Lacking the numbers necessary to subdue the entire country, the Normans aimed to establish a military presence at selected strategic locations by building motte-and-bailey castles. These light wooden structures were rapidly constructed (one was built at Dover in only eight days) using forced local labour. As the *Anglo-Saxon Chronicle* later recalled, 'And they filled the whole land with these castles. They burdened the unhappy people of the country with forced labour on the castles. And when the castles were made they filled them with wicked men.'

William made it a condition of their tenure that the Norman nobles he put in charge of these strongholds should replace them with permanent stone structures as soon as possible. By the time of William's death in 1087 they had built over 80 of these massive stone fortresses, an alien presence to the Saxon people, who had never seen anything like them. The propaganda message was clear: 'We are here to stay. Do not attempt to resist.'

William knew, of course, that the long-term success of his new regime ultimately depended on the collaboration of the Saxons. Rather than rely on force alone, the invaders had to persuade them to accept Norman rule and, specifically, the legitimacy of William's succession, which they set out to do by means of diplomacy, intermarriage and a carefully managed propaganda campaign.

Despite its fragility, one fragment of that effort has survived. The Bayeux Tapestry - actually an embroidered cloth 50cm (20in.) high by 70m (230ft) long - tells the story of the invasion of England from the Norman point of view. A series of pictures sparingly annotated in Latin, but full of contemporary detail, the tapestry is a beautiful and fascinating document which has probably influenced

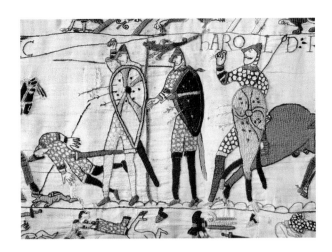

12. ARTIST UNKNOWN
Bayeux Tapestry (detail), England/France, 1070s.
Embroidered woollen yarn on linen, 50cm x 70m
(20in. x 230ft).

In the Norman version of events, Edward the
Confessor sends Harold on a mission to William
in 1064 in the course of which William has
Harold swear an oath of allegiance to him and
his right to the throne of England. Thus, when
Harold returns to England and takes the throne
for himself, in Norman eyes he has broken his
vow and perjured himself, justifying the
invasion.

This famous scene from the tapestry is said to
represent the moment of Harold's death, struck
in the eye by an arrow. Medieval iconography
commonly prescribed death by a weapon in the
eye for perjurers.

the English attitude to the Norman Conquest more than any other source.

In France legend had it that the tapestry was created by William's wife, Queen Matilda, and her handmaidens, and even today it is sometimes still referred to there as 'La Tapisserie de la Reine Mathilde'. But contemporary scholarship suggests that it was commissioned by Bishop Odo, William's half-brother, and created in England. Wherever it came from, the tapestry clearly aims to justify the Norman invasion and establish the legitimacy of William's claim to the English throne, subtly portraying William as the hero and Harold as the noble but flawed pretender. At one point he is portrayed making an oath of allegiance to William that he will later break. At another Halley's Comet appears, casting a medieval gloom over Harold's coronation. However, while the invasion and the events of the ensuing battle are recorded with a carefully controlled bias to the Norman side, the tapestry does not deal harshly with the Saxons but respectfully records their skill and bravery and preserves their dignity even in defeat, a generosity which does suggest its propagandistic purpose. Had it been conceived simply as the celebration of a great victory, the tapestry might have dealt less kindly with the defeated enemies of its sponsors. (Fig. 12)

Also, and perhaps above all, the Bayeux Tapestry is a great work of art, full of drama and compelling detail. Contained, top and bottom, between two continuous bands of beasts and symbols which provide a kind of subtext to the main story, the scenes are not separated from each other like the cells of a modern comic strip, but flow freely from one to the next, drawing the viewer along and into the narrative, all 230 feet of it. The meaning of some of it is obscure - this is to be expected from a story told in pictures so long ago - but the scale and power of the work are undeniable, and we can only speculate about its effect on contemporary viewers.

In fact the creators of the tapestry could hardly have imagined the extent to which it has fulfilled its purpose. Created to reconcile a defeated people with their enemies, it has come to represent, 900 years later, the joining of their two cultures, and to occupy a unique place in the story of the British people.

Onward Christian soldiers

Throughout history there has been no more active source of propaganda, particularly visual propaganda, than the great proselytising religions of the world. Frequently bound by expedience to politics and the pursuit of material advantage, their currency is nevertheless abstract. Through art they find expression and the means of converting non-believers. Moreover, of all the reasons throughout history why wars have been fought - to win territory, elections, market shares - those inspired by religion have been the most bitter.

When Pope Urban II emerged from the Council of Clermont in 1095 to address the great crowd which had gathered there, no one present could possibly have imagined the consequences of what they were about to hear - that 50,000 ill-prepared Christians would immediately rush to the East in a righteous frenzy, most of them to their deaths; that Christianity and Islam would be plunged into a series of wars that would last for 200 years - yet before he had finished his famous inflammatory speech Urban had set in motion the Crusades. This celebrated exercise in crowd manipulation is a landmark in the history of propaganda and worth looking at in some detail.

To begin with, he spoke at the right time. The people of Europe in 1095 were in a ferment of religious zeal. Their living conditions were grim, food was scarce, disease rampant. The world seemed an evil place, relief from which was to be found only through the mortification of the flesh, faith in the Holy Spirit and the promise of heaven above. In this climate people believed what their priests told them.

Urban also spoke at the right place - that is to say, he prepared his ground well. By organising the Council of Clermont and by publicising beforehand that he would speak on matters of real importance, he ensured the presence of clergy and nobility, and also the crowd - the excitable, unpredictable crowd. Speaking from a great platform raised for the purpose, he told them that they, and all the faithful, were in danger. Infidel Turks were invading and laying waste to Jerusalem and Constantinople, murdering their brother and sister Christians, desecrating their holy sites. According to one surviving version, he took time to thoroughly demonise the adversary, describing in splendid medieval detail how the Turks would 'perforate their navels, and dragging forth the extremity of the

13. ARTIST UNKNOWN
The Knight's Tale, England, early 15th century, illuminated manuscript on vellum. 40 x 28cm (15 x 11in.). Wikimedia Commons.

This picture shows the beginning of *The Knight's Tale* from the Ellesmere Manuscript, which was produced shortly after the death of Geoffrey Chaucer in 1400. A high-quality example of scribal workmanship, the Ellesmere was a luxury product the likes of which would have been accessible only to the very rich.

intestines, bind it to a stake; then with flogging they lead the victim around until the viscera having gushed forth the victim falls prostrate upon the ground.' (Jowett and O'Donnell, p.63)

He reminded the crowd of their Christian duty to avenge these outrages. Then, skilfully switching from stick to carrot, he offered a vision of the Holy Land which 'floweth with milk and honey … like another paradise of delights', a dream, a means of escape from the squalor of their daily lives. And finally a promise, of the remission of sins for all those willing to take up the cause, a shining promise which to the medieval mind offered nothing less than an opportunity to escape the very real and present threat of eternal damnation in hell.

Before Urban II finished his address, the crowd were crying 'Deus volt' ('God wills it') and tearing up their clothes to make ragged signs of the cross to wear on their chests. They dispersed already in possession of the battle cry and the symbol which would sweep through the entire continent and set fire to the Holy Land.

If religion provided one motive force for the medieval period, war provided

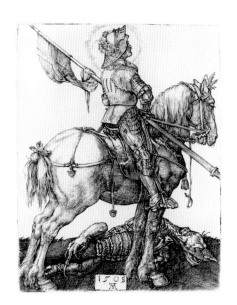

14. ALBRECHT DÜRER (1471–1528)
St George and the Dragon, Germany, 1508.
Engraving, 10.8 x 8.5cm (4 x 3 in.). Library of
Congress LC-USZ72-173.

the other. Crusades against Islam were followed by crusades against northern barbarians, eastern barbarians, heretic Cathars, Prussians, Tartars and Jews. It was the time of the knights in armour, the warrior class of the feudal system. Trained from childhood, a knight was not necessarily an aristocrat, nor in many countries did knighthood automatically give access to the ruling class. But what defined him was his code of conduct, the Chivalric Code, which sought to reconcile Christian duty with a soldier's virtues and courtly manners - an ideal well described by Geoffrey Chaucer's near-contemporary account in *The Canterbury Tales*: (Fig.13)

There was a knight, a most distinguished man
Who from the day on which he first began
To ride abroad had followed chivalry,
Truth, honour, generousness and courtesy.
He had done nobly in his sovereign's war
And ridden into battle, no man more,
As well in Christian as in heathen places,
And ever honoured for his noble graces …
He was of sovereign value in all eyes.
And though so much distinguished, he was wise
And in his bearing modest as a maid
He never yet a boorish thing had said
In all his life to any, come what might;
He was a true, a perfect gentle-knight. (Fig.14)

After the defeat of Saladin at Arsuf in 1191, the fame of the Crusader Knights was carried up and down the pilgrim routes in the songs and epic poems, the *chansons de geste*, of the wandering troubadors. This new propaganda, the idea of chivalry, of fighting strength and courtly virtue combined, was immensely successful and has endured, projecting an image down the centuries which has inspired art of every kind. To this day it is used by those who wish to evoke their noble traditions. (Fig.15)

The Crusades in the Middle East ended badly for the Europeans. By 1300, after 200 years and nine separate military adventures which according to one estimate cost a million lives, all their territorial gains had been lost, Jerusalem and

15. ERWIN PUCHINGER
Subscribe to the 5½% Third War Loan,
Hoflieferent, Vienna, 1915. Lithograph, 127 x
95cm (50 x 37in.). Library of Congress LC-USZC-
11954.

The ancient practice of wearing insignia to help
distinguish friend from foe in battle was
extended in the Middle Ages to reflect the
allegiances of the feudal system. By the 15th
century the art of heraldry had evolved into a
symbolic world of dazzling complexity – the
perfect visual complement to the songs and
tales of chivalry and an inexhaustible source of
material for propaganda purposes.
 This poster, published in Vienna in 1915 to
promote the sale of war bonds, attempts to
provoke a patriotic response by reference to the
noble heritage of the Austro-Hungarian Empire.

Constantinople were abandoned and
the Holy Land was once again firmly in
the possession of Islam. But despite
this, despite the thwarted ambitions of
the Catholic Church and the Christian
monarchs, defeat and disillusion were
not the only legacy of the Crusades.
Contact with the material and
intellectual riches of the East had been
re-established after an interval of 400
years. The commercial and technical
challenges of moving armies and
pilgrims up and down the
Mediterranean had strengthened
European sea power, particularly that
of the maritime republics of Venice and
Genoa who cleared the seas of pirates
and opened up the trade routes. Traffic
would increase and wealth would flow
into Europe. The power of the great
feudal families, exhausted by their
exertions and challenged by new ideas
brought back from foreign parts,
would diminish, while the
bureaucracies of the monarchy and the
nation state would grow and organise
for a changing world.

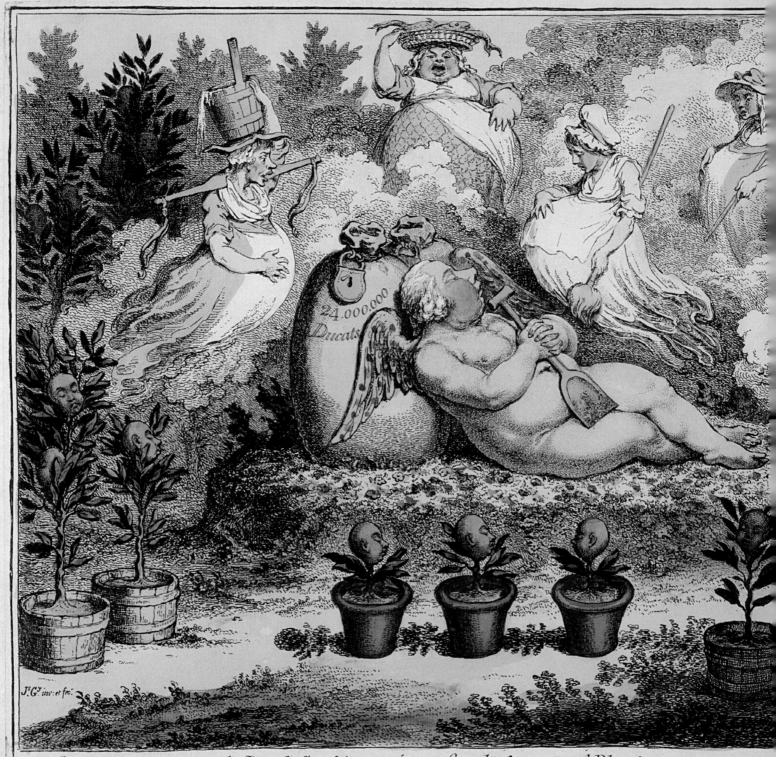

The ORANGERIE; — or — the Dutch Cupid reposing, after the fatigues of Planting. — Vide. *The Visions*

3

The Early Modern Period

Pub. Sep. 16. 1796. by H.Humphrey, New Bond Street
ington Bower.

JAMES GILLRAY (1756–1815)
The Orangerie, or the Dutch Cupid reposing after the fatigues of planting, London, 1796. Hand-coloured etching. Library of Congress LC-USZC4-8765.

William of Orange, as a fat naked Cupid, reclines on a huge bag of money in front of many pregnant women. Having emigrated to Britain in 1795, William soon earned a reputation as a ladies man. As Lord Holland put it, 'When the Prince of Orange resided at Hampton Court, his amours with the servant maids were supposed to be very numerous.' Here Gillray shows the chubby cupid-gardener dreaming of his heavily pregnant conquests and little orange trees bearing fruit made in his image.

Incipit liber Bresith quez nos Gene
si principio creauit deus celu sin vön
et terram . Terra autem erat inanis et
vacua: z tenebre erant sup facie abissi:
et spiritus dni ferebatur super aquas.
Dixitqz deus. Fiat lux. Et facta e lux.
Et vidit deus lucem cp esset bona : et
diuisit lucem a tenebris· appellauitqz
lucem diem et tenebras noctem. Factu
cp est vespere z mane dies vnus. Dixit
quoqz deus. Fiat firmamentu in me-
dio aquaru: et diuidat aquas ab a-
quis. Et fecit deus firmamentu : diui-
sitqz aquas que erant sub firmamen-
to ab hijs que erant super firmamen-
tum: z factum est ita. Uocauitqz deus
firmamentu celu: z factum est vespere
et mane dies secundus. Dixit vero de-
us. Congregentur aque que sub celo
sunt in locum vnu et appareat arida.
Et factum est ita. Et vocauit deus ari-
dam terram: congregationesqz aquaz
appellauit maria . Et vidit deus cp es-
set bonu· et ait. Germinet terra herba
virentem et facientem semen: et lignu
pomiferu faciens fructum iuxta genus
suu: cuius semen in semetipo sit super
terram . Et factum est ita . Et protulit
terra herbam virentem et facientem se-
men iuxta genus suu: lignuqz faciens
fructu et habes vnuqdqz sementem scdm
specie sua. Et vidit deus cp esset bonu:
et factu e vespere et mane dies tercius.
Dixitqz aut deus. Fiant luminaria
in firmameto celi · z diuidat diem ac
nocte: z sint in signa z tepora· z dies z
annos: ut luceat in firmameto celi et
illuminet terra. Et factu est ita. Fecitqz
deus duo luminaria magna: lumiare
maius ut pesset diei et lumiare min⁹
ut pesset nocti: z stellas· z posuit eas in
firmameto celi ut lucerent sup terra: et

pessent diei ac nocti: z diuiderent lucem
ac tenebras. Et vidit de⁹ cp esset bonu:
et factu e vespere et mane dies quart⁹.
Dixit etiam deus . Producant aque
reptile anime viuentis et volatile sup
terram : sub firmameto celi. Creauitqz
deus cete grandia· et omne anima vi-
uentem atqz motabilem qua produxe-
rant aque in species suas: z omne vo-
latile secundu genus suu. Et vidit de-
us cp esset bonu: benedixitqz ei dicens.
Crescite et multiplicamini· et replete a-
quas maris : auesqz multiplicentur
super terram. Et factu e vespere z mane
dies quitus . Dixit quoqz deus. Pro-
ducat terra anima viuentem in gene-
re suo: iumenta z reptilia· z bestias ter-
re secundu species suas. Factu e ita. Et
fecit deus bestias terre iuxta species su-
as: iumenta z omne reptile terre in ge-
nere suo . Et vidit deus cp esset bonu:
et ait. Faciam⁹ homine ad ymagine z
similitudine nostra· z psit piscibz maris·
z volatilibz celi· z bestijs vniuseqz terre:
omiqz reptili qd mouet i terra. Et crea-
uit deus homine ad ymagine et simi-
litudine suam : ad ymaginem dei crea-
uit illu: masculu et femina creauit eos.
Benedixitqz illis deus · et ait. Crescite
et multiplicamini z replete terram · et
subicite eam: z dominamini piscibus
maris· z volatilibus celi: z vniuersis
animatibus que mouentur sup terra.
Dixitqz deus. Ecce dedi vobis vmne
herbam afferentem semen sup terra:
et vniuersa ligna que habet i semetipis
semete generis sui: ut sint vobis i esca·
z cuctis aiantibus terre· omiqz volucri
celi z vniuersis q mouetur in terra· et i
quibus e anima vines: ut habeat ad
vescendu. Et factu est ita. Viditqz deus
cucta que fecerat: et erat valde bona.

The art of printing

Of all the technical advances of humankind, perhaps the greatest to date has been the combination of cheap paper and the printing press. No invention has done more to stimulate the spread of knowledge, and none has more profoundly altered the art of propaganda.

The first prints, made with woodblocks on cloth, were produced in China about AD200. The art of papermaking was mastered at about the same time, and by 600 the first presses had appeared. One hundred years later woodblock-printed newspapers were circulating in Beijing. Woodblock printing was introduced to Europe in the 13th century, and when paper became available there in around 1400, it was used first for small, crudely coloured woodcuts of religious images and playing cards, which were produced in very large numbers.

However, one other innovation was required in order to turn printing into the medium which would change the world. This was moveable type, a system using individual letters which can be assembled together to make a page of text and then printed - a much more flexible and efficient method of reproduction than either manuscript copying or woodblock.

The Chinese had started working with movable type as far back as the 11th century, first using porcelain letters and later wooden ones. In 1377, the Chinese also produced the first known book, a Buddhist text, printed with moveable metal type, news of which probably hadn't reached Johannes Gutenberg (1398-1468) before he developed his own version in Germany in the late 1430s. Nine years later his Bible, which in the light of subsequent events is now looked upon as one of the treasures of western civilisation, was published. (Fig.16)

Its high quality and relatively low price demonstrated the value of the new technology, and printing presses rapidly began to appear all over Europe. By 1500 there were at least 250 of them, the heavy artillery of the propaganda war which was about to break out and change the course of history.

The troublesome priest

It is difficult to overestimate the importance of the printing press to the outcome of the Reformation. Some authorities even think that without it the Reformation would never have happened. Martin Luther himself spoke of the press as 'God's highest act of grace whereby the business of the Gospel is driven forward', and the sheer volume of material which was produced in the early years - some 300,000 copies of Luther's 30 publications appeared between 1517 and 1520 - illustrates not only the effectiveness of Luther's propaganda machine but the seemingly insatiable demand for its output.

Most of these publications came in the form of handy 8-16 page pamphlets, easy to conceal from the authorities and cheap to buy. Written not in Latin but in the local German, and supplemented by woodcut illustrations from leading artists, they were easy to understand, entertaining and aggressively marketed. (Fig.17)

The extent of their popularity surprised even Luther himself. The sermon on 'Indulgences and Grace', for example, sold in such numbers that it became the world's first printed bestseller. In this work Luther suggests that it is preferable for Christians to atone for their sins through good works and penance than to pay the Church cash for an indulgence which will take care of it. This is not a complex issue of doctrine. It is easy to understand and as such is perfect propaganda material. The exposure of this abuse of power, and others like it, provided the impetus which carried the Reformation movement forward.

The pamphlet sermons also served as models for the spoken word delivered by preachers to congregations all over the country, thus carrying the message out to a much wider audience, including the illiterate majority. This technique, enlisting the cooperation of influential individuals in the community to relay the message to the masses, is a key characteristic of the modern propaganda campaign - one which we will meet again later.

The Church authorities could find no effective countermeasure to this tidal wave of literary persuasion and growing public dissent. Slow to understand the importance of printing, they were overwhelmed by the Protestant campaign. Official Church publications only accounted for a small proportion of the available printing capacity during the critical years between 1520 and 1526, and most of those were written in Latin. Yet their main argument against reform, that

17. LUCAS CRANACH THE ELDER (1472–1553)
Christ and Antichrist, Lutheran pamphlet, Germany, 1521. Woodcut. Wikimedia Commons.

The Passionary of the Christ and Antichrist was one of Luther's most successful pamphlets. Structured as a series of double images which contrast the actions of Christ with those of the Pope, it has the communicative power of the satirical newspaper cartoons of today. This beautifully produced pair shows Christ casting out the moneylenders and the Pope selling indulgences.

giving the people unmediated access to scripture would lead to confusion and disorder, turned out to be only too true. Despite Luther's strong condemnation of rebellion, the Peasants' War broke out in 1524, and 100,000 died before it was over. Persecution continued on both sides throughout a period now referred to as the Age of Religious Wars, which lasted until around 1650. Gradually the ideas hammered out in the great propaganda campaign settled into new practices of worship and education. But the upheaval left behind it a permanently changed social landscape, a growing literate class with an appetite for books of all kinds, and a mature printing industry to cater to it. In fact, the use of print marked a new departure in the art of literary persuasion. In the words of Professor Mark Edwards, 'The crisis of authority that was the Reformation owed a great deal to print. Not only did the printing press broadcast the attack on traditional authorities to a broader audience and with greater rapidity than had ever been possible before, it itself embodied the subversive message it conveyed.' (Edwards, p.172)

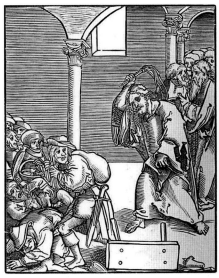
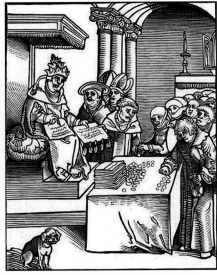

A red and white rose

The division of the western Christian Church had profound political consequences. As their subjects embraced the new faith, the kings and princes of Northern Europe saw an opportunity to resist the political influence of the Vatican, even to break with the Church, a drastic step which could lead to confrontation with the Holy Roman Empire, but which would put the great wealth of Church property within their grasp. Such was the case in England. When Henry VIII succeeded his father Henry VII, he took charge of a young but already well-defined dynasty. Henry the elder had taken the throne by force of arms, famously defeating Richard III at Bosworth Field in 1485. His first priority had been to consolidate his family's hold on the crown:

Henry was determined to legitimise his dynasty in the eyes of God, the Pope, and Europe, not to mention the English people, and he did this with the aid of a judicious marriage, ceremonial and propaganda. He presented his Bosworth standards to St. Paul's cathedral, the white and red roses of the Houses of York and Lancaster were combined into a united two-coloured rose, papal recognition was published with the aid of the printing press introduced to England in 1476 by William Caxton … and he went on a 'progress' to various English cities, including York. (Philip M. Taylor, p.102)

So when young Henry came to power in 1509 he had something to work with. He also inherited his father's considerable fortune but not his abstemious nature. He threw himself into a strenuous programme of ceremony, courtly splendour, hunting, mock battles and tournaments, all designed to reflect the wealth, sophistication and vigour of the English monarchy. The signing of the Treaty of Universal Peace, which culminated in 1520 in his meeting with Francis I of France on the Field of the Cloth of Gold near Calais, provided Henry with his most celebrated propaganda opportunity. A spectacular set piece of late medieval chivalry, the event managed to gloss over the uneasy relationship between the two and gave the impression that England was a power to be reckoned with - exactly as Henry intended. (Fig.18)

Since their marriage in 1509 Henry and his Queen, Catherine of Aragon, had been trying without success to produce the male heir which Henry wanted in order to secure the Tudor succession. In 1525 he resolved to divorce her and embarked on a long, vexatious and ultimately fruitless attempt to secure the

18. HANS HOLBEIN THE YOUNGER (1497–1543)
Henry VIII, England, 1536. Oil on panel.
Wikimedia Commons.

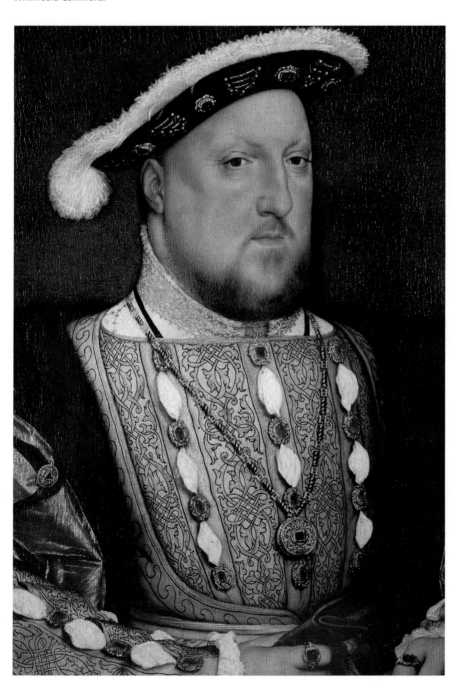

necessary permission from the Pope. The frustration of his manoeuvres led to a gradual deterioration in relations with Rome, culminating in 1534 in the Act of Supremacy, which placed him at the head of the Church of England, virtually guaranteeing a break with Rome in the near future. King or not, his position would be untenable if he could not carry the people of England with him. This was a different sort of Reformation, provoked not by a groundswell of popular opinion orchestrated by a charismatic preacher like Luther, but by a political expediency drawn from Henry's determination to preserve the Tudor dynasty at all costs.

He was fortunate to have at his disposal a most able propagandist in the person of his chief minister, Thomas Cromwell, for it was not at all clear that the English, a notoriously conservative people, were ready to throw away a thousand years of tradition and culture. Cromwell, who spoke Latin, French and Italian and as a young man had worked for Florentine merchant bankers and an English cardinal, launched 'the first campaign ever mounted by any government ... to exploit the propaganda potential of the printing press'. (Philip M. Taylor, p.102)

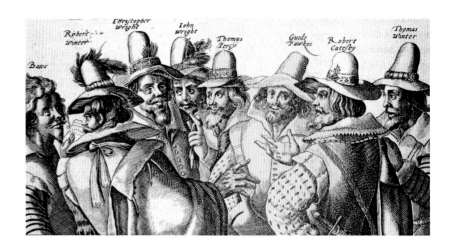

He used a group of English intellectual humanists to produce printed material supporting the English Reformation, in both English and Latin. *A Little Treatise against the Muttering of Some Papists in Corners* provided guidance for clergymen in the preparation of their sermons, and in 1536 Richard Morison, one of Cromwell's chief writers, produced a piece entitled *An Exhortation to Stir All Englishmen to the Defence of Their Country*, in which he linked the practice of Catholicism with the threat of invasion by foreign (Catholic) powers. This classic propaganda device proved to be immensely successful, to the extent that for the next 300 years Catholicism in England would be treated as unpatriotic and even traitorous. (Fig.19)

With grim determination Cromwell visited every possible channel of communication with the people. Official Church books were rewritten without reference to the Pope but with a great deal of reference to Henry as Supreme Head of the Church. Schoolteachers were given instruction. Bishops were put under surveillance and magistrates empowered to punish dissidents. In the eight years between 1532 and 1540 a new national consciousness emerged in England, a patriotism which would later find its full expression in the reign of Elizabeth I, Henry's daughter.

Cromwell made many enemies in his career. In handling the dissolution of the monasteries he had become immensely, imprudently, rich, and many resented his special relationship with the king. Under constant pressure, he was eventually held responsible for Henry's botched marriage with Anne of Cleves, imprisoned and executed in 1514.

Renaissance

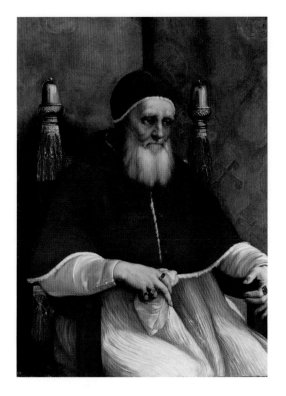

20. RAPHAEL (1483-1520)
Portrait of Pope Julius II, National Gallery, London.1511-1512, oil on wood panel, 108.7x81 cm. © The National Gallery, London

Here Julius is shown in his papal robes, flanked by the acorn motifs in the chairback, (a heraldic device associated with his family), and the papal crossed keys. But in Raphael's hands these elements of a conventional official portrait are subsumed into the likeness of an old man in pensive mood. 'So true and so lifelike,' according to Vasari, 'that the portrait caused all who saw it to tremble, as if it had been the living man himself.'

Generally believed to have begun in Tuscany in the 14th century, the Renaissance was characterised by a renewal of interest in classical antiquity, a shift away from the medieval world in which man's place was fixed by religious dogma and feudal society to one which encouraged the individual to take his place in a political constituency based on the nation state. The medieval emphasis on transcendental spirituality was replaced by a search for knowledge of the world, with man at the centre of it. Since the Renaissance did little to reduce the old evils of war, poverty and disease for those alive at the time, it was probably not the Golden Age which the 19th-century humanists would later describe, but there can be no doubt that in the field of the arts at least, both the artists and the patrons who sustained them believed themselves to be the vanguard of a new age, in which humanity would free itself from the superstition and ignorance of the past.

In politics too, new ideas were emerging. Humanist historians such as Leonardo Bruni (c.1369-1444) offered an objective analysis of past events, uncoloured by Christian dogma, which set in motion a tendency towards the separation of politics from religion. By the 16th century, stimulated by a deterioration in the political circumstances of the Italian city states, the Florentine writer Niccolò Machiavelli developed this trend in his celebrated book, *Il Principe* (*The Prince*) in which he sought to base the art of governance on logic and science rather than Christian doctrine. Highly influential, this manual of statecraft outlined the principle of the preservation of the state by any effective means, and though the author's name has become associated (some would say unfairly) with the ruthless exercise of power, this new political perspective provided an essential ingredient for the development of modern propaganda technique - the idea that the affairs of men could be influenced by the objective analysis and manipulation of their circumstances.

In contrast to the new beginnings launched in Renaissance art, the business of warfare proceeded as an evolution of late medieval practice. The nobility and military leaders maintained and developed the customs of chivalric arms and heraldic display, happy to associate themselves with its code of honour and their regimes with the trappings of traditional legitimacy. The abiding imperative for the rulers of the city

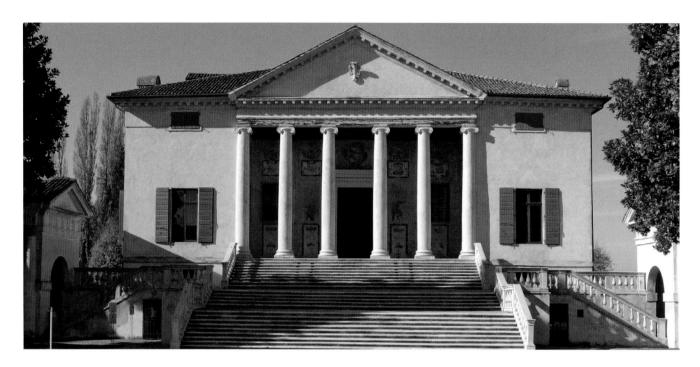

21. ANDREA PALLADIO (1508-1580)
Villa Badoer, Veneto, N. Italy, 1556-63,
Wikimedia Commons

Around 1520 the Venetian aristocracy began to develop new farmland in the Veneto. In response to the demand for appropriate accommodation a young Vicentine architect, Andrea Palladio, developed a new building type, consolidating the main residence and farm buildings into one symmetrical and beautifully proportioned structure which he provided with a Roman temple front, an extraordinary and imaginative solution quite without precedent in the ancient world. The Romans had not been in the habit of putting temple fronts on their villas and Palladio, an accomplished scholar of the ancient architecture, knew it. But this was the Renaissance. For Palladio's sophisticated humanist clients all things classical were desirable, and the well-documented relationship of the Roman patricians with their country estates was no doubt both familiar to them and something they found easy to identify with. By the 1550s Palladio had built over 20 of these villas. They were hugely successful and launched a career which made him arguably the most influential architect of all time.

Besides the progress of a genius, this account provides an illustration of one of the key principles of propaganda - that a campaign need not necessarily offer the truth or even real value, but must deliver perceived value in terms of the propagandee's self image. It did not matter to Palladio's clients that their villas had no classical precedent. They looked as if they did, so it pleased their owners to possess them, just as it pleased the Romans themselves to borrow the culture of the Ancient Greeks, and a modern city bank to provide itself with a medieval coat of arms.

states, none of whom was ever strong enough to control the others, was to preserve their hold on power, and to project an image which expressed their indisputable capacity to do so. Here is the glory of the Renaissance, as the Medici in Florence, the Sforza in Milan, the d'Este in Ferrara and a succession of Popes poured money into the creation of art and architecture designed to overawe their subjects, deter their enemies and secure their place in posterity. (Fig.21)

It seems that no period in history has yielded more men of ability and personal accomplishment than the High Renaissance (c.1500-25). The great artists and architects of the time equalled and surpassed the achievements of antiquity and established professional benchmarks which endured for generations. But perhaps the outstanding figure, and without doubt the most significant propagandist, was not an artist. Pope Julius II, who was pontiff from 1503 until his death in 1513, would probably be remembered for his political and warlike accomplishments alone - he is often referred to as the 'Warrior Pope' - but his real legacy derives from his role as a patron of the arts. This is the man who commissioned Michelangelo to paint the Sistine Chapel; who commissioned Raphael to paint the murals now known as the *Stanze di Raffaello* in the Vatican, and who, in 1503, engaged Donato Bramante to completely rebuild St. Peter's Basilica, the biggest architectural project of the 16th century and a breathtaking act of self-assurance which probably no one but Julius could have pulled off. With these and many other projects, his contribution to the image of the Church was enormous. He was a man of action who never neglected his duties as leader of the Church, but understood instinctively that in these turbulent times his best contribution would be to extend and protect the temporal power of the papacy, by force of arms if necessary, and by bringing into the world, if at all possible, the finest art it had ever seen. The persistent rumours of his addiction to the practice of sodomy, while vexatious to him, were a gift to Reformation propagandists, who at every opportunity produced them as evidence of Catholic decadence. (Fig.20)

The propaganda of the senses

22. GUARINO GUARINI (1624–83)
Capella della Santissima Sindone, Turin, Italy, 1667–90.

As finely balanced a combination of mathematical reason and divine inspiration as anything from the Baroque, the *Capella della Santissima Sindone* was built to house the shroud of Christ at the east end of the cathedral, adjacent to the royal palace. Gazing up into this spectacular dome, the faithful could be forgiven for believing they had discovered a direct conduit to heaven.

The 16th century brought change and uncertainty to the people of Europe. Before it had ended, many of the medieval certainties which had sustained them for generations had been challenged and swept away. Voyages of discovery such as those of Columbus and Magellan showed that the Mediterranean was not in the middle of the earth after all, and the work of the astronomer Copernicus proved that the world itself was neither at the centre of the universe, nor flat. But much worse was the apparent undermining of the very bedrock of society, the authority of the Church, as the Protestant Reformation gained ground. No longer a matter of a few dissident clerics, the movement had, by the middle of the century, acquired real political significance.

Forced to act, Pope Paul III summoned the Council of Trent, an ecumenical conference that took place between 1545 and 1563. Though interrupted on a number of occasions by war and religious disputes, the council succeeded in addressing two fundamental issues: reform of the Church, to address the institutional failings which were the root cause of the Reformation; and the initiation of an aggressive campaign to win back the lost legions of the faithful, which came to be known as the Counter-Reformation. As well as dealing with institutional matters, the Council examined every aspect of presentation with the intention of making the Church and its message more accessible and attractive to the masses, issuing detailed instructions for the reform of everything from music to religious art. This resulted in a monumental campaign of ecclesiastical building and artistic production of every kind in the lavishly decorative style that epitomises the era now known as the Baroque. By the beginning of the 17th century the radical new style began to appear in the new and refurbished churches of Rome. Whereas the appeal of a Renaissance church was essentially an intellectual one derived from the arrangement of simple classical elements in symmetrical repose, the Baroque interior made a direct appeal to the senses. For the first time architecture, sculpture and painting were integrated in dramatic, even illusionistic, compositions designed to evoke an emotional response in the viewer. Strong colours, hidden light sources and rich textures were all enlisted. Classical stillness was discarded in favour of a dynamic balance which drew the eye and invited the viewer to participate. In short, the Baroque was a propagandistic *tour de force*. (Fig.22)

Here comes the sun

23. HYACINTHE RIGAUD (1659–1743)
Louis XIV, Apollo Salon, Chateau de Versailles, France, 1701. Oil on canvas, 2.05 x 1.52m (6ft 9in. x 5ft). Wikimedia Commons.

Opposite
24. PIERRE PATEL (C.1605–1708)
Versailles, France, 1662. Oil on canvas, 115 x 161cm (45 x 63in.). Courtesy: Wikimedia Commons.

This bird's-eye view allows us to see Versailles in relationship to the landscape. With strict regard for symmetry the royal bedchamber was placed at the centre of the complex, and exactly at the centre of the bedchamber stood the royal bed from which emanated the mysterious and awe-inspiring will of Louis XIV. The axis of power extends beyond the palace, bringing order to nature, and eventually reaches the heavens, the source of the Sun King's majesty.

The compelling visual power of the Baroque style and the prestige associated with its endorsement by the Church ensured its adoption by secular patrons, and in France the style reached its secular apotheosis during the reign of Louis XIV (r.1643-1715). An eccentric and determined man, Louis sought to concentrate the power of the state in the monarchy at the expense of the feudal aristocracy, obliging the nobles to live at court, where he could paralyse them in luxury and exclude them from power by employing able commoners like Colbert and Le Tellier to administer the affairs of state. (Fig.23)

Louis found the Baroque style to be the ideal propaganda medium to support his extreme brand of absolutism, and he used every means at his disposal to construct an appropriate image, employing a host of artists, writers and composers for the sole purpose of creating and perpetuating the myth of his princely perfection. The author Racine, an unashamed sycophant, described his reign as 'an unbroken series of marvels', suggesting that 'every word in the language, every syllable, is precious to us because we consider them as the instruments which must serve the glory of our august protector'. (Philip M. Taylor, p.124)

Motivated perhaps by a wish to distance himself from the mob physically as well as constitutionally, Louis decided to move the royal court from the capital, Paris, to the Palace of Versailles. Beginning in 1669 he undertook a series of renovations and expansions which turned it into the greatest Baroque palace in Europe, a staggering exercise in autocratic display unseen since the days of Imperial Rome. Here was concentrated not only the ritual of the ornamental court, but the apparatus of government - all the power of France - like some great and perfectly regulated clockwork machine revolving round the person of the king. In the overwhelming scale of its conception Versailles expresses not only the ambitions of a monarch but the utopian vision of an ordered universe, of man's dominion over nature as promised by Newton and the other men of science of the Baroque Age. (Fig.24)

For Louis, a man who habitually wore built-up shoes and big wigs to make himself look taller, the Baroque was the perfect style. Devised by Italians for the glorification of God, it transformed him into the 'Sun King', the last true and absolute monarch of the western world.

Above
24. PIERRE PATEL (C.1605–1708)
Versailles, France, 1662. Oil on canvas, 115 x
161cm (45 x 63in.). Courtesy: Wikimedia
Commons.

This bird's-eye view allows us to see Versailles in relationship to the landscape. With strict regard for symmetry the royal bedchamber was placed at the centre of the complex, and exactly at the centre of the bedchamber stood the royal bed from which emanated the mysterious and awe-inspiring will of Louis XIV. The axis of power extends beyond the palace, bringing order to nature, and eventually reaches the heavens, the source of the Sun King's majesty.

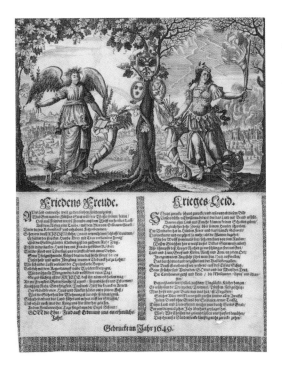

25, ARTIST UNKNOWN
Peace joy. War suffering, Germany, 1649. Engraving and letterpress, 55 x 28cm (21 x 11in.). ©Trustees of the British Museum.

A broadside comparing the upheaval of the Thirty Years War with the hoped-for blessings to be derived from the Peace of Westphalia.

After the spectacular success of the printing press in the Reformation, the use of printed propaganda became an indispensable feature of war and ideological conflict for governments and dissidents alike. During the Thirty Years War (1618-48), a catastrophic conflict involving most of the countries in Europe (and resulting in the death of around a quarter of the population and the wholesale destruction of property), printed propaganda was employed for the first time in a major conflict. Huge quantities of printed material, mostly posters and leaflets, were produced by both sides as they attempted to control civilian populations shattered by the mercenary armies which were rampaging back and forth across the Continent. For the first time copper printing plates were used; these could be produced much more quickly than woodblocks. Both sides engaged in the dissemination of atrocity stories, warnings to besieged towns, appeals for enlistment, defamation of opposing leaders - all the hallmarks of modern war propaganda. It was the first propaganda war in history to reach a mass audience while the fighting was going on, and this despite the fact that the vast majority of its audience was illiterate. (Fig.25)

In France both Cardinal Richelieu and his successor Mazarin maintained a system of strict censorship to control public opinion, providing only one official newspaper, Renaudot's *La Gazette de France*, which first appeared in 1631. A weekly four-page journal, the *Gazette* acted as the government mouthpiece and carried a selection of local and international news. Not surprisingly, given that it was the only source apart from the clandestine pamphlets printed abroad and smuggled in by Huguenot *émigrés*, it was avidly read and collected by those who could afford it. The monopoly of the Gazette continued throughout the reign of Louis XIV. This failure to provide a constitutional outlet for public opinion, coupled with the King's celestial remoteness, contributed to the widening of the gulf between the monarchy and the French people, which 74 years after Louis's death would end in revolution.

The English Civil War

26. ARTIST UNKNOWN
Levellers' pamphlet, W. Larner (publisher), Bishopsgate, London, 1649. Letterpress. Wikimedia Commons.

The arrival of the printing press fundamentally altered the way information circulated in early modern Europe, notably expanding the role of public opinion in politics, and forcing governments to address the issues surrounding both state and oppositional propaganda. While Luther's campaign represents the first use of the press in religious opposition, and the Thirty Years War its first mass deployment in wartime, England in the 17th century provides an early example of its use in political opposition.

In the early 1600s Puritans opposed to the absolutist and quasi-Catholic attitudes of the king, Charles I (r.1625-49), conducted a powerful propaganda campaign to counter what in their view was a threat to their civil liberties. Unable to contain the growing criticism, and unwilling to change, Charles was eventually forced to fight.

In the ensuing civil war (1642-46) the system of licensing and censorship first introduced by the Tudors and perpetuated by the Stuarts broke down, leading to a vicious propaganda war. Thousands of pamphlets and hundreds of news-sheets were published during the course of the war, mostly by the Parliamentarians, who controlled the majority of the printing presses in the country. Alarmed by the intensity and sheer volume of material being produced, Parliament re-imposed censorship by licensing in 1643, a measure which was severely criticised, notably by the Puritan poet John Milton in his celebrated work Areopagitica, and by the Levellers, a group of hardline Puritans who displayed great skill in frustrating the authorities' attempts to muzzle them. (Fig.26)

Following his defeat at Naseby in 1645 and his subsequent refusal to meet Parliamentarian demands, Charles I was seized, tried and executed. England became a Puritan republic. Its Lord Protector, Oliver Cromwell, a man with deep religious convictions and a harsh way of dealing with opposition, saw his mission as a godly struggle to eliminate evil from the world. But the people saw the makings of a dictatorship and, lacking an effective propagandist, the new government failed to win them over. Popular support disappeared in a rising tide of protest against the loss of

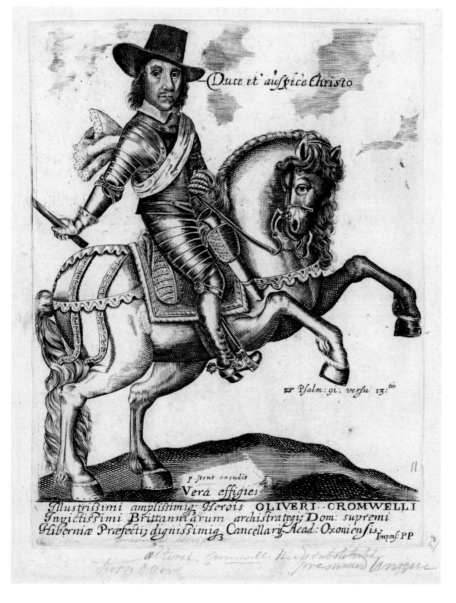

Duce et auspice Christo

☞ Psalm: 91: versu 13:tio

p. stent excudit
Verá effigies

Illustrissimi amplissimiq; Herois OLIVERI CROMWELLI
Invictissimi Brittanniarum archistrategi; Dom: supremi
Hiberniæ Præfecti; dignissimiq; Cancellarij Acad: Oxoniensis; Impens: PP

the very freedoms which the Puritans had fought to protect. Cromwell died in 1658 and the political crisis which followed led to the restoration of the monarchy in the person of Charles II. (Fig.27)

Two propaganda lessons emerged from the collapse of England's brief republican experiment: that for a revolution to survive it must have at its disposal the means to communicate its agenda positively; and that, in a future where its subjects have access to the printing press, a monarchy's continued existence will depend on public opinion rather than the will of God.

27. ARTIST UNKNOWN
A full and true likeness of the hero Oliver Cromwell, Peter Stent publisher, Britain, 1642. Engraving, 21.3 x 16.7 cm (8 x 6in.). © Trustees of the British Museum.

Into the light

The Age of Enlightenment is an expression used to describe the period, broadly equivalent to the 18th century, during which the authority of reason was established in western thought and cultural activity. The social and political ideas developed at that time fuelled an aspiration towards common sense, liberty and the right of man to self-governance, which led to revolution in the western world and a decisive break from the old principles of religious authority and absolutism. Improvements in paper and printing technologies, and in transport, were reflected in higher rates of literacy and a corresponding expansion in the role of public opinion in political life. Accordingly, both the means and the practice of propaganda were brought to the threshold of the modern world.

The 18th century saw the introduction of the political and satirical cartoon. Often hand-coloured etchings or engravings, these highly topical and engaging illustrations played an increasingly important role in the propaganda campaigns of the time, and in the hands of gifted artists such as William Hogarth, Thomas Rowlandson and James Gillray represented a formidable and indispensable tool of the propagandist. Gillray in particular devoted himself to political subjects. In his early career he mercilessly lampooned King George III, 'Farmer George', and his family, and after the French Revolution he recorded his dismay at its progress in an extended series attacking Napoleon and the French, and glorifying John Bull, the quintessential Englishman. (Fig.28)

Hogarth, a less mordant propagandist but a greater artist, is best remembered for his penetrating analyses of the social mores and human foibles of the day.

28. JAMES GILLRAY (1756–1815)
Little Boney in a strong fit, 1803. Hand-coloured etching. Library of Congress LC-USZC4-8795.

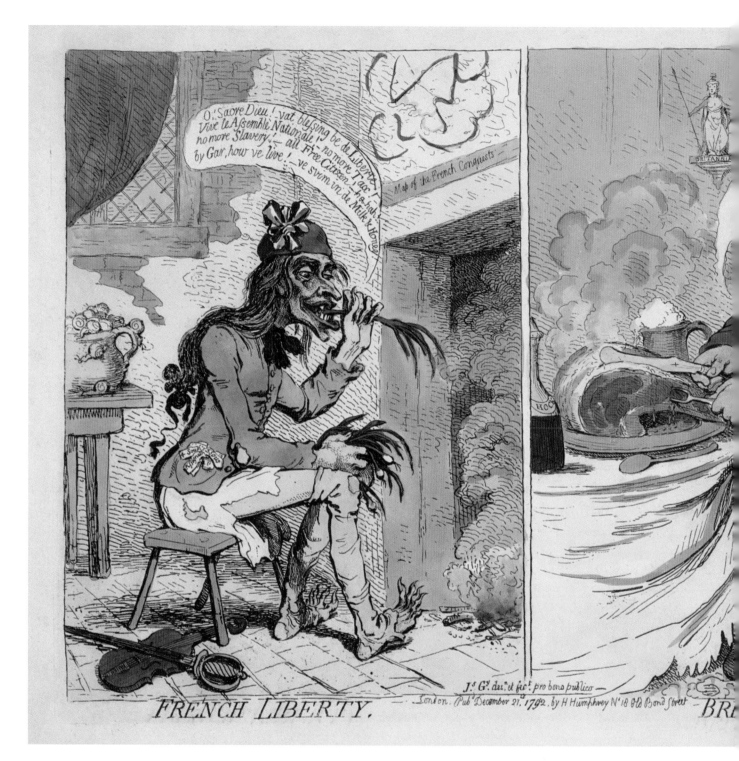

FRENCH LIBERTY.

J.ᵉ Gᵧ. desⁿ et fecⁱ pro bono publico —
London. Pubᵈ December 21, 1792, by H Humphrey Nᵒ 18 Old Bond Street

29. JAMES GILLRAY (1756–1815)
French Liberty – British Slavery, London, 1792.
Hand-coloured etching. Library of Congress LC-USZC4-6088.

30. WILLIAM HOGARTH (1697–1764)
Gin Lane, 1751. Engraving, 38 x 32.5cm (15 x 12in.)
© Trustees of the British Museum.

Published in a pair with its companion, *Beer Street*, this print was intended to support the campaign led by Hogarth's friend, the novelist Henry Fielding, against gin drinking among London's poor. In the early years of the 18th century consumption of gin, a strong spirit

previously unfamiliar to English people, had reached epidemic levels, the dire consequences of which Hogarth depicts brilliantly in the print. By way of contrast *Beer Street* celebrates the virtues of that mildly intoxicating traditional national drink.

31. *Beer Street*, 1751. Engraving, 38 x 32.5cm (15 x 12in.).
© Trustees of the British Museum.

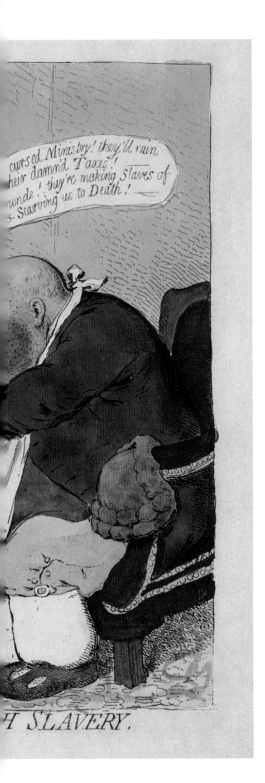

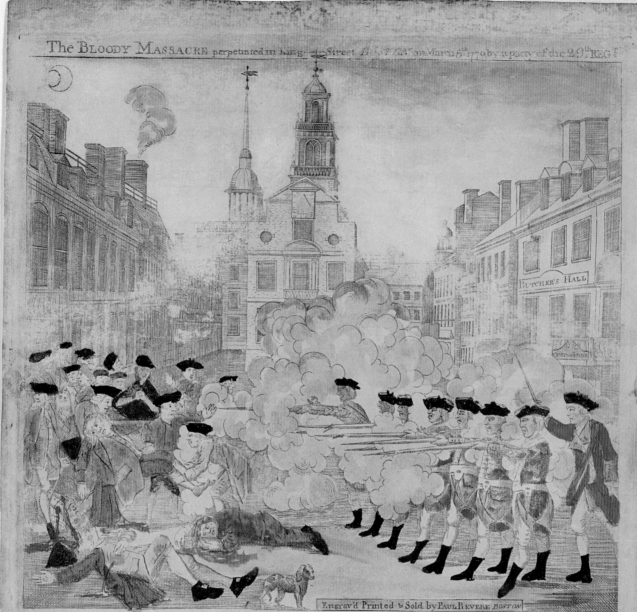

The American revolution

32. PAUL REVERE
The Boston Massacre, published by the artist, Boston, USA, 1770. Hand-coloured engraving. Wikimedia Commons.

This hand-coloured engraving was produced for sale in the streets of Boston by Paul Revere within three weeks of the event. The illustration portrays the brutal killing of defenceless citizens by a disciplined and heartless detachment of British troops. But contemporary accounts suggest that an incident which began with the taunting of a lone sentry by a group of youths progressed to a confused brawl, and ended in shots fired by a group of soldiers hard-pressed by an angry mob. The officer, who in the picture is clearly shown giving the order to fire, was acquitted in the subsequent trial.

What really happened did not matter in the end. The incident revealed the depth of resentment felt by Bostonians at having to put up with the presence of troops in their town, and the popularity of the print showed that many in the colonies were ready to pursue the goal of independence.

The defeat of the French in the Seven Years' War (1756-63) resulted in the British conquest of Canada and the end to French colonial hopes in America, but the ruinous cost of this war left Britain with a national debt which it determined to pay by taxing its colonies. Lacking elected representation in Parliament, American colonists rejected the right of the British government to impose these taxes (notably the Stamp Tax of 1763), considering these and other restrictions designed to limit their autonomy as a violation of their rights as Englishmen. 'No taxation without representation' became the first slogan of the American revolutionary movement. The tax, and the royal proclamation of 1763 which attempted to protect native Indian interests by banning westward expansion into the Ohio territory, ensured a deterioration in relations with the colonists, whose greatest incentive for cooperation with Britain had been eliminated with the defeat of the French. Conflict seemed inevitable.

The American Revolution was underpinned from the first by republican ideals. The work of English philosopher John Locke (1632-1704) particularly influenced the thinking of leading colonists, who found in his *Treatises on Government* (1690) the moral and intellectual justification for action against an oppressive and unjust government. British attempts to impose controls only served to fuel increasingly open criticism of what was seen as a corrupt and unsympathetic colonial power. In fact well-informed public debate, conducted mainly through the medium of pamphlets and newspapers, ensured that literary persuasion would play a key role in the outcome of the coming conflict, and the colonists were clearly aware of the need to manage public opinion, both at home and abroad, by means of propaganda. (Fig.33)

Newspapers were the most effective medium for revolutionary propaganda. The British attempted to control them by means of taxation, but failed. Some were forced under by the burden of tax but others quickly appeared to take their place, even more determined to defy the colonial authorities, while high levels of literacy among the colonists ensured a wide circulation for revolutionary news.

In 1770 an incident occurred in Boston, a focus of revolutionary sentiment, which was to provide the colonists with a classic propaganda opportunity. British troops who had been quartered in the town were confronted by a hostile mob and, sorely tried, fired into it, killing five people. News of the incident,

33. ARTIST UNKNOWN
The Pennsylvania Journal and Weekly Advertiser, William Bradford, publisher, USA, 31 October 1765. Woodcut and letterpress. Private collection.

On 31 October 1765, eight colonial newspapers which had been forced into closure by the Stamp Act were published with black borders, skulls and other symbols of death, to commemorate the demise of press freedom under British oppression. This illustration shows the masthead of the *Pennsylvania Journal,* with a statement by its owner, William Bradford, regretting the situation and asking subscribers to pay their arrears so that he might survive and 'be better prepared to proceed again ... which I hope will be soon'.

Many colonial newspapers closed in the course of the revolution, but these were soon replaced by others, often with a new name but the same proprietor. This situation, while no doubt stressful for those involved, encouraged editors to be more outspoken, in the knowledge that death would quite possibly be followed by resurrection.

subsequently referred to as the Boston Massacre, was widely circulated in the press and depicted in a partisan hand-coloured engraving by a local silversmith Paul Revere, who would later be immortalised in Longfellow's poetic account of his midnight ride to warn the people of Concorde of the approach of British forces. (Fig. 32)

In 1772, Samuel Adams, known as the 'master of the puppets' in recognition of his powers of propagandistic manipulation, began to create the committees of correspondence, which linked patriots in all thirteen colonies to provide a forum for revolutionary activity and eventually the basis of a rebel government. The next year he organised the celebrated Boston Tea Party, a public protest against unfair taxes which involved throwing a cargo of tea into Boston harbour, and the subject of a carefully managed propaganda coup which focused discontent among the colonists and has since acquired iconic status in American history.

But perhaps the greatest propagandist of the American Revolution was Thomas Paine, an English writer and radical intellectual who emigrated to America in 1774 at the suggestion of Benjamin Franklin. Paine became the editor of Franklin's *Pennsylvania Magazine*, a post which he ably fulfilled, and in 1776 he published anonymously a pamphlet entitled *Common Sense*, an emotionally persuasive argument in favour of independence from Britain, which was widely distributed throughout the colonies. Paine had a gift for dealing with difficult subjects in straightforward language which ordinary people could understand, aiming to 'fit the powers of thinking and the turn of the language to the subject, so as to bring out a clear conclusion that shall hit the point in question and nothing else' - good advice which the present author promises to apply here, to the best of his abilities.

Shortly after the outbreak of hostilities in 1775, Paine published *The American Crisis*, a series of sixteen pamphlets designed to bolster the revolutionary forces' resistance to the British in the difficult early days of the war. General George Washington had the famous first pamphlet read out to his troops on the eve of the Battle of Trenton:

These are the times that try men's souls. The summer soldier and the sunshine patriot will, in this crisis, shrink from the service of their country; but he that stands it now, deserves the love and thanks of man and woman. Tyranny, like

Above left
34. BENJAMIN FRANKLIN
Join or Die, published in the Pennsylvania Gazette (owned by Franklin), USA, 1754. Woodcut, Library of Congress LC-USZC4-5315.

This celebrated woodcut image was first published by Benjamin Franklin on 9 May 1754 to support a plea for colonial unity during the French and Indian War. Referring to a popular superstition of the time, that a snake which has been cut into pieces will come back to life if you put the pieces back together before sunset, it was the first-ever political cartoon published in an American newspaper. Other publishers took up the image and it was reprinted in newspapers throughout the colonies.

Ten years later the snake was used again, in an appeal for unity against the iniquitous Stamp Act and the increasingly oppressive interference of the British government in the affairs of the colonies. As the situation deteriorated and the colonists moved towards rebellion, the snake became a symbol of American unity and independence, appearing on buttons, banknotes, banners and flags.

Above right
35. GEORGE EDWARD PERINE (1837–85)
Benjamin Franklin, USA, 1860–85. Engraving after the original painting by Charles Cochin. Library of Congress LC-DIG-09852.

In his fur hat and spectacles, Franklin won the hearts of the French and probably did more than anyone to enlist their support in the American Revolution.

hell, is not easily conquered; yet we have this consolation with us, that the harder the conflict, the more glorious the triumph. What we obtain too cheap, we esteem too lightly: it is dearness only that gives every thing its value.

Benjamin Franklin, sponsor of Thomas Paine and prototypical publicist, was one of the founding fathers of the United States. A noted polymath, he was an early proponent of colonial unity and worked tirelessly to promote the cause of independence. In France his was the face of the American Revolution, and his diplomatic efforts in securing the support of that country and its allies proved critical to the outcome of the revolutionary struggle. In October 1777 France entered the war with its ally Spain, and in 1780 the League of Armed Neutrality, an impressive list of European countries keen to assert their rights to trade with the newly formed United States of America, also joined in. Faced with a front stretching from America to India and an unwinnable war which had never been popular at home, the British granted independence in 1783. (Figs. 34 and 35)

The American Revolution was inspired by Enlightenment philosophy, but once underway it was entirely dependent on the support of ordinary people. The newspapers played their part in guiding popular opinion, as did the men who would become the heroes of the American foundation myth - Adams, Thomas Jefferson, Franklin, Paine and Washington. This war, the first people's war which demanded the involvement of every household in the land, presented its propagandists with new challenges and opportunities (and before the end of the century the potential of the 'nation in arms' would be dramatically fulfilled in France). Indeed, there never was a more eloquent revolution. Even today, much of the material produced in its name is a pleasure to read. Perhaps the best of it, *The Declaration of Independence*, published on 4 July 1776, is a moving proclamation of the rights of man, a compelling example of literary persuasion and an enduring legacy from the Age of Reason.

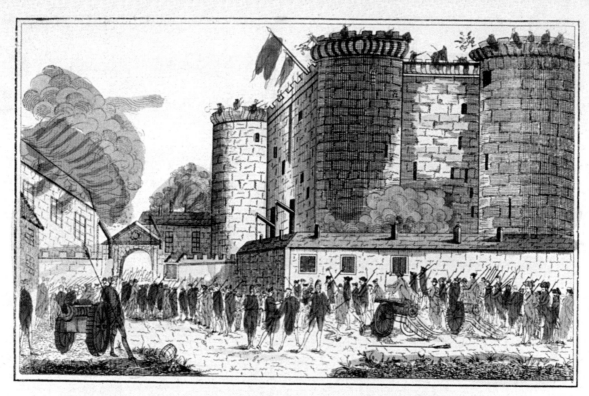

PRISE DE LA BASTILLE

Par les Citoyens de Paris ayant à leurs têtes Mrs les Gardes Françoises, le 14 Juillet 1789

Cette Forteresse fut commencée en 1369 sous le règne de Charles V. Hugues Aubriot Prevot de Paris en posa la 1re Pierre elle ne fut entierement achevée qu'en 1382. Il étoit natif de Dijon. Il y fut un des premiers renfermés sous pretexte d'hérésie. Il fut délivré par les Parisiens pendant les troubles qui agitoit la Capitale, et se sauva dans sa patrie.

C'est ainsi que l'on Punit les Traitres.

The tree of liberty

36. ARTIST UNKNOWN
Storming of the Bastille by the citizens of Paris,
Paris, France, 1789. Hand-coloured etching.
Library of Congress LC-USZC2-3565.

In the 1780s, the same Age of Reason was also bringing change to France. Nowhere were the new ideas more enthusiastically embraced by those who would listen to them. But whereas in America the Enlightenment shone on a robust young nation eager to rid itself of its colonial masters and build a new country without interference, in France people were starving. The ruling class, insulated by ingrained indifference, distracted itself in conspicuous material consumption, and the King, Louis XVI, clinging like his grandfather and his great-grandfather before him to absolutist dogma, and surrounded by false advisers, was incapable of meaningful dialogue with his people. France was broke. Her antiquated institutions could not cope, and the government staggered from one crisis to the next.

Despite the continued existence of censorship, the press in 18th-century France grew with the spread of literacy and an ever more vocal professional class, and though official restrictions prevented the open distribution of printed material, republican ideas circulated freely, especially after the success of the American Revolution, which the *ancien régime* had supported, perhaps imprudently, in its zeal to disoblige the British. However, the ineffectiveness of state censorship did not negate its damaging effects. Its very existence was an affront to free-minded people, and as the British Government had realised a hundred years before, denying the people a constitutional means of dissent is a dangerous game. As Edmund Burke remarked, 'A state without the means of some change is without the means of its conservation.'

In 1789 political pamphlets and newspapers appeared in growing numbers, and though their contents were often contradictory their tone was uniformly and increasingly critical of the regime. By July of that year the inflamed state of public opinion and the intransigence of the king had frustrated all attempts to establish a process of orderly reform. The government sent mercenary soldiers into Paris. The people took to the streets and the revolution had begun.

In the storming of the Bastille, the revolution found its essential act, a symbol not only of revenge against a tyrannical regime, but of the realisation of a dream, a breakthrough to a new and better life. Within two weeks prints portraying the event were in the streets. (Fig. 36)

Borne on a wave of euphoria, a new graphic art poured out to drive the revolution forward and to commemorate 14 July, Bastille Day. Spontaneous

37. EMILE WATTIER (1800–68)
Sans-culottes, France, 1842. Etching. Wikimedia Commons.
An idealised 19th-century reworking of earlier 1790s illustrations of the classic –'sans-culottes' fashions.

Below
38. ARTIST UNKNOWN
Robespierre operating the guillotine, France, 1790s. Engraving. Working amid a nightmare forest of guillotines, Robespierre is in the process of killing everyone in France.

popular improvisation brought to life the symbols and patriotic character of the French Revolution. The Phrygian cap, the dress code of the *sans-culottes*, the tricolour in sash and cockade, Marianne and the tree of liberty were all deployed in glorification of the new world at hand. (Fig. 37)

Propagandists will tell you that every successful campaign has a compelling idea at the heart of it. This revolution had three of them: *liberté*, *egalité*, *fraternité*, three ideas so beautiful as to make the world wonder how it was that any people could dare to have them. That summer in Paris they danced the Carmagnole and sang 'La Marseillaise'.

Everything changed. The political geography of France was rearranged into new *départements* (administrative regions) and districts. The calendar was recast in weeks of ten days and months with new names. Everything was questioned, renovated, and for a while the propaganda was almost redundant because the revolution was everywhere. Yet the propagandists were there, organising, teaching and directing the mob as best they could. The summer passed into autumn, and the *Declaration of the Rights of Man* was proclaimed in October 1789. The nobility and the clergy fled the establishment of the Constitution of 1791, which provided for the government of the country as a constitutional monarchy. But the Legislative Assembly set up for that purpose failed within a year, leaving the country bankrupt, the armed forces in disarray and a population dangerously accustomed to mob rule. Crisis followed. The king was arrested in August 1792, condemned to death, and executed in January 1793.

Now the revolutionaries found themselves in control of a republic for which they were required to provide the instruments of government, and it fell upon the revolutionary propagandists, men like Marat and Robespierre, to fill the void in the collective consciousness of the French people left by the removal of the king and clergy, and to do it quickly before the new republic was torn apart by civil war and external interference. Through newspapers and political 'clubs' they worked to create from republican ideals and revolutionary symbolism an alternative to religion and feudal loyalty, but without coordinated action this cultural revolution inevitably led to the emergence of factions competing to set the revolutionary agenda. Taking advantage of the instability, Robespierre and his Jacobins seized power, resolved to meet an extreme situation with extreme

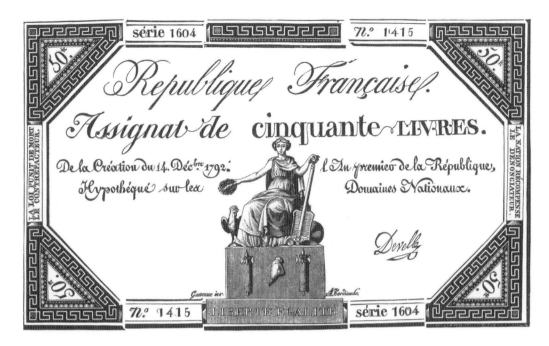

39. ARTIST UNKNOWN
The Assignat (banknote), French Revolutionary
Government, 1792. Engraving. Private
collection.

This is an example of the paper money, known
as the Assignat, which was issued by the French
revolutionary government in 1792 to raise funds
to pay for the revolutionary wars. The basis for
its credit was the property of the Roman
Catholic Church and royalist *émigrées* which the
government had seized and intended to sell.
Originally meant to be a bond, it was soon
being used as currency and since no effective
control was kept of the amount printed, the
value in circulation soon far exceeded that of
the confiscated properties. The resulting
hyperinflation contributed significantly to the
parlous state of the economy and the social
instability which plagued the country
throughout the 90's. Not until 1803, when
Napoleon introduced the Franc, was inflation
brought under control, by which time the
Assignat was virtually worthless.

Many different designs were used for the bills
themselves. This one is a good example of how
the revolutionary symbols were being used at
the time. Marianne, the national emblem of the
French Republic, and by extension an allegory
of Liberty and Reason, is accompanied by the
Gallic cock, traditional symbol of the nation and
its culture. She holds the laurel wreath of
victory in her right hand and the plough of
wealth and fertility in her left. On the plinth
beneath her the Phrygian cap, a symbol of the
pursuit of liberty from ancient times and
preferred headgear of the revolutionaries, is
flanked by the Fasces. Originally the badge of
office of the Consul in Republican Rome, the
fasces here represent equality and strength in
numbers (you can break one stick but a bunch
of them together is unbreakable).

measures. Robespierre, 'a sanguinary demagogue' as one American commentator
described him, made his intentions clear. 'The revolutionary government owes to
the good citizen all the protection of the nation; it owes nothing to the Enemies
of the People but death.' And, more chillingly, 'Pity is treason'.

There followed a period of some eleven months which came to be known
simply as the Terror, an orgy of institutional violence in which as many as 50,000
people were executed. Day and night the thump of the guillotine accompanied
the work of the Revolutionary Tribunal until at last, when all but the most
extreme revolutionaries were sickened by the slaughter, Robespierre himself was
arrested by his enemies and executed. (Fig. 38)

The graphic art of the revolution now had more to work with than just the
sans-culottes dancing round the tree of liberty. The early euphoria had dissipated,
and as the bloodshed continued, death slipped into its place to join liberty,
fraternity and equality in the troubled iconography of the revolution. The
propaganda of freedom was recast to support the new republic, its symbols
carefully codified by the newly created Committee of Public Instruction. (Fig. 39)

No regime had ever given propaganda such prominence in the conduct of its
affairs, and in the dark days ahead its role would expand even further.

Outside France, reactions to the events of the revolution varied. In the United
States, whose own recent revolution had received invaluable help from France,
popular enthusiasm was tempered by an administration unwilling to get involved
in a foreign war, while Europeans observed the chaos with growing
apprehension, particularly after the death of Louis XVI and the appalling
bloodshed of the Terror. The British, who had suffered in order to create their
constitutional monarchy, and were quite fond of it, were sceptical, as the political
cartoons of the day clearly demonstrate. (Fig. 40)

Inspired by revolutionary enthusiasm, France rapidly became a nation-in-arms,
nothing new in itself - the Americans had achieved something of the kind - but
quite unprecedented in scale. In the words of an American observer, 'A force
appeared that beggared all imagination. Suddenly war again became the

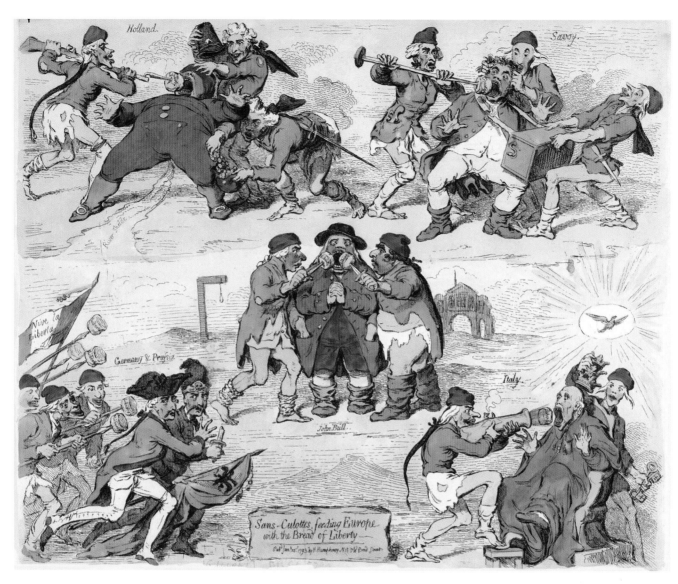

40. JAMES GILLRAY
Sans-culottes feeding Europe with the Bread of Freedom, Britain, 1793. Hand-coloured etching.

As the *sans-culottes* force-feed different countries of Europe, in the centre Gillray portrays Sheridan (left) and Fox (right), two prominent British Whig politicians, doing the same to John Bull.

business of the people - a people of thirty millions, all of whom considered themselves to be citizens ...' (Philip M. Taylor p.150)

Thus, military and civilian propaganda were drawn together. Thousands of revolutionary songs, plays and poems were written. Every fête and public event had its soldiers, every family had someone in the army, and the soldier of the Grand Armée quickly became one of the symbols of universal republicanism. As recruits flocked to the defence of Liberty, a huge propaganda campaign was launched to motivate and indoctrinate them.

The army could have stopped the revolution in 1789. Instead the soldiers joined it in overwhelming numbers and, despite the fact that about 60% of the officer class had joined the aristocratic emigration, the revolutionary army won an early victory over an invading Austro-Prussian army at Valmy in 1792. But when Britain entered the war in 1793 it became clear that this revolution was turning into a conflict which would engulf the whole continent. With breathtaking enthusiasm a million young Frenchmen went marching off to a new kind of war, not the usual mercenary pursuit of national interest but a heartfelt struggle for the survival of the revolution itself.

The man on the white horse

After the Reign of Terror, in 1795 a traumatised nation stood alone surrounded by enemies, with a shattered economy and an unpopular government in the form of the Directory. It seemed as though the revolution had failed, but things were to take an unexpected turn.

'The Revolution is made fast on the principles on which it began; the Revolution is finished.' This statement was made by Napoleon Bonaparte on the occasion of the *coup d'état* which brought him to power in 1799, and it typifies the man - his complexity, his confidence and the ambiguous relationship with the revolution that would define his career. What did he mean? Was he going to save the revolution or did he intend to undermine it?

Bonaparte had been a Jacobin, a minor military commander and protégé of Robespierre who had reversed his fall from grace by crushing, most efficiently, a royalist uprising in Paris in 1795. He was given command of the army of Italy, campaigned brilliantly, and returned a hero. In 1799 he undertook an ambitious campaign in Egypt, the success of which on land was frustrated by the destruction of the French Navy by a British fleet under Horatio Nelson at the Battle of the Nile. But by means of judicious public relations he avoided blame for this reverse and on his return to France took part in a coup to overthrow the government, emerging from the subsequent chaos as First Consul, effectively the most powerful man in the republic. Two years later he was named Consul for life and, two years after that, Emperor of the French, a remarkable rise to power that owed much to the skilful use of propaganda.

Driven from the outset by boundless ambition, Napoleon took every opportunity to promote his interests. During the first Italian campaign (1796-97) he began to shape a favourable image of himself by carefully manipulating the contents of his bulletins, dispatches and proclamations. These routine forms of communication from a general in the field were transformed by Napoleon into instruments of propaganda. Always patriotic, always positive and self-serving, they were written in a clear, accessible style which was good enough to attract positive comment from the literary establishment, and effective enough to establish in his readers' minds both the superiority of the French Army in Italy and the image of Napoleon, the brilliant revolutionary hero.

While in Italy he launched two newspapers, the *Courrier de l'Armée d'Italie*

and *La France vu de l'Armée d'Italie*, ostensibly to address the morale of his troops but clearly intended to engage with a wider audience in France and serve his growing political agenda. He invested time and energy on these publications, controlling content and frequently contributing editorials on important topics, and the fact that he was prepared to do this while conducting a strenuous military campaign demonstrates the importance Napoleon attached to the management of public opinion. The *Courrier de l'Armée d'Italie*, produced by a staff of professional journalists, well designed and printed on high-quality paper, had the feel of a quality periodical with real authority and permanence. Interest in it grew, and the phenomenal growth of the popular press during the revolution provided a ready market for it. The eyes of France were on Italy.

During the Italian campaign Napoleon showed his real worth as a military commander - to this day his campaigns are studied in military academies, and he is considered one of the greatest generals of all time - and as news of his exploits reached home, his popularity and demand for information about him grew.

Many Paris-based newspapers began to reprint articles from the Courrier, securing for it a much wider circulation than would normally be expected for a military gazette. With his success in the field and his growing political reputation, Napoleon would return to France, first from Italy and later from Egypt, a national figure, a man to be reckoned with. To the bourgeoisie, who had gained most from the redistribution of wealth caused by the revolution and had most to lose by its failure, Napoleon had a compelling appeal. He offered stability, a strong executive and an effective administration. He promised to safeguard the principle of equality, and if he would compromise the principle of liberty to do it, who could blame him? As historian Albert Vandal put it, 'Bonaparte can be reproached for not having established liberty; he cannot be accused of having destroyed it, for the excellent reason that on his return from Egypt he did not find it anywhere in France.'(Tom Holmberg, *Napoleon and the French Revolution*, www.napoleonbonaparte.nl) (Fig. 41)

To a country exhausted by war and corruption, the man on the white horse emerged as a saviour. That he did so was due in no small measure to the effectiveness of his propaganda and his painstaking cultivation of public opinion.

Once Napoleon was established in power the focus of his propaganda shifted

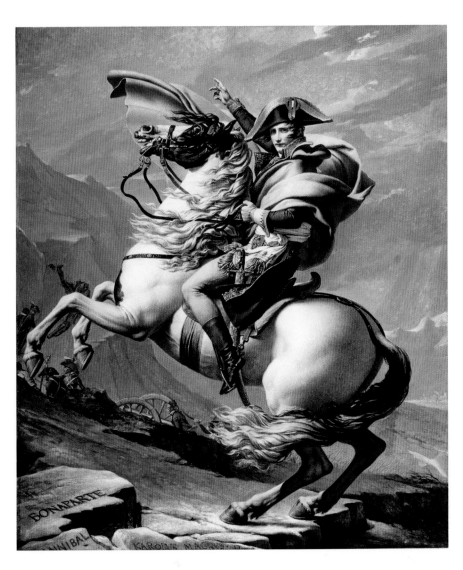

41. JACQUES-LOUIS DAVID (1748–1825)
Napoleon crossing the Saint Bernard Pass,
France, 1802. Oil on canvas. Wikimedia
Commons.

Already established as the outstanding painter
of his generation and the leading exponent of
the Neoclassical style, David became a
prominent supporter of the Revolution and an
intimate of Robespierre. His devotion to the
republican regime led him to take control of
the visual aspects of its propaganda, notably in
the processions and festivals for which he
devised a world of revolutionary symbols
derived from ancient Greek and Roman sources.
The great success of these events and their
propagandistic value was recognised by
Robespierre and may have provided inspiration
for the great public spectacles organised by the
later regimes of Lenin, Mussolini and Adolf
Hitler. Following the downfall of Robespierre,
David was imprisoned but was soon
rehabilitated by Napoleon who was quick to
appreciate his usefulness.

Commissioned by Napoleon in 1802 to
commemorate the unexpected crossing of the
Alps which led to his victory over the Austrians
at Marengo, this painting reveals Napoleon as
the hero of the revolution. Thereafter, until the
Crowning of Napoleon as Emperor imposed a
different image, David and his pupils produced
a body of propaganda art to establish the
popular image of Napoleon which has endured
to the present day.

to reveal him as the giver of peace and a cultivated patron of the arts. He
blatantly courted the intellectual and artistic elite of the day in order to impress
the educated bourgeoisie, and through his patronage turned their work to his
advantage in a deliberate campaign to prepare the way for his apotheosis. When
he crowned himself Emperor of the French in 1804, the flower of the artistic
community was on hand to record it. (Fig. 42)

In fact a whole industry appeared. Painters, engravers, sculptors and craftsmen
turned out a profusion of likenesses, furniture and every kind of memorabilia in
what came to be known as the empire style. As one historian put it, 'The
combined effect of these propagandistic efforts produced for the French public
the image not only of a seemingly invincible general and peacemaker, but also
that of a man of cultural refinement and intellect: a universal man to whom
nothing was impossible.' (Hanley, *The Genesis of Napoleonic Propaganda 1796-
1799*.)

Of course, this image proved to be untrue. The emperor's attempts to export
his vision committed France to a burden of war and sacrifice which she was
unable to bear. The near destruction of the Grand Armée, almost half a million

THE EARLY PERIOD 67

42. JEAN-AUGUSTE-DOMINIQUE INGRES (1780–1867)
Napoleon I on his Imperial Throne, Musée de l'Armée, Paris, 1806. Oil on canvas, 259 x 162cm (102 x 63in.). Wikimedia Commons.

Rejecting both the identity of Napoleon the revolutionary hero as developed by David, and Baroque traditions of royal portraiture, Ingres turned to archaic modes of imperial representation. The emperor is depicted robed in ermine, sitting on a great throne, holding a sceptre topped with a statuette of Charlemagne in one hand, an ivory hand of justice purported to belong to Charlemagne in the other, and Charlemagne's own sword. A work of state propaganda, it seeks to justify the new regime by associating it with the country's glorious past. What must Bonaparte's old Jacobin friends have thought of it?

men, during the catastrophic invasion of Russia in 1812, was a blow from which it never recovered. Despite a series of French victories against the forces of the Sixth Coalition, the sheer weight of numbers eventually overcame them at Leipzig. Paris fell in 1814 and though Napoleon's triumphant return from exile in Elba relit the dream for a hundred days, it was extinguished for good at Waterloo.

Like those of Alexander the Great and Julius Caesar, the life and personal attributes of Napoleon Bonaparte have become the stuff of legend. So completely did he fulfil the role of the revolutionary hero, the romantic man of action, that he completely dominated his times. Through his administrative and legal reforms he did more than any man to promote the emergence of the modern state, and though, as he himself acknowledged, his many military victories would be eclipsed in posterity by his defeat at Waterloo, he is remembered for his civil code, which is still relevant today. By applying the same rigorous pragmatism to public relations as he did to warfare and politics, he laid the foundations of modern propaganda technique. A brilliant communicator, blessed with the genius for inspiring others which seems to attend all great men, Napoleon was, without doubt, one of the greatest masters of propaganda who ever lived.

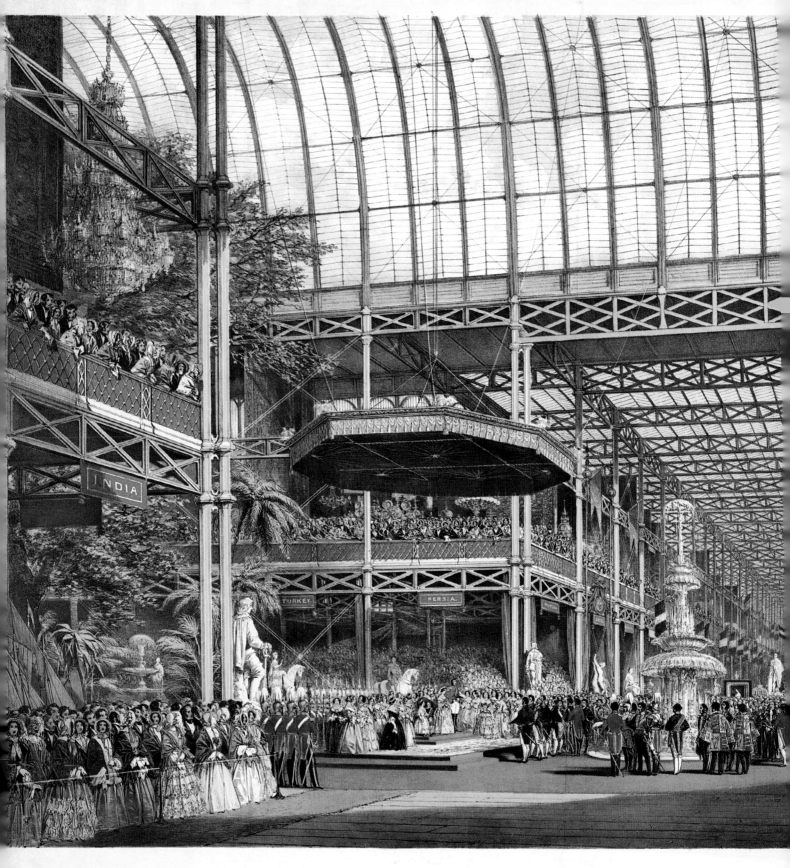

THE GREAT INDUSTRIAL EXHIBITION

Lithographed by Joseph Nash from his Drawing in the possession of Her Majesty

Plate 1. — The Inauguration.

Paris, E. Gambart & Cie, R. Rue d'Orléans Germany. PRINTED AND PUBLISHED BY DICKINSON BROTHERS NEW BOND STREET

Recd at S.S.
19 April N.5.2

163

Deposited in Clerks Office & Dist. Ms. Nov. 24. 1857.

4

The Machine Age

The 19th century

With the removal of Napoleon from the scene, the people of Europe could turn to the tasks of peaceful reconstruction, but while the Congress of Vienna provided for the restoration of monarchies throughout the Continent, conservative hopes of a return to the good old days were not to be realised. The forces of change which had caused the revolution were still at work. The spread of literacy and political suffrage would continue, and the Industrial Revolution, which had been gathering momentum in Britain since the 1750s, would bring change on an unimaginable scale before the new century was done. In the field of communications, advances in print technology and the introduction of the telegraph later in the century would contribute to the emergence of an informed public which, with the means at its disposal of making its views known, would challenge authority and change the conduct of politics. 'Even those whose attitude towards public opinion in politics did not change found that of necessity they had to learn the mechanics of peaceful persuasion by propaganda. With an extended franchise and an increasing population it was becoming too expensive to do anything else. Where at one time voters could be bought, they now had to be persuaded. Politicians had therefore to become interested in propaganda.' (Qualter, in Philip M. Taylor, p.158)

All over Europe a liberal press which had broken decisively with the 'salon literature' tradition of the 18th-century gazette in favour of a deliberately aggressive radical style confronted governments determined to suppress the free expression of revolutionary ideas. In Paris during the summer of 1830 people revolted in support of press freedom, and forced a change of government. Then in 1848 the whole continent seemed to go mad. Revolutions broke out everywhere: Palermo in January, Vienna in March, the Germanic states, Switzerland, Italy - all were caught up in a storm of protest which brought change in the social order. France became a republic again. But there was no great Continental war. Before long things got back to normal. The authorities resumed production of the old diet of flags and symbols, and in the free press liberalism and nationalism vied with socialism for the favour of a public opinion nourished as

43. A. PEARSE
Chartist riot, From the book *True Stories of the Reign of Queen Victoria* by Cornelius Brown, Britain, 1886. Engraving. Wikimedia Commons.

CHARTISTS' RIOTS.

44. GEORGE CRUIKSHANK (1792–1878)
The Peterloo Massacre (detail), published by Richard Carlile, Britain, 1819. Engraving and etching. Wikimedia Commons.

never before by a feast of newspapers and pamphlets.

There was no revolution in Britain. Perhaps the people there were distracted by the glories of empire, or perhaps the government, in the course of building the empire, had developed superior means of propaganda which could be deployed as effectively inside the country as outside. Whatever the case, to say there was no revolution in Britain is not to imply the absence of dissent. In fact political activism, and its vigorous suppression by the authorities, was a prominent fact of life in 19th-century Britain. In 1819 British cavalry rode down a crowd demonstrating for universal suffrage at St Peter's Field in Manchester, a bloody incident which came to be known, ironically, as the Peterloo Massacre, and was vividly recorded in the popular press of the time. (Fig. 44)

Between 1838 and 1848 the Chartist movement campaigned for political and social reform, producing cheap popular weekly papers, such as the Northern Star, in order to reach its audience. It quickly gained massive support throughout the country, and its failure to achieve its goals is probably due less to ineffective propaganda than to a lack of internal cohesion in the broad base of radical groups which comprised the movement. But Chartism did show what a working-class reform movement might achieve using the free press. It also showed which way the wind was blowing. Before 1900 almost all of the Chartists' aims had been realised. (Fig. 43)

The Fourth Estate

The principal medium for the expression and also the control of public opinion in the 19th century was the newspaper. At the beginning of the century the best presses were capable of producing only about 200 prints an hour, but the introduction of steam-driven, and later electrically-driven, presses was to achieve dramatically improved performance, so that by the middle of the century the latest presses could produce up to 10,000 prints an hour, an improvement which galvanised the development of the newspaper industry. The first mass-circulation papers began to appear in the 1830s, and, with the introduction of the *New York Sun* in 1833, the cheap daily newspaper, the 'penny press', had arrived.

For the first time city dwellers could consume printed news on a daily basis, not only the national and international material upon which the traditional periodicals had concentrated, but local news and even entertainment. This combination of topicality and local relevance provided a new social context which compensated for the cultural dislocation experienced in the rapidly expanding cities of the Industrial Revolution. The press became the Fourth Estate, the key intermediary between the people and their government, and newspapers became a potent influence on public opinion.

Encouraged by the growth in sales, the press began to make increasing use of pictures, and with the founding of the *Illustrated London News* in 1842 the era of the cheap illustrated newspaper began. At first the images were reproduced from engravings, but after the invention of photography by Louis Daguerre in 1839, and Fox Talbot's calotype halftone printing process two years later, the printed reproduction of photographs became possible, though it was not until after 1880 that this innovation was introduced to newspapers. Now the effectiveness of illustrated propaganda, so well demonstrated 300 years earlier by Martin Luther and Lucas Cranach, could be readily observed in the first mass medium.

Rule Britannia

By the middle of the century Britain possessed a truly global empire, and, free from the political upheavals which had beset the rest of Europe, had established a dominant position in both international trade and industrial manufacture. The Victorians, perhaps the most civically proud people since the Imperial Romans, put on the Great Exhibition of 1851 to glorify Britannia in their own achievements, and did so with their customary energy. The centrepiece of the show, sited in Hyde Park in London, was the Crystal Palace.

Designed by Thomas Paxton in nine days and built in an incredible five months, the huge exhibition hall of glass and iron was itself an early demonstration of the possibilities of machine production. Six million people visited it, the equivalent of one third of the British population at the time, and were immersed in an extraordinary world of exotic imperial booty and the breathtaking products of new technology. The optimism of the 19th century and the faith of its people in the virtues of industry and free trade were reflected there. So too was the overwhelming power of the western nation states. The Great Exhibition was no doubt great fun, but it was also a deliberate exercise in state propaganda, as were the New York World's Fair and the Universal Exhibition in Paris which followed it in 1853 and 1855 respectively.

Despite their traditional antagonism and imperial rivalries, the great powers of the 19th century managed for the most part to avoid major conflict amongst themselves, but the period was far from peaceful, and the same forces which were at work in the worlds of labour and politics - industrialisation, improved communications and the influence of public opinion - would also affect the conduct of war. Three years after the Great Exhibition, the apparent invincibility of the British Army was put to the test in the Crimea. With the Ottoman Empire in decline and Russia looking for a way into the Eastern Mediterranean, Britain and France formed an alliance with Turkey, the 'sick man of Europe'.

A great deal had been made in the press about securing access to the Christian holy places in the Near East, and on that basis the British and French Governments had more or less secured public approval for the war by the time it began in 1854. But it soon became clear that things were going badly. The campaign was ill-conceived, maladministered and poorly conducted, and while these circumstances were not unique in British military history, they did not

45. ROGER FENTON (1819–1869)
Cooking house, 8th Hussars, Thomas Agnew (publisher), UK, 1855. Photographic print: on salted paper, 16 x 21cm (6 x 8in.). Library of Congress LC-USZC4-9344.

Roger Fenton's Crimean War photographs represent one of the earliest systematic attempts to document a war through the medium of photography. He went to the Crimea in March 1855 on commission from publisher Thomas Agnew, and presumably with the blessing of the government, to record the activities of the troops. The fact that he was allowed to carry out this mission, the success of which depended on the collaboration of the army, tends to imply that the authorities hoped for some 'good pictures' to address the growing public anxiety over and disapproval of the war.

This would explain why none of the 360 images which he collected during his four months at the front show the horrors of war or any actual combat. In fairness the technical limitations of his equipment ruled out moving subjects, and since this was a commercial venture Fenton probably felt constrained to make photographs which he could sell. There are plenty of pictures of groups of officers, for example. Also, he was forced to work in very trying circumstances, carrying everything around in a converted wine van (which can just be seen at the left side of the picture) and enduring several broken ribs and a bout of cholera in the course of his campaign.

Despite all that, the photographs are marvellous. Although posed, they are real. No effort has been made to glorify anything and nothing much is ever going on in them, which is probably what war is like most of the time. Perhaps for this reason, and the likelihood that people had no desire to be reminded of the wretched war, his exhibitions and books of prints did not do very well at home.

Nevertheless, Fenton was the first war photographer, and though his photographs did not fulfil his sponsors' hopes for them, they represent a step forward in the story of war propaganda.

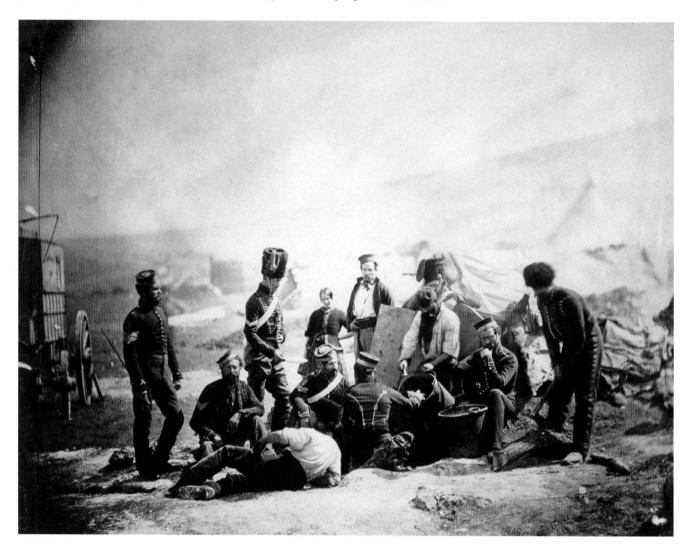

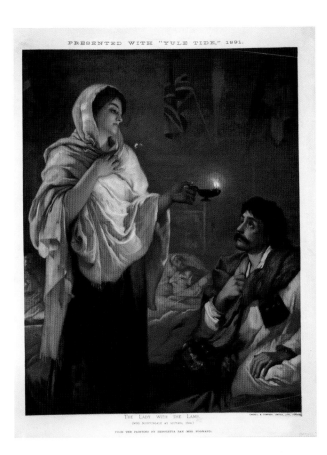

PRESENTED WITH "YULE TIDE." 1891.

THE LADY WITH THE LAMP.
(MISS NIGHTINGALE AT SCUTARI, 1854.)

FROM THE PAINTING BY HENRIETTA RAE (MRS. NORMAND).

46. HENRIETTA RAE (ORIGINAL PAINTING)
The Lady With the Lamp, Miss Nightingale at Scutari, 1854. Cassell and Company (publisher), UK, 1891. Chromolithograph. Library of Congress LC-USZC4-4239.

Florence Nightingale, an attractive young woman from a privileged background, determined to improve the practice and status of professional nursing, was appointed by Sidney Herbert, Minister at War, to lead an expedition of 38 women to take over the barrack hospital at Scutari in 1854. A great deal depended on her success. Such was the public outrage caused by reports in *The Times* of the shocking conditions suffered by soldiers in the Crimea that the government could have fallen if it had not been seen to act quickly.

She did succeed, and in doing so was transformed into the living embodiment of Victorian female virtue. Up to their necks in gore, she and her companions created order out of chaos. The soldiers were comforted and the lady with the lamp, rendered here in biblical mode, provided a much-needed point of light in the deepening gloom of an unpopular war.

correspond with the public's fondly held belief in the superiority of their army. This, and the presence of journalists at the scene with access to telegraphic communications which brought the bad news home with unprecedented immediacy, converted military failure into a political crisis. One man in particular, William Howard Russell of *The Times*, appalled by the conditions endured by the troops, began to send back dispatches from the front criticising the conduct of the war.

Few of those who were with the expedition will forget the night of the 14th September [1854]. Seldom or never were 27,000 Englishmen more miserable... No tents had been sent on shore... the showers increased about midnight and early in the morning dew in drenching sheets ... pierced through the blankets and great coats. (Philip M. Taylor, p.163)

As British soldiers continued to die of neglect and official incompetence in the bitter Crimean winter of 1854, the dispatches of Russell and his colleagues prompted a public outcry which embarrassed the generals, shocked Queen Victoria and eventually led to the fall of the government. Clearly the use of the telegraph had allowed the press to mobilise public opinion quickly enough to influence events almost as they happened. After the Crimea, no government contemplating a military solution to its problems would fail to take account of public opinion as a strategic factor. (Fig. 45)

The Crimean War was a watershed in the history of propaganda. The emotive, eyewitness approach of the journalists, the first war correspondents, supported by the war artists whose work often accompanied their dispatches, stirred the popular imagination, and the balaclava helmet, the Lady of the Lamp, the Light Brigade and the Thin Red Line have all passed into popular culture as a testament to it. (Fig.46)

From sea to shining sea

In 1774 the Scottish–Dutch soldier John Gabriel Stedman witnessed the brutal oppression of slaves during a campaign against the maroons (communities of escaped slaves), which he described in his *Narrative of a Five Years Expedition Against the Revolted Negroes of Surinam*. The book, which included illustrations by William Blake, was adopted by those who advocated the abolition of the slave trade, though Stedman was thought to support reform rather than abolition.

This sexualised and sadistic image of a female slave being whipped became a key element in the visual vocabulary of British abolitionism. Blake's bold graphic design, in which the slave is an isolated figure in the foreground, framed by the tree to which her hands are tied, led to the illustration being frequently reproduced in anti-slavery tracts. (V&A website: http://collections.vam.ac.uk)

The 19th century was a time of steady growth for the United States. In 1803 the Louisiana Purchase secured a great swathe of land in the centre of the continent from France. Following the defeat of Mexico in the Mexican-American War (1846-48), the US won Texas and California under the terms of the Treaty of Guadalupe Hidalgo, as well as an enormous area which would later become the states of Utah, Nevada, Arizona and New Mexico. By mid-century the nation stretched from coast to coast, and ever-increasing numbers of people began to move west in search of the American Dream - land, freedom, a decent life - a key concept in the formation of the new country's identity that was vigorously promoted by those who had most to gain from it.

The new railways, pushed eastbound by the Central Pacific and westbound by the Union Pacific, met at Promontory Point, Utah Territory in 1869, and where a golden spike was driven with the following message etched into it: 'May God continue the unity of our country, as the railroad unites the two great Oceans of the World.' (Fig. 47)

River traffic increased significantly too. Between 1820 and 1880 6,000 paddle-wheel steamboats were built to work on the Mississippi and Ohio rivers. There seemed to be no limit to the possibilities, but before the dream could be realised the unity of the country would be sorely tested. In order to fulfil its potential, the United States had to deal with the issue of slavery.

Before the 18th century there had been little public criticism of slavery anywhere, but Enlightenment ideas about the rights of man, along with the Christian ethics of the Quakers and other evangelical religious groups, brought both the practice of slavery and the trade into question. The first abolitionist organisation was founded by British Quakers, who introduced a petition to Parliament in 1783. Prominent members of the Church of England began to demand a review of its policy with regard to slavery at about the same time, and the attention of the public was drawn to the issue by news brought by British explorers from Africa - the Dark Continent as it was known in the popular imagination of the time - that, contrary to traditionally held beliefs, its inhabitants were not fearful savages but human beings with their own cultures.

In 1787 the Committee for the Abolition of the Slave Trade was formed with the aim of bringing to an end the trafficking of slaves across the Atlantic by

THE CHAMPIONS OF THE MISSISSIPPI

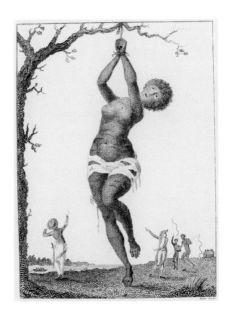

British merchants, and as research carried out by evangelical activists such as Thomas Clarkson and William Wilberforce brought to light the shocking brutality involved in the practice, the abolitionist movement grew in size and political influence. In 1807, Parliament passed the Slave Trade Act, outlawing the trade in human beings throughout the British Empire. (Fig. 48)

The introduction of this legislation occurred in the middle of the Napoleonic War, and coincided with Napoleon's decision to revoke the abolition of slavery introduced by the revolution, as he sent troops to re-enslave the people of Haiti and other French dominions in the Caribbean. Whether fortuitous or not, the timing of these events presented the British Government with an opportunity not only to take the moral high ground on the question of slavery but to cast further doubt on Napoleon's already tarnished revolutionary credentials. However, it was not until the Slavery Abolition Act was passed in 1834 that all slaves in the British Empire were freed.

In America too the Quakers were prominent early activists. In 1775 the first abolitionist society was founded in Philadelphia, and in that same year the first abolitionist article was published by Thomas Paine in the *Pennsylvania Magazine*. By 1804 legislation was in hand to free all the slaves in the North, and in 1808 the importation of slaves into the United States was officially banned.

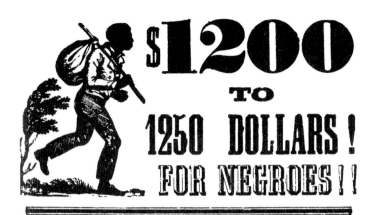

$1200
TO
1250 DOLLARS !
FOR NEGROES ! !

THE undersigned wishes to purchase a large lot of NEGROES
for the New Orleans market. I will pay $1200 to $1250 for
No. 1 young men, and $850 to $1000 for No. 1 young women.
In fact I will pay more for likely

NEGROES,

Than any other trader in Kentucky. My office is adjoining
the Broadway Hotel, on Broadway, Lexington, Ky., where I or
my Agent can always be found.

WM. F. TALBOTT.

LEXINGTON, JULY 2, 1853.

49. ARTIST UNKNOWN
Slave advertisement, William F. Talbott,
Lexington Kentucky, USA, 1853. Letterpress and
woodcut. Courtesy of www.tagg.org

But in the Southern states slavery was a social and political institution. Its overwhelmingly agrarian economy, based on labour-intensive crops such as tobacco and cotton, depended on the exploitation of slave labour, which comprised about 30% of the population. (Fig. 49)

As the 19th century advanced the North grew in both industrial capacity and population as the vast majority of immigrants chose to settle there. The South, fearing the erosion of its power in the federal government and suspicious of Northern motives, withdrew into strident defence of its traditions. (Fig. 52)

Meanwhile, the abolitionist movement gained momentum. In 1835 alone abolitionists mailed over a million items of anti-slavery literature to the South, and public opinion in the North turned against slavery decisively when it was presented as a moral issue, a practice which was irreconcilable with the principles upon which the United States was founded. Prominent abolitionist William Lloyd Garrison wrote, 'Convince me that one man may rightfully make another man his slave, and I will no longer subscribe to the Declaration of Independence. Convince me that liberty is not the inalienable birthright of every human being, of whatever complexion or clime, and I will give that instrument to the consuming fire. I do not know how to espouse freedom and slavery together.' (Garrison, *No Compromise with Slavery*, 1854, quoted in Mason I. Lowance, *Against Slavery, an Abolitionist Reader*, p126, Penguin Classics, London, 2000). (Fig. 50)

In fact, no compromise was possible on either side. Abraham Lincoln, although not an abolitionist, was determined to halt the spread of slavery to the new territories, and was passionately committed to the preservation of the Union at all costs. His election to the presidency provoked the secession of the Southern slave states, and thus began the American Civil War on 12 April 1861. The Union immediately imposed a naval blockade on Southern ports, shutting down the cotton trade and ruining the Southern economy. On land the Confederates, encouraged by early successes in Virginia, sent an army into the North under General Robert E. Lee. It was halted by Union forces at Sharpsburg, with heavy losses on both sides, and Lee was forced to withdraw. President Lincoln then

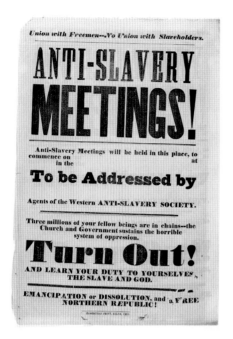

Above
50. ARTIST UNKNOWN
Anti-slavery meetings!, Homestead Print, Salem,
Ohio, USA, 1853. Letterpress and woodcut.
Courtesy of Library of Congress

Below
51. ARTIST UNKNOWN
Rebel attack on our gunboats in the Red River,
Harper's Weekly, v.8, 14 May 1864, p.305,
Woodcut, 27 x 23cm (10 x 9in.). Library of
Congress LC-USZ62-117668.

issued the Emancipation Proclamation, which not only made abolition a formal aim of the Union war effort, but ended Confederate hopes of intervention by Britain and France, and from a propaganda viewpoint, secured for the Union a telling moral and emotional advantage.

War correspondents were active on both sides. Five hundred journalists were deployed on the Union side and, as in the Crimea, the impact of their work was significantly enhanced by the use of the telegraph. The public quickly acquired the habit of following the progress of the war in the press, and though the technique of reproducing photographic images in newspapers was not available in America at the time of the Civil War, the illustrated weekly papers made full use of war artists in their coverage. (Fig. 51)

The Confederate side was less well attended, as Professor Philip M. Taylor points out. 'The Southern cause, served by about a hundred war correspondents working for low-circulation, old-fashioned weeklies, was severely hampered by its previous dependence on the North for newsprint, staff and equipment. Rather, the older system of relying upon letters and reports from serving officers furnished a deeply partisan propagandist press that progressively diminished both in numbers and circulation.' (Philip M. Taylor, p.167).

The two major Union victories at Gettysburg and Vicksburg early in July 1863 are considered by many to be the turning point of the war. Under the leadership of General Ulysses S. Grant the Union pressed home its advantage in numbers and resources. The Confederate capital Richmond fell in April 1865, and Lee, his forces depleted by desertion and casualties, surrendered, bringing the conflict to an end.

A tragic intersection of the fearsome new weapons of the industrial age with the battle tactics of the Napoleonic Wars, The American Civil War took a terrible toll. Some 620,000 soldiers died, and maybe half as many civilians. But the Union was saved, the slaves were free and the railway and telegraph networks which the urgency of war had spread throughout the nation would help propel it into the future.

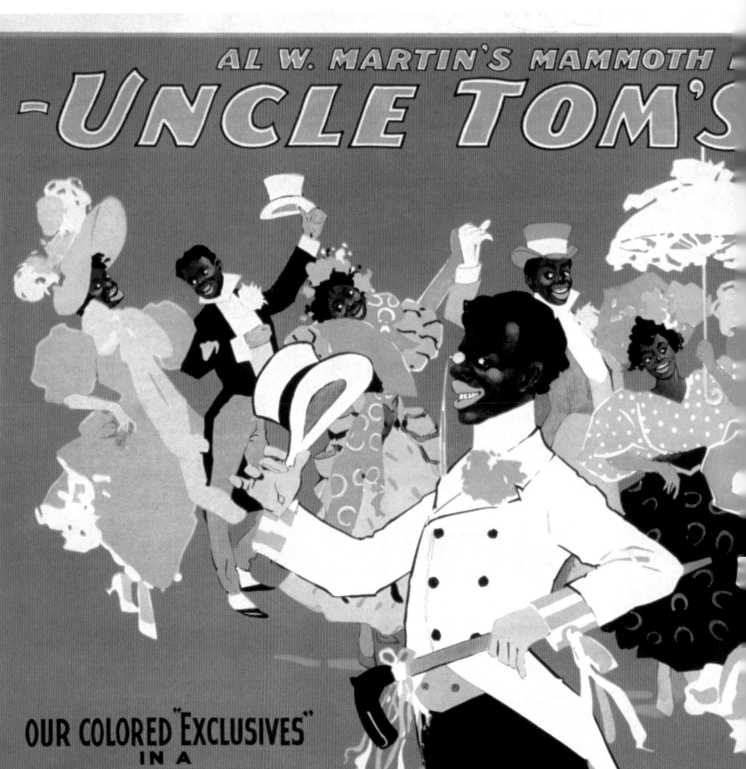

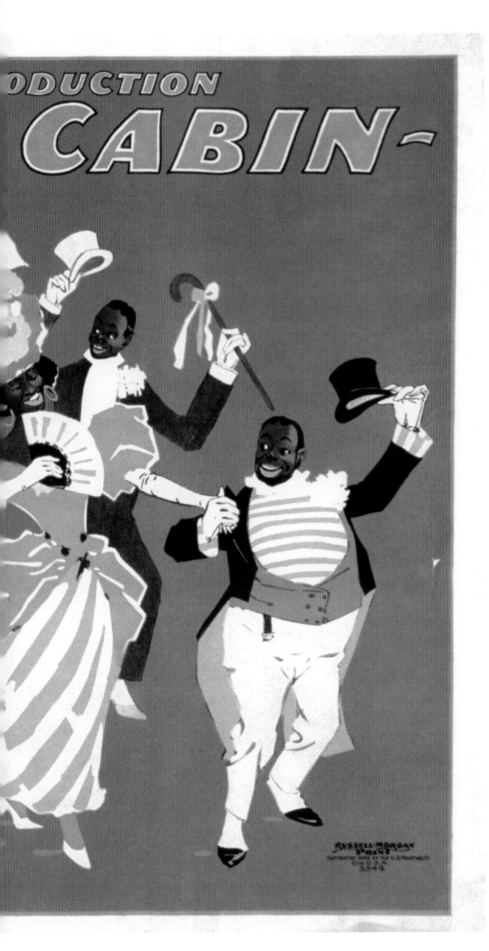

ARTIST UNKNOWN
52. *Al W. Martin's mammoth production, Uncle Tom's Cabin* US Printing Co., Cin., USA, 1898, Lithograph, 74 x 106cm (29 x 41in.). Library of Congress LC-USZC4-2425.

Uncle Tom's Cabin, by American author and abolitionist Harriet Beecher Stowe, was a sentimental novel which described the reality of slavery and suggested that its degrading effects could be overcome by the healing properties of Christian love. It was the best-selling American novel of the 19th century, and its publication in 1852 made an important contribution to the abolitionist cause. When Abraham Lincoln met Stowe at the beginning of the Civil War, he is reported to have said, 'So this is the little lady who made this big war.'

The book, and the plays it inspired, have in recent times become associated with a number of racial stereotypes, which have tended to obscure its historical importance.

Politically quite incorrect by today's standards, this beautiful poster, advertising a theatre production of 1898, anticipates 'the most sumptuous occurrence that is likely to happen'.

El sueño de la razon produce monstruos.

A new printing method

53. FRANCISCO JOSÉ DE GOYA Y LUCIENTES
(1746–1828)
The sleep of reason brings forth monsters,
Caprichos image no.43, Spain, 1799. Lithograph.
Wikimedia Commons.

A famous set of 80 satirical prints, the Caprichos
provide a dark commentary on the
unpredictability and frailty of human life.
Dealing with difficult subjects like witchcraft,
prostitution, superstition and sex abuse as well
as offering mordant critiques of the
establishment, the series is steeped in
nightmare and the supernatural. Not well
received by the public, it was soon withdrawn
by Goya, perhaps from fear of attracting the
attention of the Inquisition.

54. HONORÉ DAUMIER (1808–79)
Un héros de juillet, Mai 1831, Paris, 1831.
Lithograph, 22 x 19cm (8 x 7in.).

A hero of the Paris street insurrections in 1830,
known as the 'Three Glorious Days', stands on
the parapet of a bridge over the Seine in front
of the Chamber of Deputies. Mutilated and
dressed in what appear to be loan receipts from
the Mont-de-Piété, a state charity, he is
preparing to jump with a stone marked 'last
resorts' tied to his neck.

UN HÉROS DE JUILLET,
Mai 1831.

One day in 1796 a German printmaker, Aloys Senefelder, accidentally put a piece of limestone on top of a note which he had written with a greasy wax crayon. Picking up the stone he noticed that the note had been transferred onto it, and when he tried to wash it off, first with water and then with nitric acid, he observed that the greasy marks rejected the water, and when he then applied ink to the stone, the damp areas rejected the ink. A piece of paper lightly pressed onto the surface of the stone would thus pick up a faithful, reversed, image of the original crayon design. Senefelder, a poor playwright who had got involved with printmaking because he couldn't afford to have his plays printed for him, was intrigued enough to experiment further until, after a few years and numerous refinements, his printing method, which he called 'chemical printing' and we call lithography, was good enough to win him a gold medal from the Bavarian Crown.

Lithography is cheaper and faster than the traditional intaglio and relief methods, and since it requires only light pressure in the press, the printing surface does not wear out, allowing large numbers of prints to be taken from each stone. Best of all, the image can be drawn directly onto the stone, which faithfully reproduces every nuance of line and texture in a full range of tone from black to white, effectively offering an easy way to copy drawings. For this reason lithography quickly attracted the attention of artists, and from the beginning of the 19th century it was employed by the likes of Goya, Delacroix and Daumier, whose work helped it to become established. (Figs. 53, 54)

Workshops began to appear all over Europe to exploit the new technique not only for artists but for commercial purposes, producing prints as public announcements, a development which was to have important consequences for the history of propaganda.

As we have seen earlier in this account, public announcements printed prior to the introduction of lithography were produced mainly using letterpress, employing cast-metal moveable type for body text, and hand-produced wooden type for large and decorative letters. If a picture or decorative motif was required, a hand-cut woodblock would be incorporated into the layout. (Fig. 55)

This technique, established in the 15th century, was still used for the majority of public announcements in the early 19th century, particularly the inexpensive

56. JULES CHÉRET
Folies-Bergère – La Loïe Fuller, Imprimerie Chaix,
Ateliers Chéret, Paris, 1893. Lithograph, 124 x
87cm (48? x 34?in.). © Victoria and Albert
Museum, London.

This poster, advertising the Paris debut of the
American dancer Loïe Fuller at the Folies
Bergère, is a Chéret classic which matches the
colour and movement of the dance with the
exuberant style of the artist. Chéret printed this
poster in four different colour versions, an early
commercial exploitation of this unique quality
of the print medium.

and ephemeral posters used in public
places to advertise commercial
products and entertainments. But with
the invention of colour lithography in
1827, combined with large-format
presses, the new medium came to
offer a viable alternative.

In 1866 a Frenchman called Jules
Chéret returned to Paris after a seven-
year stay in London. He brought new
English machinery with him, set up a
workshop and started to produce a
series of lithographic prints which
would reveal the true potential of the
technique. Trained as an artist as well
as a lithographer, Chéret was strongly
influenced by British poster design, but
the work he began to produce in Paris
was truly unique: bold lithographic
posters advertising cabarets, dance
halls, theatres and, once he was
established, advertisements for a
whole range of commercial products
from drinks to cosmetics.

Chéret drew directly onto the
lithographic stones in a free, lively style
which was complemented by his
handling of colour. At a time when it
was not uncommon to employ as
many as 20 different colours in one
lithographic image, Chéret often used
as few as four or five, deploying them
in unfussy transparent combinations

Casino de Paris

Entrée 2 Fr.

Camille Stéfani

Tous les Soirs

CONCERT-SPECTACLE

BAL

FÊTE DE NUIT LES MERCREDIS & SAMEDIS

Imp. CHAIX (Ateliers Chéret) 20, Rue Bergère, PARIS. (20,454—91.)

58. LEONETTO CAPIELLO (1875–1942)
Le Frou Frou, La Lithographie Nouvelle,
Asnières, France, 1899. Lithograph, 124 x 87cm
(48 x 34in.). Library of Congress LC-DIG-ppmsca-
10084.

The Italian Antonio Capiello was one of the
best-known poster artists working in Paris at the
turn of the century. As John Barnicoat observes,
'Many of [his posters] derive from Chéret and
other pioneers, but his work also represented a
simplified version of *fin-de-siècle* designs which
gave them the character of impoverished
versions of the older works. In fact he was the
first to appreciate the quickening pace of life in
the streets and his posters are a link between
the more leisurely world of the end of the
nineteenth century and the new era created by
the speeding motorist.' (Barnicoat, p. 42)
 This poster, an advertisement for the
magazine *Le Frou Frou*, is a good example of
Capiello's signature style – simple, playful and
colourful – which carried his successful career
from the Belle Epoque through Art Nouveau to
the Art Deco of the twenties.

Left
57. JULES CHÉRET
Casino Paris, Imprimerie Chaix, Ateliers Chéret,
Paris 1891. Lithograph, 84 x 60cm (33 x 23in.).
Library of Congress, LC-USZC4-12082

which made conventional prints look dull in comparison.
These vivid and uncluttered posters carrying brief hand-
drawn texts almost always featured attractive young women.
Carefree, fashionable and clearly available, who could resist
them? The vanguard of the Belle Époque, the 'Chérettes' as
they were called, in truth the world's first pin-ups, made him
famous. They also introduced the idea, which has endured,
that you can use sex to sell almost anything. (Fig. 56)

 From our perspective the style of his work may appear to
look back - to the decorative charm of the Rococo and
perhaps to the scale and swirling movement of Tiepolo's
murals - but it must have seemed breathtakingly new when
it appeared in the austere new boulevards of Haussmann's Paris, greeting
passers-by with great splashes of colour radiating warmth, charm and optimism.
(Fig. 57)

 Largely due to Chéret's efforts, the poster began to be taken seriously as an art
form. The quality of his work provoked the idea of 'the art gallery in the street'.
Edmond de Goncourt called Chéret 'the creator of the street gallery', and public
enthusiasm for posters grew until, by the 1890s a whole international industry
had sprung up to service it. Books were written, periodicals appeared, and
collectors collected. Such was the demand that in the last five years of the century
one Parisian firm, the Imprimerie Chaix, published reduced lithographic versions of
some of the most sought-after posters, many of which were already unobtainable
or else too big to be collected easily. The series known as *Les Maîtres de l'Affiche*
provided high-quality reproductions of posters by 90 of the best artists from
Europe and America which are still avidly collected today. (Figs. 58, 59)

 Chéret's pioneering work brought a new legitimacy to graphic art. His unique
combination of artistic, technical and entrepreneurial skills ensured his place in its
history and his influence on the generation of artists who followed him. But the
success of his posters as propaganda cannot be explained only in terms of artistic
flair and technical excellence. Chéret's work had popular appeal. By adapting the
familiar visual language of traditional printed material, such as circus handbills
and programme covers, he ensured that his posters would be accepted and

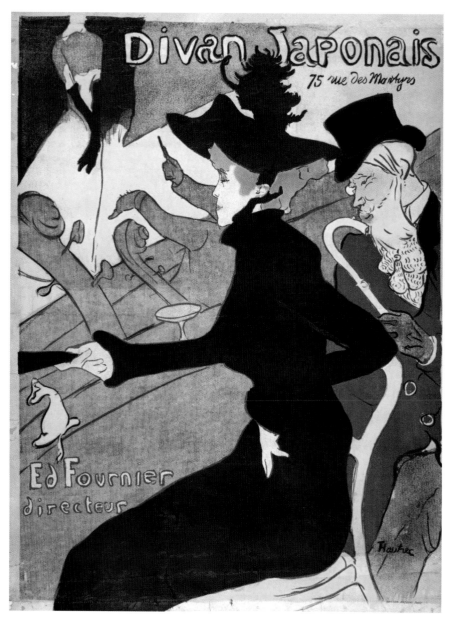

Above left
59. DUDLEY HARDY (1867–1922)
Gaiety Girl, David Allen and Sons (printers), UK, 1893. Lithograph, 224 x 100cm (88 x 39in.).
© Victoria and Albert Museum, London.

At a time when English poster design was still largely stuck in the past, the work of Dudley Hardy stood out from the rest. Although clearly influenced by Chéret, he developed his own simplified style, and his Gaiety Girls captured the optimism of London society at the turn of the century.

Above right
60. HENRI DE TOULOUSE-LAUTREC (1864–1901)
Divan Japonais, Edward Ancourt (printer), Paris, 1892. Lithograph, 81 x 62cm (32 x 24 in.).
© Victoria and Albert Museum, London.

In this, one of his most brilliant posters, Lautrec portrays three of his friends from the world of Parisian cabaret. The figure of Jane Avril, dressed in black, dominates the composition, while Yvette Guilbert, the star of the show at the Divan Japonais, is outrageously dismissed to the top left-hand corner and deprived of her head, perhaps in a mischievous response to her complaints that Lautrec's caricatures of her were less than flattering. The gentleman in the top hat is the distinguished critic and founder of the *Symbolist Révue Wagnérienne*, Édouard Dujardin.

understood by everyone. This ability to connect effectively with the audience by presenting a simple message in an attractive and memorable context is Chéret's real legacy to the art of propaganda.

The invention of photography in 1839 and the political upheavals of the mid-century led many artists to review both their purpose and their working methods. Relieved of their traditional role, of providing likenesses of people, places and things, they began to look for another, more profound one and for ways of carrying it out which did not depend on the old bag of tricks, the superficial illusion of reality which had been invented by the artists of the Renaissance and perpetuated by the academies ever since. Some, like William Morris in England, looked back to before the Renaissance to find true value in the arts and crafts of the medieval world, while others found clues to a new approach in things from faraway places, produced by cultures unaffected by the European tradition.

Trade with the Far East was expanding rapidly, and along with the porcelain

61. UTAGAWA HIROSHIGE (1826–1869)
Sugoroku Game, Japan, 1860. Colour woodcut on hosho paper, 26 x 37cm (10 x 14in.). Library of Congress LC-USZC4-10412.

This print by the famous Japanese printmaker is one of a satirical series, taking the form of a reinterpretation of the popular family board game *Sugoroku*. It shows three scenes from the board: a Japanese woman and man walking near a bridge; a foreign man smoking a pipe, and Japanese women, possibly geishas, entertaining foreign men.
Looking at this image it is easy to appreciate the profound impact that Japanese art had on the European Impressionist and post-Impressionist artists. Breaking all the rules of conventional European picture-making, this kind of thing must have set their minds racing with new possibilities.

and furniture came prints - humble paper prints from Japan which sometimes arrived as packing for other goods. These often exquisitely produced coloured woodcuts of daily life, famous people or cherished landscapes, were quite unlike European pictures. They relied much less on the perspective construction which had dominated European painting for 500 years, instead achieving depth by building up layers. Using low viewpoints and high horizons the Japanese artists piled up the view, achieving a flat, unmodelled appearance and a shallow picture space. Often boldly coloured and beautifully composed in line and pattern, these prints were to play an important part in the development of modern European art. (Fig. 61)

Manet, Gauguin, and Van Gogh acknowledged a debt to them, and the posters of Toulouse-Lautrec clearly show their influence. Lautrec's posters also show the influence of Chéret, of course, whom he knew well, but in the hands of Lautrec, who was a great artist, the poster would not simply be confirmed as a legitimate art form but would contribute significantly to the new art of the 20th century. (Figs. 60, 62)

Whereas Chéret's posters captured the spirit of the age, the charming surface of the *fin de siècle*, Lautrec's work takes us under the surface into the lives of his contemporaries, and into his own sometimes painful experience. In fact it was in his posters rather than his paintings that Lautrec felt free enough to develop the visual language which was to influence the young men, like Picasso, who would go on to invent modern art. (Figs. 63, 64)

Top
62. HENRI DE TOULOUSE-LAUTREC (1864–1901)
L'Artisan Moderne, Bourgerie & Co. (printer),
Paris, 1895. Lithograph. 94 x 65cm (37 x 25in.).
© Victoria and Albert Museum, London.

This advertisement for an interior-design
business is transfigured by the artist into an
amusing vignette, a parody of the doctor's visit.
The 'modern artisan', equipped with toolbox
and no doubt a caricature of the client André
Marty, is shown into the young lady's boudoir
by the scandalised maid, while the young lady
herself reclines in frilly negligee, apparently
looking forward to his attentions.
Lautrec conjures this quite complex scene in an
effortless tour de force of fluid
draughtsmanship and simple colour.

Bottom
63. THÉOPHILE ALEXANDRE STEINLEN
(1859–1923)
Lait pur stérilisé, Charles Verneau, printer, Paris,
1895. Lithograph, 138 x 99cm (54 x 39in.).
Library of Congress LC-USZC4-11932.

This is one of the most popular poster images in
history. Created for a local milk distributor, it
shows Steinlen's own daughter testing the milk
for the family cats to make sure it is not too hot
for them, and in its simple domesticity it
expresses the warmth and humanity which
enriched this artist's work.

Steinlen, who arrived in Paris from
Switzerland in 1882, shared the talent for social
observation which his contemporary Toulouse-
Lautrec employed so effectively in the *demi-
monde* of Montmartre. In a long and prolific
career as an illustrator Steinlen produced about
50 posters, the sensitivity and vitality of which
have secured for him a position in the highest
echelon of poster artists. His work is as popular
today among collectors as it was when it was
produced.

Opposite
64. PIERRE BONNARD (1867–1947)
La Revue Blanche, Les Maitres de L'Affiche,
Paris, 1896. Lithograph, 29 x 40cm (11 x 15in.).
Courtesy: John Gilmour Collection.

This rather enigmatic poster, probably Bonnard's
best-known one, was commissioned by the
Natansons, publishers of the monthly magazine
La Revue Blanche. The areas of flat colour,
strong outlines and shallow picture space clearly
show the influence of Japanese prints on this
artist's work and suggest that he is more
concerned with the formal qualities of the
composition than with its narrative
interpretation. But the form to the right of the
main figure, which looks like some kind of
animal with black ears, is probably better
interpreted as a gentleman in a top hat
bending over to read the messages on the wall.

The golden age of posters

65. ADOLF HOHENSTEIN (1854–1928)
Chozza e Turchi, E. Chappuis, publisher,
Bologna, Italy, 1899. Lithograph, 51 x 28cm (20 x
11in.). Library of Congress LC-USZC4-12086.

Hohenstein was a German artist who spent his
entire career working with the great Italian
publishing house Ricordi, which was largely
responsible for the growth in popularity of
poster art in *fin de siècle* Italy. His flamboyant
Art Nouveau style owes a debt to Chéret and to
Mucha.

The last decade of the 19th century saw an explosion in the production of
commercial propaganda, particularly of lithographic posters in the style known in
the English speaking world as Art Nouveau. In France it was *Le Style Moderne*, in
Germany *Jugendstil*, in Austria *Sezessionstil*, in Italy *Stile Liberty* and in Spain
Modernista, a confusing array of names for the student of art history, but also a
clear indication of the international character of the movement. Moreover,
though variations in style can be detected in the manifestations of Art Nouveau
emanating from different places, one idea, which is reflected in all the names,
unifies them: it was something new, a spontaneous response to the social,
technological and political changes which were sweeping through the western
world at the time.

The origins of the style lie partly in the English Arts and Crafts Movement,
which rejected the eclectic historicism of the Victorians in favour of a return to
medieval values and methods. But Art Nouveau embraced new materials and
technology, an essential difference which secured its relevance to contemporary
culture. The new style also reflected a wish to reconnect with the natural world,
no doubt as a reaction to the deepening squalor of the industrial cities where it
was born. But it did so by discarding the naturalism of the past and modifying in
both form and colour the motifs it drew from nature to suit its decorative and
expressive purpose. In this way too, Art Nouveau faced forward.

The resulting style, free-flowing and organic, was characterised by the sinuous
lines of the plant world and populated by floral and animal motifs. Essentially
decorative, it was applied to everything from architecture to graphic art, and
though it would soon be superseded by a more functional approach to design, it
did provide a clean break with academic classicism and a bridge to the modern
movement, while the versatility and decorative charm of the style have ensured
its enduring popularity with the public. (Figs. 65-69)

Within the diversity of the Art Nouveau movement a number of artists from
different countries were producing work which can be seen with the benefit of
hindsight to be pointing towards the future of graphic art. Two young British
artists, William Nicholson and his brother-in-law James Pride, both studied painting
in Paris where they were exposed to the work of the post-Impressionists.
Returning to London in 1894, they began to collaborate on a series of commercial

66. EDWARD PENFIELD (1866–1925)
Automobile calendar for 1906, Moffat Yard &
Co. (publisher), NY, USA, 1906. Lithograph.
Library of Congress LC-USZC2-521.

Penfield, one of the best-known American
graphic artists of the turn of the century, and
frequently compared to Aubrey Beardsley, made
his name with *Harper's* magazine, which he
served as art director for 10 years between 1891
and 1901, producing many of its monthly
advertising posters during that period. His style
draws on the work of the French masters,
Lautrec and Chéret, but his unfussy technique
using flat colour and clear lines also recalls that
of Capiello (see p.87) in its deceptive simplicity.
The class and refinement conveyed in these
posters, often seasoned with a playful sense of
humour, reflect the requirements of the
magazine. After leaving *Harper's* in 1901,
Penfield continued to produce poster designs
for Collier's and Scribner's magazines and for a
number of specialist publishers, such as the one
illustrated here.

posters under the name of the Beggarstaff Brothers
(presumably to differentiate this work from their
painting). These strikingly original works were to have
a profound influence on the development of poster
art. Employing the novel method of creating the
image by applying paper cut-outs to a board (later to
become common practice in graphic design), they
produced images of great economy with strong lines,
flat areas of rich colour and an absolute mastery of
composition. (Figs. 71, 72)

The style owes something to both the Arts and
Crafts Movement and Art Nouveau, but its daring
simplicity and boldness are entirely new and prefigure
the work of German artists such as Hohlwein and Bernhard, who would develop
the *Plakatstil* style early in the new century.

In Glasgow Charles Rennie Mackintosh played a leading role in the
development of the version of Art Nouveau known as the Glasgow Style.
Mackintosh was an architect and, like Henry Van de Velde in Belgium and Frank
Lloyd Wright in the USA, he fulfilled the Art Nouveau ideal of 'total art',
designing not only buildings, but their furniture and interior decorations too. He
exhibited at the Eighth Secessionist Exhibition at Munich in 1900, and there
found not only popular acclaim for his work but a community of artists who
understood what he was doing. Recognised today as one of the fathers of the
modern movement in architecture, Mackintosh is best known for his furniture
design and graphic art, which like his architecture reflect his unique blend of
aesthetic flair and rigorous organisation. (Fig. 74)

In common with the avant-garde art communities in other European cities, the
progressive artists of Vienna demonstrated their commitment to change by the
act of secession from the official academy, and *Sezessionstil* became the adopted
name of Austrian Art Nouveau. The work of many of these artists - the likes of
Moser, Hoffman, Klimt and Roller - shows the same balance and architectonic
order that can be found in the work of Mackintosh and his colleagues in
Glasgow. (Fig. 75)

Art Nouveau proved to be appropriate for many purposes - the design of furniture, jewellery or book illustration, for example - but the graphic artists involved in commercial advertising, particularly the advertising of new products, struggled to find an appropriate graphic context for things like electric light bulbs within its timeless vegetable world. Chéret, who set the standards in commercial art, sidestepped this problem by suppressing the product itself and relying on the charms of his young ladies to get the viewer's attention, with only the text of the ad to identify the product. But if an image of it was insisted upon - and who could blame a client for that - then the results were often a bit strange, even in the hands of a competent and imaginative artist. (Fig. 70)

The need to correct this disregard for the objective message, the essential message from the client's point of view, led to a reappraisal of advertising technique in terms of the new functional approach to design which was gaining ground at the beginning of the 20th century.

In 1907 AEG, the German electrical corporation, retained architect Peter Behrens as its artistic consultant. The new turbine factory that he built three years later in a spare and rational neo-classical style is considered to be one of the first Modernist buildings. Subsequently, he designed a range of items for AEG in a coherent style - products, advertising, graphics - all of which taken together demonstrated the potential of a comprehensive approach to design in the modern context, and showed for the first time that it was not only commodities that could benefit from a branded and managed identity. The project also served as an emphatic rejection of Art Nouveau. (Fig. 73)

Left
68. AUBREY BEARDSLEY (1872–1898)
Avenue Theatre, A Comedy of Sighs, Stafford and Co. (printers), UK, 1894. Lithograph. © Victoria and Albert Museum.

One of the outstanding draughtsmen of the Art Nouveau style, and enormously influential to this day, Beardsley is most famous for his perverse and darkly erotic images from history and mythology, most notably Aristophanes' *Lysistrata* and Oscar Wilde's Salome. Devoted to his work and to the grotesque, Beardsley was always a sickly child and died at the early age of 25.

Below left
69. HENRI MEUNIER (1873–1922)
Café Rajah, Gouweloos Lithographers, Brussels and London, 1897. Lithograph, 65 x 81cm (25 x 32in.). © Victoria and Albert Museum, London.

Many Belgian Art Nouveau posters, of which this is one of the best known, advertised coffee or cocoa, products of the country's colonial activities. Meunier's style lent itself to this exotic subject, achieving a rhythmic intensity through purity of line and a few well-chosen colours.

Below right
70. T. PRIVAT-LIVEMONT
Becauer, Goffart Lithographe, Brussels, 1896. Lithograph, 111 x 81cm (43 x 32in.). © Victoria and Albert Museum, London.

A leading exponent of Belgian Art Nouveau, Privat-Livemont followed the Chéret formula, drawing directly onto the lithographic stone and employing relatively few well-chosen colours. Regardless of the product to be advertised, the main subject was always an attractive young woman in a quasi-spiritual Art Nouveau context.

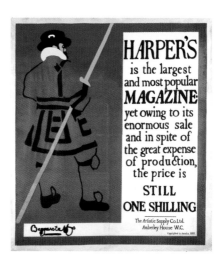

The Beggarstaffs produced this design showing a Yeoman of the Guard, or beefeater, speculatively, probably hoping it would be taken up by a theatre or a company dealing in meat. In fact it was bought by the American publishers of Harper's to advertise their very successful weekly magazine in Britain.
This very large poster was clearly designed with street hoardings in mind, where its simple, integrated layout and bright-red colour would guarantee its visibility.

This fabulous poster, probably the best of all the Beggarstaffs' output, was originally produced for a stage production, *A Chapter from Don Quixote*, at the Lyceum Theatre in 1895. The version reproduced here, part of the *Maitres de L'Affiche* series, was published later for sale to collectors, but the original was much bigger, a hoarding-size poster like *Harper's*. The original artwork, which is held in the Victoria and Albert Museum in London, clearly shows how the artists built up the image by applying paper cut-outs, a technique which allows adjustment to the position of things before they are stuck down, and encourages an expressive approach to lines and edges. At this scale lines are treated as elongated areas, so the artist gets two chances to articulate them, cutting them out on both sides. This technique closely parallels the way woodcuts are made, an art with which Nicholson, a prolific printmaker, was certainly familiar.

Below
73. PETER BEHRENS (1868–1940)
AEG lamp advertisement, Berlin, Germany, 1910.
Lithograph, 53 x 67cm (21 x 26in.). Private
collection

Right
74. CHARLES RENNIE MACKINTOSH
The Scottish Musical Review, Banks and Co.,
Edinburgh and Glasgow (publishers), 1896.
Lithograph, 111 x 81cm (43 x 32in.).
© Hunterian Museum, University of Glasgow.

Below right
75. ALFRED ROLLER (1845–1919)
Secession. 16 Ausstellung, 1903, A. Berger
(printer), Vienna, 1902. Lithograph, 189 x 63cm
(74 x 24in.). © Victoria and Albert Museum,
London.

Roller produced this poster to publicise the 16th
exhibition of the Vienna Secession Group in
1902. Its marked verticality and austere
approach to the Art Nouveau style recall the
work of the Glasgow artists who had exhibited
with the Secessionists three years earlier. The
artist has concentrated on the lettering,
treating it decoratively to extend its function
and make it the main formal element of the
composition, a device which would be explored
further in the coming years by the Russian
Constructivists and Bauhaus typographers.

The modern movement

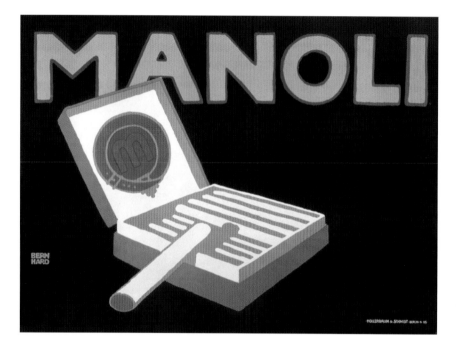

76. LUCIAN BERNHARD (1883–1972)
Manoli, Berlin, Germany, 1915. Lithograph, 94 x 70cm (37 x 27in.). Private collection

By the turn of the century widespread reaction to the social miseries of industrialisation had given rise to a new movement which sought to use art and architecture as instruments of social and political as well as aesthetic change. Dedicated to honesty, clarity and experimentation, the modernists hoped for a new world and a new way of living in it. There was no question of looking back to more innocent times. They were determined to solve their problems with the methods and materials of the machine age, and to draw their new visual language from the realities of life in the street.

Following a visit to the aeronautical and automobile salons of the Paris Fair, the French painter Fernand Léger had a glimpse of the future. 'I am amazed to see that all those men who arranged the splendid display boards, astonishing fountains of letters and light, powerful or precious machines … don't understand or appreciate that they are the real artists, that they have upended every modern plastic idea.'

The new aesthetic would not be derived from the harmony of nature but from the chaotic kaleidoscope of city life. The Russian artist El Lissitzky declared, '… the culture of painting no longer comes from the museum. It comes from the picture gallery of our modern streets - the riot and exaggeration of colours on the lithographic poster.'

It is significant that he referred to the poster in this context. The boom in commercial advertising had given the poster a striking visual presence in the modern city landscape. Bright and full of promise, it became a symbol of the new age.

In graphic art, the first evidence of the new rational approach came from a group of young designers associated with the printers Hollerbaum and Schmidt in

77. LUDWIG HOHLWEIN (1874–1949)
Richard Strauss – Woche, Munich, Germany,
1910. Lithograph, 111 x 74cm (43 x 29in.).
Library of Congress LC-USZC4-12543.

Berlin. Ernst Deutsch, Hans Rudi Erdt, Julius Gipkens and Julius Klinger were all members of this group who would earn recognition for their work, but by far the most important of them was Lucian Bernhard. In the first decade of the new century Bernhard developed what is sometimes referred to as the *Plakatstil*, a style involving a simplified image rendered in flat colours, strongly influenced by the Beggarstaff Brothers and in its purest form known as the *Sachplakat* - the objective, or functional, poster. Purged of emotion and stripped of everything but the essentials, the *Sachplakat* typically portrayed only the object and its name. (Fig. 76)

This was the first commercial art of the machine age. It influenced the work of artists all over Europe and contributed to the graphic art of the modernist movements, such as De Stijl and Constructivism, which would emerge after the First World War.

The other outstanding graphic artist active in Germany at that time was Ludwig Hohlwein. Based on fine draughtsmanship and a decorative interpretation, Hohlwein's images strike a balance between realism and abstraction - accurately drawn but subjected to graphic devices such as flat colour and unmodelled patterns (for example, the flat rendering of the pattern on an item of clothing) - and the best of them display the economy of means and the boldness of a coloured woodcut. Unlike Bernhard, who emigrated to the United States in 1923, Hohlwein stayed in Germany, serving both official and commercial clients till his death in 1949. (Fig. 77)

In Edwardian Britain a great variety of commercial art continued to dominate city streets. Enormous hoardings were plastered with large-scale posters, and gangs of several identical images were often placed together in blocks for impact. Most of this stuff was quite conventional, but some modern work was beginning to come through, following the breakthrough achieved by the Beggarstaffs. Frank Pick took control of London Transport's marketing activities in 1906, and over the next thirty years was instrumental in establishing the world's most advanced public transport system and its first truly modern approach to design and identity management. Commissioning the poster artists himself, Pick brought modern art to the travelling public of London and created an artistic patrimony of inestimable value. (Figs. 78, 80-83)

Left
78. G.E. SPENCER-PRYSE (1881–1957)
"Workless", Labour Party publisher, London, 1910.
Lithograph, 101 x 71cm (39 x 28in.).
© Victoria and Albert Museum, London.

Spencer-Pryse is best remembered as a lithographer. The remarkable set of three posters, of which this is one, made for the British Labour Party election campaign of 1910 reveal him to have been not only a great humanitarian but also a skilled draughtsman. The posters were praised by the Labour Party at the time, and they enjoyed unprecedented elevation (for a poster) to the status of fine art when exhibited at the Royal Society of British Artists in 1914. Their enduring worth was further endorsed by reissue at the time of the 1929 election, and again as commercial stock in 1971. (V&A website: http://collections.vam.ac.uk)

Below left
79. HAROLD SANDYS WILLIAMSON (1892–1978)
There and back, Underground Electric Railway Co., 1928.
Lithograph, 102 x 64cm (40x 25in.). London Transport Museum © Transport For London.

right
80. SUFFRAGE ATELIER
What a woman may be, and yet not have the vote, published in the UK, 1913. Woodcut,
51 x 77cm (20 x 30in.). © Victoria and Albert Museum, London.

The women's suffrage movement in Britain was formalised in 1903 when Emmeline Pankhurst established the Women's Social and Political Union. Voting rights for women over 30 were granted in 1918, but equal rights with men (that is, at age 21) were not granted until 1928. This poster was produced by the Suffrage Atelier, a society formed in 1909 to 'encourage artists to forward the Women's Movement, and particularly the enfranchisement of women, by means of pictorial publications'. The relatively unsophisticated technique of block printing was partly a consequence of limited funds, but it also allowed 'fresh cartoons [to be] got out at very short notice'. (V&A website: http://collections.vam.ac.uk)

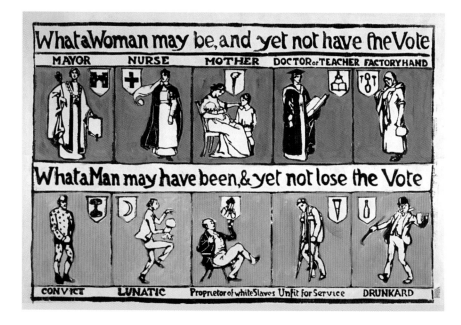

Above left
81. CHARLES SHARLAND
Light, power and speed, Underground Electric
Railway Co., 1910. Lithograph, 102 x 64cm (40 x
25in.). London Transport Museum © Transport
For London.

Above right
82. EDWARD MCKNIGHT KAUFFER (1890–1954)
Route 160, Reigate, Underground Electric
Railway Co., 1915. Lithograph, 74 x 51cm (29 x
20in.). London Transport Museum © Transport
For London.

Right
83. TOM ECKERSLEY (1914–1995) AND ERIC
LOMBERS (1914–1978)
By bus to the pictures tonight, London
Transport, 1935. Lithograph, 26 x 31cm (10 x
12in.). London Transport Museum © Transport
For London.

The First World War

84. ADOLF TREIDLER
Help stop this – Buy W(ar) S(avings) S(tamps),
National War Savings Committee, NY, USA,
1917. Lithograph, 70 x 52cm (27 x 20in.). Library
of Congress LC-USZC4-9928.

Here an almost ape-like Hun is portrayed
marauding over a shattered landscape. The
constant repetition of this theme, supported by
its attendant visual symbols (spiked helmet,
bloody bayonet, jackboots) aimed to establish
the stereotype of the inhuman, bloodthirsty
German soldier in the minds of the
propagandees. Though there was no evidence
to support the theory that German soldiers
were any more inhuman, bloodthirsty or ape-
like than their Allied counterparts, this
stereotype was useful in dehumanising the
enemy, thus reducing any moral or religious
misgivings which might obstruct the full
complicity of the propagandee in his
destruction.

At the beginning of the 19th century Lord Stanhope's new all-metal printing
press was able to produce about 250 sheets an hour; by the end of the century
the Daily Mail, a populist British newspaper, had a circulation of nearly a million
copies. At the beginning of the century it could take weeks for news from a
remote theatre of war to reach home; by the 1850s, war correspondents were
using the telegraph to inform newspaper readers of events on an almost daily
basis, and by the end of it (1902) an Italian inventor, Guglielmo Marconi, had
successfully transmitted wireless radio messages across the Atlantic. In Paris in
1896, the Lumière brothers launched the first commercial cinematograph. So, by
the beginning of the 20th century, the new mass media - newspapers, radio,
cinema - had all arrived, and after another decade of development they were
ready to report upon, and participate in, the Great War.

Within hours of the expiry of the British ultimatum to Germany on 28 June
1914, the British cable ship Telconia had cut the submarine cable linking
Germany with the United States, a clearly premeditated act which demonstrates
that the British understood the vital role of communications in the coming
conflict and, even at that early stage, the importance of popular opinion in
America to its ultimate outcome. Britain and Germany both needed America.
Before the war they had been each other's biggest trading partner. Now only
increased trade with the expanding markets of the USA could compensate for
the loss, and the goodwill of the American people was the key to its markets.
But beyond that the British hoped to take advantage of their shared language
and heritage to win over the American people to their cause.

A new secret propaganda bureau was set up in Wellington House in London
and under the direction of Charles Masterman, a Liberal politician and journalist,
it undertook a campaign of unprecedented scale, designed to bring the
Americans into the war. Between 1914 and 1917 the bureau produced huge
amounts of material - pamphlets, posters and articles, all of which was delivered
through friendly American hands so that the American people were unaware of
its real source. This was important. No sooner had the war begun than the
German government organised the open distribution of large quantities of
propaganda material through its network of German-American societies, a
blatant and ill-advised course of action which proved counterproductive. Nobody

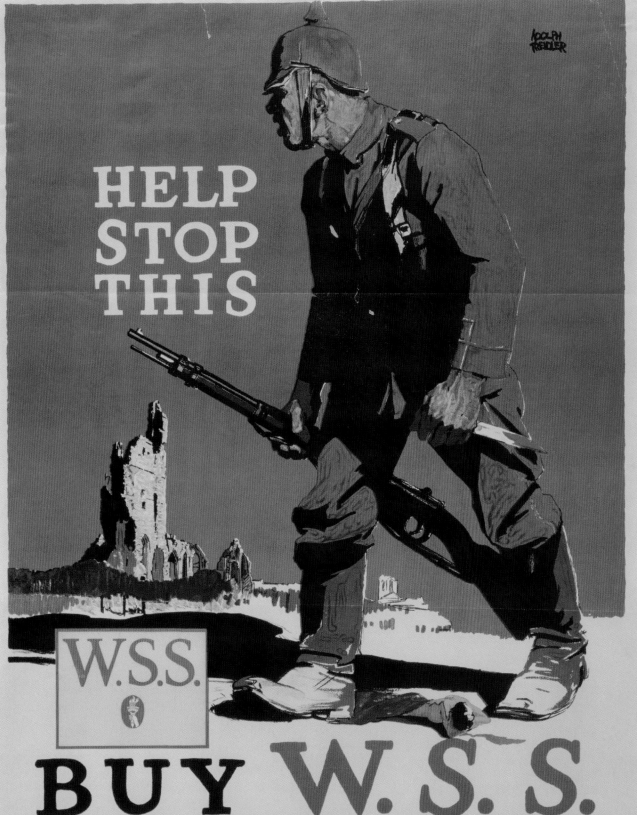

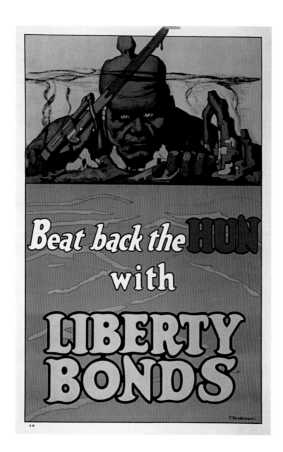

85. FREDERICK STROTHMANN
Beat Back the Hun, USA, 1918. Lithograph, 76 x 51cm (30x20 in). Library of Congress LC-USZC4-2950

likes to be told how to think, especially by people with foreign accents.

In contrast, the subtle activities of Wellington House were carried out behind a veil of secrecy so impenetrable that very few were aware of them. Topics were carefully selected. Friendly persuasion was entrusted to a network of American spokesmen, often influential individuals in government, business or education, and everything was organised around the news. Since the British held all the direct telegraph cables between America and Europe, they could effectively control both the timing and the content of news, even from American correspondents working behind German lines. These dispatches arrived in America as raw material which was then converted into the familiar formats by local editors, thus ensuring optimum credibility for their contents. It is difficult to overstate the advantage the British derived from this brilliant arrangement.

The German High Command's sense of honour, on the other hand, impeded its capacity to treat lies and deception as worthwhile weapons of war. They preferred to trust to the legitimacy of their cause to win them friends, often with disastrous consequences. From the beginning they were put at a moral disadvantage by the simple fact that they had started the war by invading Belgium and France. Their attempts to justify this act of aggression on the basis of their obligation to defend the honour of the fatherland proved less successful than the more emotionally compelling British claim that the Allies were fighting to defend humanity in 'the war to end all wars'.

The invasion of Belgium was fully exploited by the Allies. The sufferings of 'brave little Belgium' at the hands of the Germans were returned to time and again in the early years of the war and played a prominent role in the creation of the 'Hun', the cruel and bloodthirsty creature the elimination of whom was the clear duty of the civilised world. (Figs. 84-5)

Atrocity stories - impossible to verify and equally impossible to disprove - circulated regularly, and as the war progressed the German propaganda machine proved incapable of countering them effectively, as one dramatic incident illustrated.

At ten past two on the afternoon of Friday 7 May 1915, some 30 miles off the south coast of Ireland, the Cunard liner RMS Lusitania was struck by a torpedo

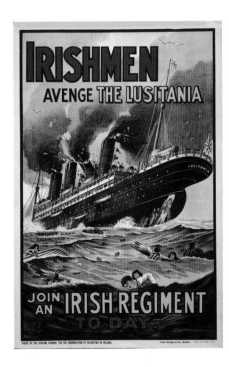

86. ARTIST UNKNOWN
Irishmen, avenge the Lusitania. Central Council for the Organisation of Recruiting in Ireland, 1915. Lithograph, 76 x 50cm (30 x 19in.). Library of Congress LC-USZC4-10986.

Right
87. FRED SPEAR
Enlist, Sackett & Wilhelms Corp., NY, USA, 1915. Rotogravure, 82 x 57cm (32 x 22in.). Library of Congress LC-USZC4-1129.

Comparison of the two posters shown here, which both attempted to exploit the Lusitania story to stimulate enlistment, but tackled the job in different ways, gives us an insight into the options available to the propagandists involved.

The first image, *Irishmen, avenge the Lusitania,* commissioned by the Central Council for the Organisation of Recruiting in Ireland and printed in Dublin, takes a straightforward approach to the incident, combining a realistic view of the stricken vessel and victims in the water with a text designed to appeal to Irishmen, who would be considered a particularly sensitive group because the sinking occurred so close to the Irish coast.

The second image, entitled simply *Enlist,* showing a young woman sliding down into the depths with a baby in her arms, the cold blues and greens emphasised by a bloodless pink in the text, may have been designed to correspond with contemporary reports of a mother and child washed up on the beach. It is a brilliant, harrowing piece of work, and the fact that it was issued in America, by the Boston Public Safety Committee, and that it was not considered necessary to make direct reference to the Lusitania, gives us some indication of the scale of reaction to the incident in that country.

from a German submarine. The great ship sank in 18 minutes, taking 1,195 people to their deaths, including many notable individuals, 198 American citizens and nearly a hundred children. Perhaps the most notorious disaster ever to involve a passenger liner, with the exception of the Titanic, this event had immeasurable consequences for the outcome of the First World War.

Seizing the opportunity, British propagandists and their allies in America launched a campaign designed to defame Germany and to sustain the sense of outrage created by the incident. Despite German attempts to compare it with the hardships caused to their civilians by the British naval blockade, and allegations that the ship was carrying war materials (which it was), the sinking turned world opinion against Germany, and contributed significantly to the entry of the United States into the war some two years later. (Figs. 86-7)

Some six months after the event, a German sculptor, Karl X. Goetz, struck a bronze medal, the latest in a series dealing with the outstanding events of the war. Produced in an edition of 500 at his own expense and without official sanction, the medal blamed Cunard and the British Government for allowing the Lusitania to sail despite German warnings. The obverse clearly shows war material on the deck of the sinking ship under the text 'Keine Bannware' ('No Contraband'), and the reverse shows a skeleton selling Cunard tickets to the unwary with the motto 'Geschäft Über Alles' ('Business Above All').

On the anniversary of the sinking, in May 1916, photographs of this medal, an example of which had been obtained by the British authorities, were widely circulated in the American press with reports (false) that it had been awarded to the crew of the submarine, implying that the medal represented official German commemoration of the deed.

The widespread reaction created by these accounts prompted Lord Newton, head of propaganda at the Foreign Office, to commission a replica which was

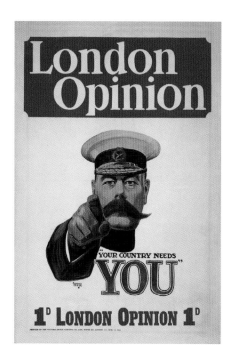

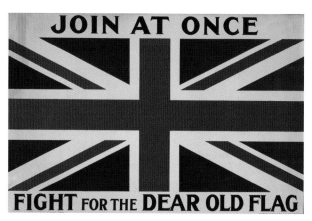

Above left
88. ALFRED LEETE (1882–1933)
Your country needs you, Victoria House Printing
Co. Ltd, London, 1914. Lithograph, 74 x 50cm
(29 x 19in.). Library of Congress LC-USZC4-3858.

Above right
89. ARTIST UNKNOWN
Join at once. Fight for the dear old flag.
Parliamentary Recruiting Committee, London,
1915. Lithograph, 74 x 50cm (29 x 19in.). Library
of Congress LC-USZC4-11045.

Opposite Above left
90. HAL ROSS PERRIGARD
Fight for her, Harris Lithographing Co., Canada,
1915. Lithograph, 90 x 57cm (35 x 22in.). Library
of Congress LC-USZC4-12703.

A homage to James McNeill Whistler's
celebrated portrait *The Artist's Mother*.

Above right
91. ARTIST UNKNOWN
Daddy, what did you do in the Great War?,
Parliamentary Recruiting Committee, London,
1915. Lithograph, 76 x 50cm (30 x 19in.). Library
of Congress LC-USZC4-10923.

Below left
92. E.V. KEALY
Women of Britain say – "GO!", Parliamentary
Recruiting Committee, London, 1915.
Lithograph, 75 x 50cm (29 x 19in.). Library of
Congress LC-USZC4-10915.

Below right
93. ARTIST UNKNOWN
Line up, boys!, Parliamentary Recruiting
Committee, London, 1915. Lithograph, 75 x
50cm (29 x 19in.). Library of Congress
LC-USZC4-10911.

marketed in a nice box with a pamphlet denouncing the atrocity. Two hundred and fifty thousand of these were sold at a shilling each, every one a tangible symbol of German barbarism and of the destructive power of opportunist propaganda.

Britain was relatively unprepared for war in 1914. The Liberals, who had been in power since 1905, were largely anti-war, as was the Labour Party, and, uniquely among the European powers, Britain did not have universal conscription at that time. Consequently, the first priority for the home-front propagandists was to encourage enlistment. The usual patriotic appeals, drawing on the Union flag and other imperial symbols, worked well enough, particularly when the atrocity stories began to come out of Belgium, and by September 1915 over two million volunteers had enlisted. (Figs. 88-9)

But as time passed the propagandists had to come up with other ideas, and eventually a whole range of heartstrings were being pulled - your mother, your wife and/or children, all the women in your country, your pals, your manhood, your culture. (Figs. 90-95, 99)

As well as the things you cared for, the propagandists conjured the things you were afraid of, the things that would happen if you didn't act in the appropriate way - such as the arrival of the Hun if you were British, or the arrival of the Royal Flying Corps if you were German. (Fig. 96)

We have already seen how an alleged atrocity could be exploited. In the same way the propagandists made reference to other objects of disapproval, underhand behaviour such as the bombing of civilians or submarine warfare. (Fig. 97)

Finally, perhaps in desperation, the propagandists working for the Department of Recruiting for Ireland suggested that you should enlist in order to make up the numbers in a game of cards. In the trenches. (Figs. 98, 100, 103)

In Germany the military wielded more authority in matters relating to propaganda than their British counterparts, and as we have seen they had less enthusiasm for it than perhaps they should have. Certainly, coordination between agencies was poor, and there were recriminations after the war that civilian morale had been neglected as it suffered under the pressure of the British naval blockade. Perhaps due to lack of official support, the German designers who had

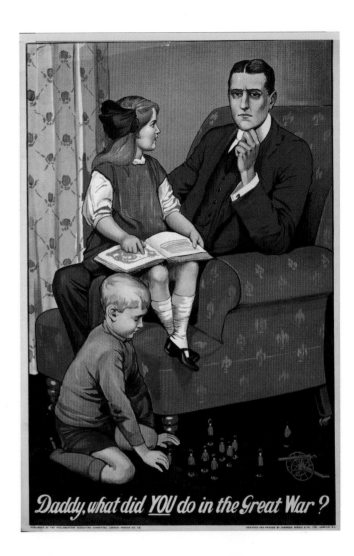

Above
95. ARTIST UNKNOWN
The Second Artillery, Committee of Public
Safety, Dept. of Military Service, Philadelphia,
USA, 1917. Lithograph, 73 x 58cm (28 x 22 in.).
Library of Congress LC-USZC4-8373.

In order to provoke the desired response from
an audience the propagandist must understand
its values, hopes and fears, and while some of
these may be shared by the whole population,
others are not. So an appeal to a particular
group must take these variations into account.
This technique of differentiation, of segmenting
the population into groups, allows the
propagandist to deploy more targeted, effective
messages. From simple beginnings it has grown
in sophistication to become an important
feature of current marketing practice.

These two examples from the First World War
both deal with enlistment, and both use only
text and colour. The fact that they look so
different reveals that the propaganda artist in
each case has taken account of the target
audience, for while one addresses men, the
other addresses women.

To the women of Britain employs a
reasonable message in a quiet, confidential
tone, using a soft cursive typeface and natural
tertiary colours. The overall effect is warm,
relaxed, and gently persuasive.

In contrast *The Second Artillery* states the
facts and figures of the case, asks the question
directly, and quite ruthlessly implicates our
manliness, by using the word 'real' and
underlining it with two cannons. The no-
nonsense black typeface is smartly outlined in
white on a red background – quite beautiful in
its own way.

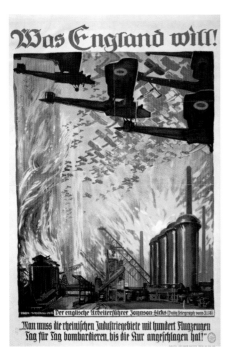

Above left
94. ARTIST UNKNOWN
To the women of Britain, Parliamentary
Recruiting Committee, London, 1915.
Lithograph, 74 x 50cm (29 x 19in.). Library of
Congress LC-USZC4-10912.

Left
96. EGON TSCHIRCH (1889–1948)
What England wants, Selmar Bayer, Berlin,
1918. Lithograph, 98 x 67cm (38 x 26 in.).
Library of Congress LC-USZC4-12309.

The additional text is a quote from British
Labour Party leader Johnson-Hicks which
appeared in the *Daily Telegraph*, 3 Jan 1918:
'One must bomb the Rhine industrial area day
by day with hundreds of aeroplanes, until the
cure [destruction of German industrial
production] has occurred.'

Above left
97. ARTIST UNKNOWN
It is far better to face the bullets..., Publicity
Dept., Central Recruiting Depot, London, 1915.
Lithograph, 74 x 50cm (29 x 19in.). Library of
Congress LC-USZC4-10972.

As the war wore on, the fearful conditions at
the front created an insatiable demand for
fighting men. Enlistment was the first priority
of the British propagandists who, having
thoroughly covered the usual themes of
patriotism, family, manhood and the like, were
eager to exploit any new angle. The appearance
of Zeppelins in the skies over British cities and
the indiscriminate bombing of civilians, an
unprecedented and shocking development,
provided a golden opportunity for the British
propagandists, and though the proposition
suggested by the text may seem a bit absurd to
us (the chances of being killed by a Zeppelin
were extremely remote, while death at the
front was anything but) it probably did not
matter at the time. The mere depiction of a
Zeppelin about its dirty work would make
people mad for a fight.

Above right
98. ARTIST UNKNOWN
Will you make a fourth?, Department of
Recruiting for Ireland, Dublin, 1915. Lithograph,
76 x 50cm (30 x 19in.). Library of Congress LC-
USZC4-11003.

Right
99. ARTIST UNKNOWN
*Anibyniaeth sydd yn galw am ei dewraf dyn
(Independence calls for the bravest of men)*,
Welsh Recruitment Poster, Parliamentary
Recruiting Committee, London, 1916,
Lithograph, 76 x 51cm (30 x 20in.). Library of
Congress LC-USZC4-11037.

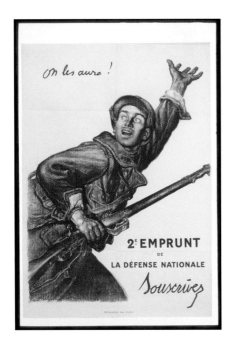

100. ABEL FAIVRE (1867–1945)
We will get them! Second national defence loan. Imp. Devambez, Paris, 1916. Lithograph, 114 x 80cm (45 x 31in.). Library of Congress LC-USZC4-3864.

This became the most popular French poster of the war. The slogan is a quote from General Pétain at Verdun, and the pose of the soldier is a reference to the sculpture of Victory on the Arc de Triomphe.

been the vanguard of modern commercial art before the war were not given much opportunity to treat war-related subjects in their colourful *Plakatstil* style. Lucian Bernhard did produce a number of posters to do with war loans and savings bonds, but these were mostly typographical and, although very fine, bore little relation to his brilliant pre-war commercial work. Ludwig Hohlwein continued to work in his signature style during the war years, mainly publicising a variety of charitable initiatives, as did Julius Gipkens and Ilse Hoeltz. (Figs. 101, 102, 104, 105)

But perhaps the most striking German posters of the First World War were actually produced after the Armistice, a time of great hardship when thousands of demobilised troops returned to a country with a shattered economy and an overheated political atmosphere. Contemporary observers recalled a profusion of posters in the streets of Berlin. (Figs. 106, 107, 111)

America declared war on Germany on 6 April 1917. Within a week a new propaganda organisation, the Committee on Public Information (CPI), had been set up under the direction of George Creel, a former newspaper editor and confidant of President Wilson. Creel had a clear view of the nature of his mission - 'a plain publicity proposition, a vast enterprise in salesmanship, the world's greatest adventure in advertising' - and of how to achieve it, as he later recalled: 'There was no part of the great war machinery that we did not touch, no medium of appeal that we did not employ. The printed word, the spoken word, the motion picture, the telegraph, the cable, the wireless, the poster, the signboard - all these were used in our campaign to make our own people and other peoples understand the causes that compelled America to take arms.' (Creel, How We Advertised America, p.5)

The American people were then subjected to the most intense propaganda campaign ever devised. Over a 150,000 people were mobilised to serve it, and unlike the British organisation in Wellington House, which had achieved its goal of getting America into the war and was now content to act in a supportive role, the CPI operated in full view of the public.

The main aim of the Creel Committee, as it became known, was to explain to the American people why they should be involved in a war which did not directly threaten them. President Wilson, only a year after being elected on an anti-war

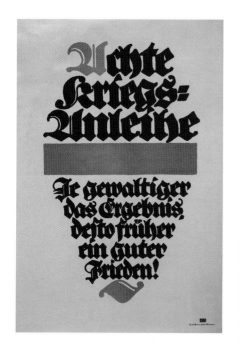

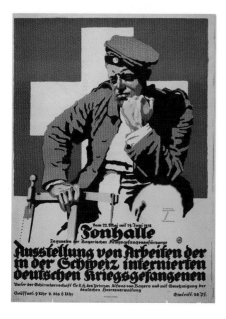

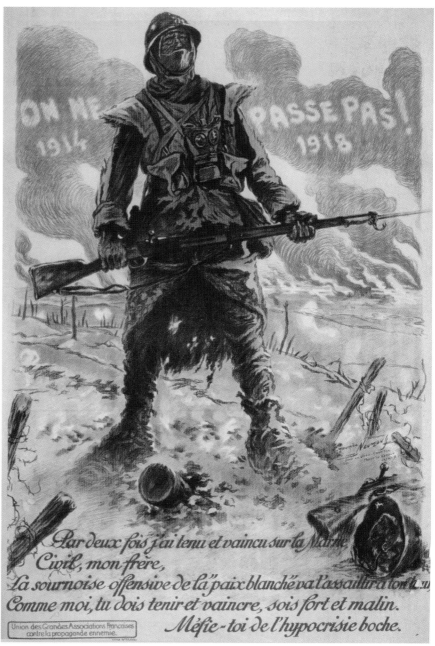

Above left
101. LUCIAN BERNHARD (1883–1972)
The Eighth War Loan, Dr. C. Wulf u. Sohn, Munich, 1918. Lithograph, 70 x 48cm (27 x 19in.). Library of Congress LC-USZC4-11269.

Below left
102. LUDWIG HOHLWEIN (1874–1949)
Exhibition of artwork by German prisoners, Fritz Maison, Munich, 1918. Lithograph, 124 x 90cm (48 x 35in.). Library of Congress LC-USZC4-11637.

Above
103. MAURICE NEUMONT
They shall not pass, Devambez, Paris, 1917. Lithograph, 115 x 80cm (45 x 31in.). Library of Congress LC-USZC2-3936.

A ragged French infantryman, who seems to be growing out of the muck and detritus of the battlefield, cries, 'They Shall Not Pass', a phrase made famous by General Nivelle at Verdun and in later years taken up by various left-wing forces, notably the Spanish Republicans at the defence of Madrid in the Civil War. The two dates, 1914 and 1918, refer to the first and second battles of the River Marne. At the first, the French under General Joffre famously repulsed a German advance on Paris. At the second, in 1918, the German general, Ludendorff, put 35 weakened divisions across the river in an attack which became known as the 'Peace Offensive'. An attempt to win a negotiated peace before the arrival of the Americans made defeat inevitable, it failed and marked the beginning of the end for Germany.

The poster warns the French people against these peace overtures and urges them to stay firm and distrust the Germans. The bedraggled appearance and resolute attitude of the soldier have been so well drawn that this poster became famous as a symbol of the capacity of fighting men to endure almost anything for a cause they believe in.

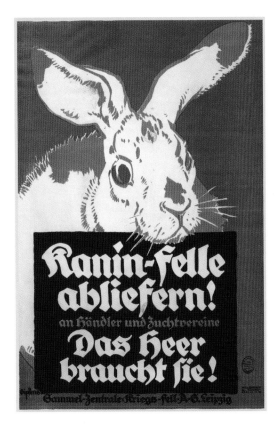

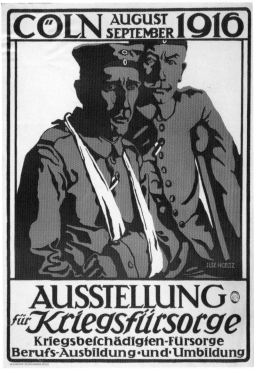

104. JULIUS GIPKENS (1883–1969)
Deliver your rabbit pelts, the army needs them,
Hollerbaum and Schmidt, Berlin, 1917. Lithograph, 71 x
47cm (28 x 18in.). Library of Congress LC-USZC4-11599.

105. ILSE HOELTZ
Exhibition to raise money for the war wounded, M.
Dumont Schauberg, Cologne, 1916. Lithograph, 88 x 63cm
(34 x 24in.). Library of Congress LC-USZC4-11631.

platform, stated in 1917, 'We have no quarrel with the German people. We have no feeling towards them but one of sympathy and friendship. It is not upon their impulse that their government acted in entering this war.'

In other words, the enemy was not the German people but the regime. It was to be an ideological war, fought on behalf of all the people of the world in the name of peace, freedom and justice, and presented in a manner calculated not only to motivate Americans, but to appeal to neutral countries, and to separate, if possible, the German people from their leaders.

The campaign had a number of novel features. Radio was not yet advanced enough to offer an effective propaganda medium for speech, but the CPI organised a network of speakers, the 'Four Minute Men,' who were trained to give short speeches to groups in public places on topics concerned with the war effort, boosting public morale and promoting enlistment and the sale of war bonds.

The American advertising industry, which along with its British counterpart had led the world in the development of commercial advertising before the war, was brought in to support the production of propaganda material. Posters were produced on every conceivable topic, the largest categories being enlistment, war production and the promotion of war bonds. (Figs. 109, 110, 112, 113)

Much of the material was traditional in appearance and content, but some designs reveal the commercial expertise behind them in their energetic style and use of humour, something which occasionally appears in British designs but never at all in German material.

For the first time the cinema was exploited on a large scale as a propaganda medium. The rapidly expanding American motion-picture industry, which by then had moved from New York to Hollywood, threw itself into the task of producing films in cooperation with the CPI's Films Division. (Fig. 108)

The collapse of Austria-Hungary weakened German morale, as did the arrival of the Americans on the Western Front and the failure of the last

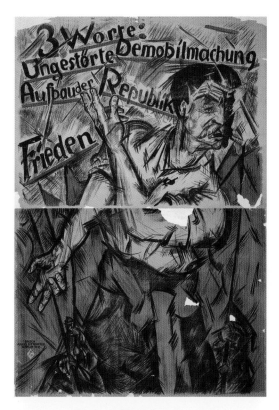

Undisturbed demobilisation, Creation of the Republic,
Peace, J. Sittenfeld, Berlin, 1919. Lithograph, 139 x 96cm
(54 x 37in.). Library of Congress LC-USZC4-11960.

As part of a strategy designed to attract the extreme left
towards Social Democracy, Paul Zech, the director of the
publicity office of the Weimar Republic, encouraged the
use of expressionist imagery in the belief that it provided a
break with the old regime and commercial interest. It did
not work. The leftists condemned it as elitist and the
bourgeoisie as a style designed for personal expression
rather than political statement. But looking at Richter's
image you have to admit that its fractured agitation
perfectly suits the state of cultural and political hysteria
current in Germany at the time.

great German offensive in July 1918, after which defeat was inevitable.
The German High Command were later quite prepared to admit that
they had been outwitted by the Allied propagandists. General
Ludendorff said, 'We were hypnotised by the enemy propaganda as a
rabbit by a snake,' and others, including Adolf Hitler, said similar things.
But perhaps it would be wise to treat such statements with caution.
Defeat by propaganda was probably less unpalatable to them than
defeat in battle, and it also allowed for the preservation of the idea of
the invincible German Army, which would form an essential part of Nazi
mythology in later years.

After four years of industrialised slaughter the Great War, the 'war to
end all wars' which most had confidently predicted would be 'over by
Christmas', ended in a wood in northern France with the signing of an
armistice which formalised the destruction of four European empires and
the invention of a number of new independent but insecure states. It
seemed that those who had won got revenge, and those who had
surrendered faced humiliation and an uncertain future. But really,
everyone lost, including a large number of people who had not yet been
born.

When George Creel published his book about the wartime activities
of the CPI in 1920 he confirmed a growing suspicion that the American
people had been duped into going to war by vested interest ably
supported by its British mentors. So overwhelming had been the success
of the propagandists that many people became concerned about the
power of these unelected functionaries and the implications for
democracy, a debate which continues to this day. On the other hand,
propaganda had come of age. It worked. It worked so well that
henceforth governments and corporations would ignore it at their peril.
Its practitioners - the boosters and carpetbaggers who had been held in
contempt by the pre-war establishment - now enjoying a newly acquired
respect, found doors open which had previously remained shut, and in
the post-war boom they went on to build the huge marketing services
industry which helped to define the 20th century.

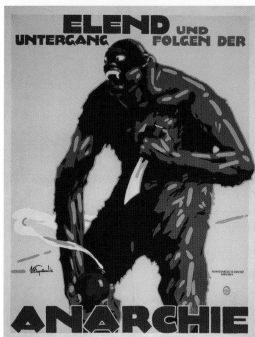

107. JULIUS USSY ENGELHARD (1883–1964)
Misery and destruction follow anarchy, Kunstanstalt O.
Consée, Munich, 1918. Lithograph, 106 x 90cm (41 x 35in.).
Library of Congress LC-USZC4-11544.

Following its aborted foray into expressionism the
publicity office shifted to a more populist, but no less
shocking imagery derived from the cinema and popular
literature. Here a nightmarish monster stalks the land with
anarchist bomb and knife at the ready.

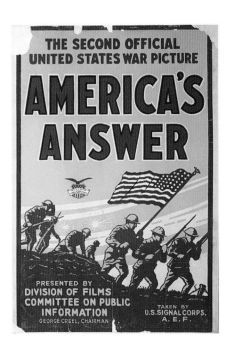

Top row from left
108. ARTIST UNKNOWN
America's Answer. The second official United States war picture. Committee on Public Information, USA, 1918. Lithograph. Library of Congress LC-USZC4-2823.

109. RICHARD FAYERWEATHER BABCOCK
Join the Navy, the service for fighting men
USA, 1917. Lithograph, 106 x 72cm (41 x 28in.). Library of Congress LC-USZC4-9568.

110. LAURA BREY
Enlist. On which side of the window are you?,
National Printing and Eng. Co., Chicago, USA, 1917. Lithograph, 99 x 66cm (39 x 26in.). Library of Congress LC-USZC4-9659.

Bottom left
111. VALENTIN ZIETARA (1883–1935)
Freedom, peace, work – Elect the German Democratic Party, Kunstanstalt O. Consée, Munich, 1919. Lithograph, 94 x 71cm (37 x 28in.). Library of Congress LC-USZC4-11908.

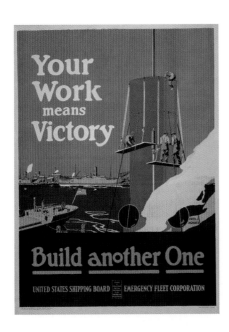

Left
112. FRED J. HOERTZ
Your work means victory – build another one,
Emergency Fleet Corporation, Philadelphia,
USA, 1917. Lithograph, 97 x 70cm (38 x 27in.).
Library of Congress LC-USZC4-10140.

Bottom
113. HOWARD CHANDLER CHRISTY
I want you for the Navy, The Copperplate
Engraving Company, NY, USA, 1917. Lithograph,
28 x 36cm (11 x 14in.). Library of Congress LC-
USZC4-9459.

While this enlistment poster makes an obvious
reference to the famous 'I Want You' originals
featuring Lord Kitchener and Uncle Sam, the
demeanour of this young woman suggests that
she wants us for something else, a message
guaranteed to draw the attention of many a
healthy young man. Such is her ardour, in fact,
that she seems to have scrawled the text with
her lipstick.

The artist Howard Chandler Christy first came
to prominence when he was sent to Cuba in
1898 to cover the Spanish-American War for
Scribner's Magazine, but was best known for
the 'Christy Girls' who populated many of his
book illustrations. Charming society girls,
reminiscent of Jules Chéret's Parisian poster
girls, they were pressed into service during
World War I and provide a lasting testament to
Christy's brand of red-blooded patriotism.

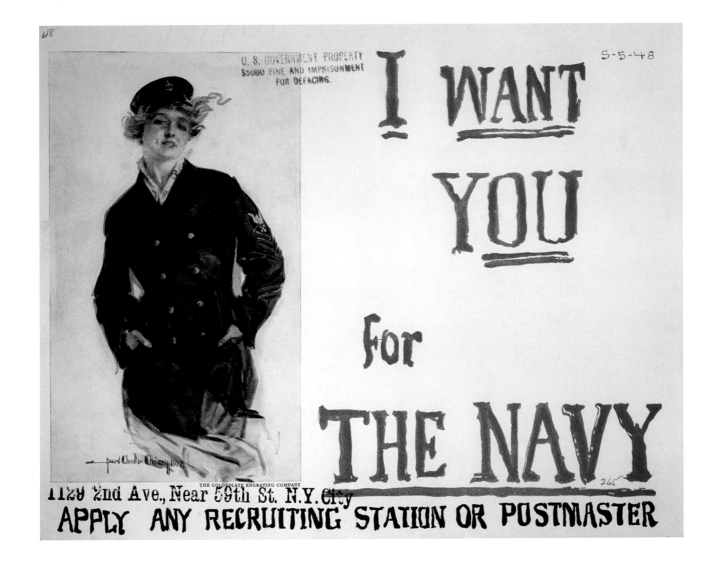

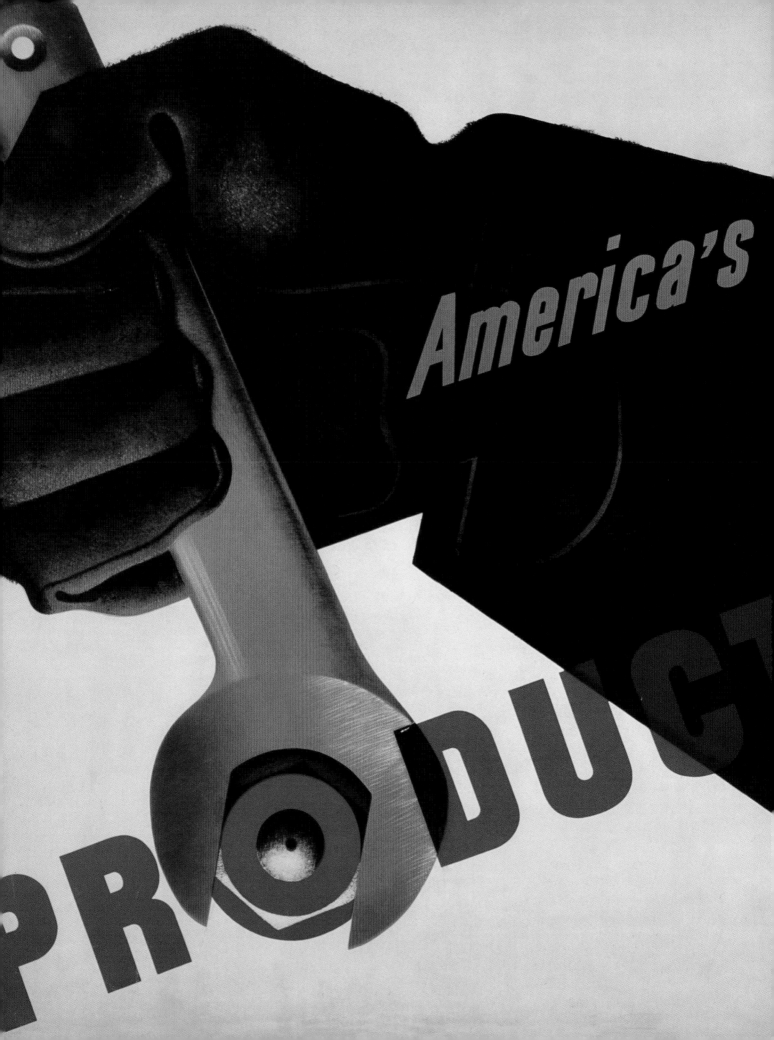

5

The early 20th century

JEAN CARLU (1900–1997)
Detail: *America's answer!* Production, Division of
Information, USA, 1942. Offset, 76 x 102cm
(30 x 40in.). Library of Congress LC-USZC4-7085.

The Mexican Revolution

114. JOSÉ GUADALUPE POSADA (1852–1913)
La Catrina, Mexico, 1913. Zinc etching. Private collection.

La Catrina is the best-known of Posada's *calaveras*, humorous images of contemporary figures depicted as skeletons, which were often accompanied by poems and distributed as broadsides. These figures reflect the ancient Aztec approach to death as a joyous occasion, which, when combined with the macabre iconography of Spanish Catholicism, produce a unique and potent imagery, most commonly associated with the Day of the Dead celebrations. La Catrina herself ('catrín' means 'elegant' in Spanish), in her ribbons and bonnet, is a particularly poignant, and comical, aid to meditation on the essential transience of human life and beauty – a Mexican vanitas.

In Mexico there have always been two really distinct kinds of art, one of positive value, and another negative, imitative and colonial, based on the imitation of foreign models to satisfy the demand of a feeble bourgeoisie, which always failed in its attempts to establish a national economy, and has ended up in unconditional surrender to the imperialist powers.

The other kind of art, the positive one, has been the work of the people, and embodies everything, pure and rich, which has come to be known as 'popular art'. This art also includes the work of artists who have managed to find their own style, but have lived, felt, and laboured to express the aspirations of the working masses. Of these the greatest, without doubt, is the printmaking genius, José Guadalupe Posada.

(Diego Rivera, *José Guadalupe Posada, Mexican Folkways*, 1930, translation by Colin Moore.)

In this, the opening paragraph of an introduction to the first monograph on the work of Posada, Diego Rivera not only offers a heartfelt tribute to him but declares what he believes is, and is not, true art, and also his belief that the true purpose of art is political. In these few lines Rivera also puts his finger on a fundamental issue, the dark tragedy which has obfuscated the identity of the country for 400 years - that is, the genocidal invasion of Mexico by a colonial power, the disenfranchisement of its people and the systematic destruction of their culture. The re-evaluation of indigenous culture in modern terms and the cause of the working class are what drove his life's work and that of the other muralists, Siquieros and Orozco, along with hundreds of others. For there never was a country better served by its artists.

The Mexican Revolution began in 1910 with a revolt led by a young patrician, Francisco Madero, against the deeply unpopular regime of autocratic President Porfirio Díaz, whose long period in office, from 1876 to 1910, had been characterised by rapid industrialisation, the influx of foreign capital and, critically, new laws designed to return the land to private ownership, effectively undoing the land reforms of previous president and popular hero Benito Juárez. By 1894, 20 *per cent* of Mexico's arable land was in foreign hands, most of the rest had been returned to the wealthy landowners of European descent, and many peasants and urban workers were living in dire poverty.

115. JOSÉ GUADALUPE POSADA (1852–1913)
Maestro tú estás solo, Mexico. Woodcut and
letterpress. Courtesy: José Luis Lugo.

This political handbill, a curious piece of
propaganda on behalf of propaganda, reveals
the uncertain conditions faced by many during
the revolution. The full text reads:
'Schoolteacher, you are alone against: the
assassin white guards (armed paramilitaries);
fools stirred up by the rich; the slander which
poisons and ruins your relations with the
people. Fight back with illustrated propaganda,
an effective weapon.'

Above right
116. LEOPOLDO MÉNDEZ (1902–69)
*Let us stop the aggression towards the working
class! Help the strikers from Palau, Nueva Rosita
and Cloete*, Taller de Gráfica Popular, 1950.
Poster printed from an original linocut, 70 x
95cm (27 x 37in.). Private collection

This was the situation when a young Posada joined the print workshop of
Antonio Vanegas Arroyo in Mexico City to work on the broadsides, songbooks,
pamphlets and posters which would take their place among the jewels of
Mexico's artistic patrimony. Through this cheap and ephemeral medium Posada
illustrated the sensational news of the day, capturing the drama and emotion of
the revolution. His robust and unflinching eye also recorded everything else going
on around him. His enormous output of prints, some 15,000 according to
Vanegas, preserved the daily lives and customs of his people, a treasure trove for
the social and political artists who would follow him, and a vital piece in the
puzzle of what it means to be Mexican - which is why Rivera loved him. (Figs.
114, 115)

The revolt turned into a multi-sided civil war, ten years of confused agony in
which legendary figures like Pancho Villa and Emiliano Zapata came and went
and two million people died. When exactly the revolution ended is a matter of
historical debate. The ascension to power of General Álvaro Obregón in 1920 is
generally taken to mark its military conclusion, but attempted coups and
uprisings, the Cristero Wars of 1926-29, for example, continued at least until the
1917 'Constitution of Mexico' was implemented by the administration of Lázaro
Cárdenas (1934-40). The confrontation of extreme political views and armed
resistance to the government remains a feature of Mexican public life to this day.

In 1937, printmaker and political activist Leopoldo Méndez and a group of
like-minded artists founded the Taller de Gráfica Popular (People's Graphic
Workshop) in Mexico City. Dedicated to the promotion of social and political
change, the TGP worked in most print media but specialised in relief prints, in
lino or wood, which could be quickly and cheaply made and combined with
letterpress to produce propaganda material, or editioned and sold to raise funds.
Although firmly rooted in Mexican culture and committed to local progressive
action, the TGP took an international socialist view of political events, with
opposition to fascism as well as support for the Soviet Union and foreign causes

117. JESÚS ESCOBEDO (1918–78)
How to combat Fascism – 8th conference, Taller
de Gráfica Popular, Mexico, 1939. Lithograph, 42
x 47cm (16 x 18in.). Private collection

Below
118. LEOPOLDO MÉNDEZ (1902–69)
Homage to José Guadalupe Posada (detail),
1953. Lithograph, 36 x 79cm (14 x 31in.).
Private collection

featuring regularly in the workshop's output. (Figs. 116, 117)

In time the TGP gained an international reputation and is now considered one of the most important graphic workshops in the Americas. Méndez himself is recognised as one of the great Mexican artists of the 20th century. The distinguished German art critic Paul Westheim wrote of him in 1954, 'If Posada is the faithful interpreter of the pains and joys of the Mexican people, of their soul and spirit, Leopoldo Méndez is undoubtedly his spiritual and artistic heir.' (Fig. 118)

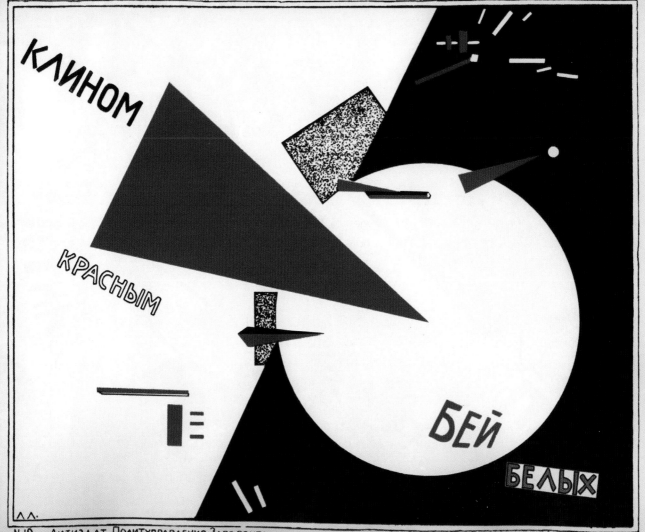

КЛИНОМ

КРАСНЫМ

БЕЙ

БЕЛЫХ

N 19 Литиздат Политуправления Запфронта Уновис

The Russian Revolution

119. EL LISSITSKY (1890–1941)
Beat the Whites with the Red Wedge, Vitebsk,
USSR, 1919. Letterpress, 59 x 48cm (23 x 19in.).
Courtesy: Vitaly P. Sitnitsky,http://eng.plakaty.ru/

Published at a time when the Red Army (the
Reds) was engaged in a desperate civil war with
a coalition of counter-revolutionary forces (the
Whites), this poster has been purged of all
figurative content in favour of the pure formal
geometry and simple colours of Suprematism.
While this uncompromising approach was
undoubtedly inspiring to the revolutionary
avant-garde – and its message is easily
understood if it is explained to you – the
question of whether it was valid for
propaganda aimed at the masses was a subject
of debate for the next decade, until the forces
of reaction eventually banned it and imposed
the more prosaic Socialist Realist style.

El Lissitsky, who produced this poster while
working at the newly formed People's Art
School in Vitebsk with Marc Chagall and
Kasemir Malevich, was a key influence in the
development of Constructivism. His works
intended for printing employ only the contents
of the typesetter's case, albeit with
breathtaking originality, and always
demonstrate his unfailing sensitivity to the
relationship between type and open space.
After his designs for Mayakovsky's collection of
poems, entitled *To Be Read Aloud,* were
published in 1923, his reputation as the leading
European graphic designer of his generation
was secure

When Vladimir Lenin returned to Russia from exile in Switzerland he did so with
the active support of German officials who arranged for him and his associates to
pass through the war zone in a train. They did this not out of sympathy - far
from it, as the train was sealed to prevent the contagion of Bolshevik ideas
leaking out on its passage through German territory - but in the hope that
Lenin's revolutionary activities would reduce Russian commitment to the war and
allow the Germans to divert resources from the eastern front to the west, where
a greater threat was gathering.

Arriving in Petrograd (St Petersburg) in April 1917, Lenin found Kerensky's
Provisional Government struggling to prosecute the war with Germany and losing
support at home, a situation which the Bolsheviks immediately set out to exploit.
Their messages of 'Peace, land and bread' and 'All power to the Soviets' won the
support of both peasants and industrial workers, and their promise to end the
war ensured the support of an army which was on its last legs. By October they
were in a position to seize power, and the revolution began, a revolution which
would depend for its success on the Bolsheviks' ability to communicate with a
largely illiterate population of 170 million people spread out over the vast
territory of the Russian Empire. But the revolutionaries were great publicists and,
motivated by an evangelical desire to bring the truth of Marxist ideology to the
people of Russia and the world, they had been preparing for this moment for
years.

As resistance to the Bolsheviks developed into civil war, the revolution became
a race against time to win over the people. Lenin mobilised every conceivable
form of communication under the control of the Agitational-Propaganda Section
of the Central Committee of the Communist Party, mercifully shortened to
Agitprop. Activists went into the country to tell the peasants that the land now
belonged to them, to organise them, and to politicise them. The young, the
lifeblood of every revolution, were organised into the Komsomol. Agit-ships and
Agit-trains with names like V. I. Lenin, Red Star and October Revolution, covered
in flags and revolutionary images and equipped with their own printing presses
and film projectors, carried the news out into the wilderness. The impact on
simple peasants who had never seen a film must have been considerable and, if
they did not know who Karl Marx was, they understood well enough when they

120. VLADIMIR MAYAKOVSKY (1893–1930)
Rosta No.42, Sowing campaign, Let's fulfill the decree, Russian Telegraph Agency, Moscow, Russia, 1921. Stencil. Courtesy: Brown University Library.

1. Everyone fulfilled the Soviet plan

2. I wasted no time and worked with dedication

3. For this I was immediately rewarded

4. With a prize and a decoration!

were told the land was theirs.

The widespread illiteracy of the working classes was a serious challenge to the propagandists. Despite material shortages in almost every sector, literacy programmes were given state priority, and every effort was made to communicate effectively in other ways. In this respect the artistic community quickly demonstrated its support for the revolution, especially the young artists of the avant-garde, some of whom had returned to Russia from the west to take part. Between 1917 and 1923, art and politics coincided in an experimental programme to invent a universal visual language, a new language which owed nothing to the past, and which would serve the people in their struggle for self-determination. (Fig. 119)

Kasimir Malevich offered his Suprematist vision as a point of departure - a pure non-figurative art based on simple geometric forms and pure colours. Vladimir Tatlin, the visionary architect, contributed a context within which to question the whole basis of easel painting, as did the Cubist and Futurist ideas of the pre-war avant-garde. But most influential of all was the revolution itself, from which the new art became inseparable. With the civil war raging and the Red Army fighting for survival, the art became incorporated into the social and political struggle, and its experiments were played out in the real world as agitation.

In Petrograd and Moscow the first practical steps towards developing the new agitational media were the designs of 'mass action' performances by workers. These were political rallies. Demonstrations of political solidarity, public festivals … Artists created larger-scale effects and structures than anyone had ever seen before: vast panels carried enormous slogans; great edifices, garlands and decorations changed the look of whole squares, bridges, palaces and monuments. By contrast with the humdrum everyday city, where all the signboards had been taken down and every bit of commercial colour and graphics from the pre-Revolutionary era had been removed, where shop windows stood empty, the city of these festival days became a symbol of victory and a celebration of the new power structure. (M. Anikst, p.13)

Another priority was the effective dissemination of news. The cinema industry

121. ARTIST UNKNOWN
The Red Ploughman, USSR, 1921. Lithograph, 53 x 71cm (21 x 28in.). © Victoria and Albert Museum, London.

This poster was made soon after the Russian Revolution of 1917. Aimed at rallying Russia's large and predominantly illiterate population, it pledges to do away with the old order, symbolised by the paraphernalia of Church, aristocracy and army being ploughed into the ground by a red-shirted peasant. The caption reads, 'On the wild field amid the ruins of evil Lordship and Capital we shall drive our plough and gather the good harvest of happiness for the whole working people.' (V&A website: http://collections.vam.ac.uk)

had been smashed in the war and a few years would pass before it recovered to enter the great age of Soviet cinema. The newspaper industry did not offer a solution either. At that time circulation was pitifully small in comparison to the size of the population, and there was also an acute shortage of newsprint. The answer was found in a new type of poster known as the 'Satire Window of the Russian Telegraph Agency', or ROSTA for short. This consisted of a series of simple illustrations with captions not unlike the modern comic strip, which could be quickly and economically produced by unskilled workers using stencils, and put up in the same empty shop windows mentioned in the quotation above. Probably derived from the lubok, a traditional folk-art form popular in the previous century, the ROSTA were masterfully exploited by the poet Mayakovsky, and offered an effective means of providing information and indoctrination, even to those with limited reading skills. (Fig. 120)

The urge to commit their art to the revolution led the young artists to discuss ways of connecting with the workers, of taking the art into the factories. 'Art into life', and 'art into production' were the kinds of slogans which appeared in their manifestos. As Mayakovsky put it, 'Art must not be concentrated in dead shrines called museums. It must be spread everywhere - on the streets, in the trams, factories, workshops and in the workers' homes.'

But to be fully engaged it was not enough for the artists simply to put their creations where the workers might find them; they wanted to revise their own practice in terms of industrial production, which led them to experiment with things like collaborative working and serial production, and to embrace the new ideas of machine-age design functionality, the elimination of the decorative, and regard for the nature of materials. This 'production art' became the basis of the Russian design method known as Constructivism, which was explored in painting but found its true expression in architecture and in graphic design.

The urgent need to communicate with the people during the Civil War led to an explosion of Agitprop activity. The ROSTA were supplemented by posters on a variety of topics. Some 3000 were produced and distributed throughout Russia

Above left
122. ALEXANDER RODCHENKO (1891–1956)
(DESIGN) & VLADIMIR MAYAKOVSKY
(1893–1930) (TEXT)
Nowhere except Mosselprom, Moscow, USSR,
1925. Lithograph, 59 x 48cm (23 x 19in.).
Courtesy: Vitaly P. Sitnitsky,
http://eng.plakaty.ru/
This well-known poster, a good example of
Rodchenko power graphics, was created for
Mosselprom, the huge state enterprise set up to
market a wide range of agrarian products –
biscuits, confectionery, chocolate, beer and
tobacco. It occupied the prominent building
illustrated in the poster, one of the tallest in
Moscow at the time, which Rodchenko and
Mayakovsky exploited for propaganda by
decorating it with slogans and advertisements.
The slogan, *Nowhere except Mosselprom*, a
typically catchy Mayakovsky invention, refers to
the difficulty in locating commodities which faced
consumers in the early days of the revolution.

Above right
123. ALEXANDER RODCHENKO (1891–1956)
(DESIGN) & VLADIMIR MAYAKOVSKY
(1893–1930) (TEXT)
Baby's Dummies, Moscow, USSR, 1923.
Lithograph, 59 x 48cm (23 x 19in.). Courtesy:
Vitaly P. Sitnitsky, http://eng.plakaty.ru/

A masterpiece of Constructivist advertising art.
This poster typifies the original, light-hearted
work produced by Rodchenko and Mayakovsky
for Rezinotrest, the state rubber industry trust,
which made its rubber galoshes famous around
the world, and helped sustain the international
interest in the pair's designs which started with
their contribution to the International Exhibition
of Decorative Arts in Paris in 1925.

between 1917 and 1923, and steady production of new material continued
throughout the 1920s. (Fig. 121)

In 1921 Lenin proposed the New Economic Policy (NEP), which allowed small
businesses to reopen and trade for profit while the state retained control of
banks, foreign trade and large industries. Designed to prevent the collapse of the
Russian economy, to address the dire shortage of consumer goods in the country
and to buy time for the new communist economy to get going, the NEP
effectively put the large state industries and their distribution operations in
competition with private enterprise. The Constructivist artists saw this as an
opportunity to deploy their new ideas. In an article written in 1923 entitled
'Agitation and Advertisement', Mayakovsky made the case for Soviet advertising:

'We know the marvelous power of agitation …The bourgeoisie know the
power of advertising. The advertisement is industrial, commercial agitation. No
business, even the most certain and reliable, keeps going without advertisement.
It is the weapon which is born of competition … We cannot leave this weapon,
this agitation on behalf of trade, in the hands of the NEP men, in the hands of
the bourgeois foreigners trading here … Everything in the USSR must work for
the benefit of the proletariat. Give advertising some thought!' (in Anikst, p.23)

His point was taken, and under the name of 'Advertisement-constructor
Mayakovsky-Rodchenko' he and his friend and collaborator Alexander
Rodchenko produced, for a number of state enterprises, about 50 posters and
100 signs, package designs, and illustrations, all of which taken together may
represent the single most influential contribution to European commercial art of
the 20th century. (Figs. 122, 123)

Left
124. SHASS-KOBELEV
Lenin and Electrification, USSR, 1925. Lithograph. Courtesy:
Vitaly P. Sitnitsky, http://eng.plakaty.ru/

Below left
125. ALEXEI GAN (1893–1940)
First exhibition of contemporary architecture,
USSR, 1927. Letterpress, 107 x 71cm (42 x 28in.). Courtesy:
Vitaly P. Sitnitsky, http://eng.plakaty.ru/

Gan was the leading theorist of Constructivism, publishing
his text *Constructivism* in 1922. He helped organise the
First Exhibition of Contemporary Architecture, held in
Moscow in 1927, for which he designed this poster. The
layout demonstrates his approach to typography, involving
extreme variation in scale, creative use of space, and the
characteristic Constructivist method of building up the
image out of discrete elements – in this case letters, words
and blocks of text.

Naturally, a strong relationship existed between this advertising
agitation and the political agitation which was being produced at the
same time. State advertising was an opportunity to present political ideas
in the form of easily understood propaganda, and to invite the consumer
to support the collective by buying from state-owned enterprises.
Inevitably, a whole range of commodities received Soviet branding: Red
Front cigarettes, Red October biscuits, Red Moscow perfumes, etc. This
relationship helps account for the unique power of the Constructivist
designs - the strident tone of voice, the exclamation marks, the
agitator's pose, diagonal lines and bright colours - which are
characteristic of both the commercial and political Soviet graphic art of
the twenties. (Figs. 124-129)

Towards the end of the 1920s the role of the radical arts in Soviet
culture came under scrutiny. In truth many of the hardliners in the
Communist party, including Lenin himself, had never been comfortable
with the bohemian lifestyles and unpredictability of the avant-garde, and
associated their work with the 'decadent bourgeois styles' which had
been current in the West before the revolution. It was also suggested
that non-representational art, which the proletariat could not
understand, was inappropriate as an instrument of state propaganda.
After Joseph Stalin took control it became increasingly difficult for avant-
garde artists to secure official commissions, and in 1932 Socialist Realism
was adopted as the official art style of the Soviet Union. Certain aspects
of the Constructivist style, such as photomontage and diagonal
composition, continued to be used in propaganda material, but the days
of abstraction were over. As for the avant-garde artists, a few adapted
and worked on; many sank into obscurity, or escaped to the West. Some
were sent to labour camps. Vladimir Mayakovsky, the brightest light of
them all, committed suicide in 1930.

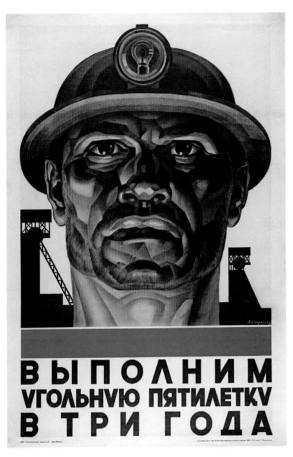

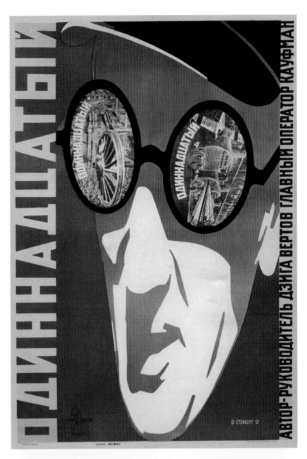

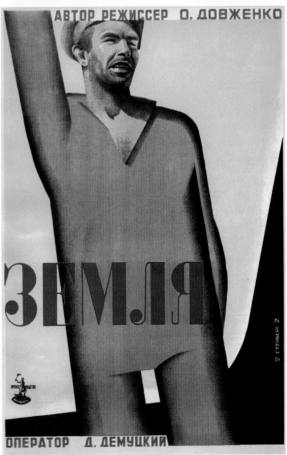

Opposite
126. GUSTAV KLUTSIS (1895–1938)
Marx and Lenin – 'Without a revolutionary theory, a system of party enlightenment cannot exist', USSR, 1927. Lithograph, 107 x 71cm (42 x 28in.). Courtesy Vitaly P. Sitnitsky, http://eng.plakaty.ru/

Klutsis was one of the Soviet pioneers of photomontage, an early experimenter with double exposure and photogram. The work for which he is best remembered commemorated revolutionary anniversaries and political events, often featuring Marx, Lenin and Stalin.

A Latvian, he was arrested by the Stalin government in January 1938 under suspicion of having participated in a Latvian fascist–nationalist organisation, and was executed three weeks later.

Above left
127. VSTRACHOV
Fulfil the five-year plan for coal in three years, USSR, 1931. Lithograph, 105 x 69cm (41 x 27in.). Courtesy: Vitaly P. Sitnitsky, http://eng.plakaty.ru/

Above right
128. VLADIMIR STENBERG (1899–1982) & GEORGII STENBERG (1900–1933)
Eleventh – film poster, USSR, 1928. Lithograph, 94 x 67cm (37 x 26in.). Courtesy: Vitaly P. Sitnitsky, http://eng.plakaty.ru/

The Stenberg brothers, initially active as Constructivist sculptors, subsequently worked as theatre designers and architects, but are now best remembered for their brilliant avant-garde cinema posters for which they won a prize at the International Exhibition of Decorative Arts in Paris in 1925. Still radical and exciting today, these designs incorporated a number of innovations – distorted scale and perspective, Dada-style photomontage, dynamic typography and colour – all of which were imitated by others later.

The two famously inseparable brothers worked together till Geogii was killed on his motorbike in 1933.

Bottom right
129. VLADIMIR STENBERG (1899–1982) & GEORGII STENBERG (1900–1933)
The Land (film poster) USSR, 1930. Lithograph, 94 x 67cm (37 x 26in.). Courtesy: Vitaly P. Sitnitsky, http://eng.plakaty.ru/

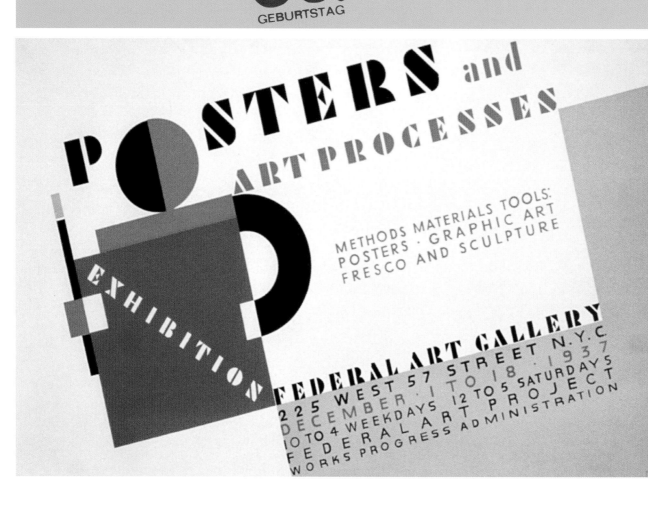

Between the wars

130. HERBERT BAYER (1900–85)
Exhibition poster, Dessau, Germany, 1926.
Letterpress, 65 x 48cm (25 x 19in.). Private
collection.

131. RICHARD FLOETHE
Posters and Art Processes, Federal Art Project,
NYC, NY, USA, 1937. Screenprint. Library of
Congress LC-USZC2-971.

The design of this advertisement for an FAP art
exhibition clearly shows the influence of the
Bauhaus, which its author attended in Weimar
before immigrating to the US in 1928. Its clean
rectilinear style and emphasis on the
participation of typography in the overall
composition reflect the Bauhaus philosophy of
design for machine production. Richard Floethe
was administrator and art director of the New
York City poster division of the FAP from 1936
to 1939 (see p.135).

The vivid demonstration of the potency of propaganda during the First World
War led to widespread concern in the western democracies. In America, despite
clear evidence that the government there was capable of manipulating public
opinion, the discussion tended to focus on the implications for democracy of the
union of private institutions, particularly the big manufacturing corporations, and
the new professions of mass communication. In Europe, where the gap between
state and people was perhaps wider, the problem was discussed in terms of the
potential dangers of state-controlled propaganda. A great deal of academic
research went on, some of it designed to influence public policy, and those
concerned by the ability of the mass media to establish direct contact with the
public, bypassing the traditional socialising institutions, such as the church, family
and schools, did try to raise the moral issue, but as the media developed into
powerful institutions, tied to the politicians and corporate leaders by mutual
dependence, the propagandists were allowed to develop their skills unchallenged
and unregulated.

Officially ignored but never fully extinguished, public fear of media
manipulation would resurface later in the 20th century when, in the depths of
Cold War paranoia, uncomfortable parallels would be drawn between North
Korean 'brainwashing' techniques and advertisers' alleged abuse of psychological
research.

Between the wars, commercial art in Europe flourished. Graphic design began
to emerge as a distinct profession, and leading designers codified the principles
of modern practice. (Jan Tschichold for example, published his highly influential
book, *New Typography*, in 1928.) In 1919 the architect Walter Gropius, who had
begun his career working with Peter Behrens, opened the Bauhaus School of
Design in Weimar.

The fundamental aim of this pioneering institution was to bring together the
arts and industry (while Gropius was influenced by the ideals of William Morris
and the English Arts and Crafts Movement, he had no interest in medieval
handicraft). Its outlook was strictly urban, technological and dedicated to design
for mass production in the Machine Age. In practice the Bauhaus teachers sought
to codify the advances in art, architecture and design achieved by the European
avant-garde before the war, drawing on Cubism, Futurism and De Stijl to develop

This celebrated image created a sensation when it
appeared. Advertising a Pullman train service, it shows no
train, no destination and only the most rudimentary of
landscapes. Instead the artist offers a homage to Machine
Age travel rendered with rigorous economy of means and
a dynamic perspective which sucks us into the image
towards our destination.

not a Bauhaus style (the idea of style was now
declared redundant), but a Bauhaus way of thinking, a
rational and efficient approach to design for machine
production, stripped of sentiment and decoration. El
Lissitsky, who exhibited in Germany and translated key
Russian manifestos into German, maintained close ties
with the Bauhaus staff. This relationship ensured that
Russian Suprematism and Constructivism also
profoundly influenced Bauhaus thinking.

The Hungarian artist László Moholy-Nagy was
largely responsible for the Bauhaus approach to
graphic design, and in 1923 he began to develop a
new Bauhaus typeface which would reflect the rational principles of the
school. Partly derived from Dada and De Stijl through the work of Kurt
Schwitters and Theo van Doesburg, it featured an absence of both
capitals and serifs. It was implemented (a full set of fonts created and
the face actually applied to printed material) by Herbert Bayer in 1924 as
the 'Universal Typeface'. (Fig. 130)

Brilliantly marketed, the Bauhaus achieved a reputation far beyond its
provincial reality. The uncompromising vision of its staff provided a focus
for modern design all over the world and helped establish an alternative
to the predominantly decorative output of commercial art even after it
was forced into closure by the Nazis in 1933.

Indeed, throughout Europe designers began to introduce the ideas of
formal and constructive design into their work. In France, Charles
Loupot, Paul Colin, and Jean Carlu all produced interesting work, but
perhaps the outstanding figure there was A.M. Cassandre. Working for a
variety of commercial clients he produced designs full of ideas, simplified
to sign-like clarity, and perfectly balanced in form and tone. (Fig. 132)

In Britain a number of artists, among them Tom Purvis and Frank
Newbould, developed a simple, flat-colour style in their work for the
railways and holiday resorts which proved popular and remained so until

134. PETER BRANFIELD
E. McKnight Kauffer, poster art 1915–1940, 1973.
Screenprint, 76 x 51cm (30 x 20in.).
© Victoria and Albert Museum, London.

To create a poster for a travelling exhibition of McKnight Kauffer's work organised by the V&A, Branfield redrew one of McKnight Kauffer's poster designs, *Soaring to Success! Daily Herald – the Early Bird*, which had relaunched the Labour Party's newspaper in 1919.

after the Second World War. Reminiscent of the flat-colour technique of Ludwig Hohlwein, the style drew on the British landscape tradition, producing romantic and calm views perfectly suited to the purpose of attracting the public to places of interest and recreation.

Edward McKnight Kauffer, an expatriate American, was probably the most internationally recognised commercial artist working in Britain at that time. A versatile and imaginative designer who drew on all of the modern trends, he consistently produced commercial art of the highest quality throughout the interwar period, most notably for Frank Pick at London Transport and for the Shell Oil Company. (Figs. 133, 134)

As the power of the Nazis grew in the 1930s it became more and more difficult for avant-garde artists to work in Germany. Many emigrated to other countries, and when the Bauhaus was closed in 1933 a number of the staff left for Britain and the United States. The presence and teaching activities of these highly respected and gifted individuals - Gropius, Marcel Breuer, Joseph Albers, Johannes Itten, Moholy-Nagy, Mies Van der Rohe - played an important role in the dissemination of modernist design practice in America. Despite the effects of the Depression, they and many other European immigrant artists did find work as the New Deal began to pump energy back into the stricken economy.

WPA

135. ARTIST UNKNOWN
Behind the Headline, Federal Art Project, Illinois, USA. 1939. Screenprint. Library of Congress LC-USZC2-1016.

Here the bits of image and graphics which make up the picture are organised into a shallow picture space in the manner of Synthetic Cubism – cool and intellectual. In contrast, the word 'extra' in the centre of the picture is rendered in an animated, commercial and unmistakably American style, making this poster a good example of the synthesis of European Modernism and American commercial art which the FAP artists helped develop.

The collapse of the American stock market in October 1929 and the Great Depression which followed resulted in economic hardship for millions of people. By 1933 almost a quarter of the working population of the United States was unemployed. President Roosevelt, recently elected on a promise to provide social relief, launched the New Deal, a raft of measures designed to reform the financial sector and stimulate economic recovery, which in its scale was unprecedented in American history. Chief among the agencies of the New Deal was the Works Progress Administration (later changed to Works Projects Administration), the WPA, which aimed to provide jobs and income for as many of the unemployed as possible through investment in public works. Between 1935 and 1943 the WPA created nearly eight million jobs, investing over $11 billion on a range of projects which included not only the great capital projects - the public buildings, roads and bridges for which the agency is now best remembered - but educational and welfare initiatives such as feeding children, distributing clothing and providing housing for displaced families.

It need hardly be stated that artists were not immune to the effects of the Great Depression. The Federal Art Project (FAP) was set up to help the thousands of artists around the country who were struggling to survive by commissioning work from them: paintings, sculpture, murals in public buildings and a range of initiatives involving the graphic arts. Committed to making the arts accessible to all, the FAP also organised exhibitions, and established a network of community art centres and classes throughout the country.

In 1935 the FAP set up a poster division in New York to publicise a range of social issues, such as health and safety, and to promote its own activities as well as those of various government departments. As the WPA gathered momentum there was a lot to publicise. By 1938 regional offices of the poster division had been opened in 18 states to help cope with demand, and the hand-lettered and hand-painted techniques of the early days were abandoned in favour of the silkscreen process, which offered much-improved quality and productivity.

In line with its remit, which focused on the welfare of the artists rather than the art itself, the FAP did not stress the value of individual expression. In fact collaborative work was encouraged and many of the posters are unsigned. Neither were the issues of style or artistic quality of primary concern, though

From left to right
136. LOUIS B. SIEGRIEST
Antelope Hunt from a Navajo Drawing. New Mexico, Federal Art Project, California, USA, 1939. Screenprint, 91.6 x 64cm (36 x 25in.). Library of Congress LC-USZC2-1771.

This is one of a series of eight posters featuring Native American cultures produced for the Indian Court exhibit at the Golden Gate International Exposition held in San Francisco. The artist created the images from examples of the arts and crafts of various tribes provided by the Bureau of Indian Affairs.

137. PHIL VON PHUL
Smoking Stacks Attract Attacks. Don't Invite Disaster. Federal Art Project, Washington, USA, 1941–43. Screenprint. Library of Congress LC-USZC4-5065.

American shipping was vulnerable to attack by Axis submarines in both the Pacific and Atlantic Oceans in the early years of the war. FAP artists produced a number of posters on the subject, mostly reminding civilians to keep quiet about shipping movements. In this one Phil von Phul drives home the message with one of his characteristic snappy texts.

138. ROBERT MUCHLEY
Work With Care, Federal Art Project, Pennsylvania, USA, 1936–37. Screenprint. Library of Congress LC-USZC4-5044.

The FAP produced a number of posters on the subject of safety in the workplace. This one, featuring a riveter at work, evokes the physical demands, the noise and the stress of the industrial environment. The artist has chosen to work in a style reminiscent of the European Futurists, whose work celebrated the speed and energy of the machine age.

other factors were at work in that respect. A number of the artists involved in the posters division were immigrants, talented people who brought knowledge of the European avant-garde with them. Also, the social purpose of the work freed it from the constraints normally present in the commercial-art market and, crucially, enlightened administrators like Richard Floethe, who himself had studied at the Bauhaus, encouraged experiment in the new silkscreen medium.

The resulting output, some 35,000 designs in all, contributed significantly to the evolution of the graphic arts in America, joining the principles of modern art with American advertising know-how. At the time the posters were ignored by the art-historical establishment, which is understandable enough. The product of a government relief programme, produced in an as-yet-unconsecrated and ephemeral medium, and dealing with unglamorous subjects like personal health and adult education, the WPA posters had no highbrow credentials. But the passage of time has revealed their worth and not just as valuable cultural documents. The best of the work is vital, colourful and new, and represents some of the outstanding American graphic art of the 20th century. It also records a unique moment in American art generally: the return of confidence to an artistic community which was to emerge in the post-war period as a dominant force in the world art business.

The WPA and the FAP always attracted conservative criticism. The autonomy of the FAP and the scale of its activities were curtailed in 1939, and in 1942 the poster division was transferred to the Defence Department to concentrate on war-related subjects. By 1943 war production had eliminated unemployment in the US. Its work done, and its place in the history of humane administration secure, the WPA was shut down by Congress. (Figs. 135-141)

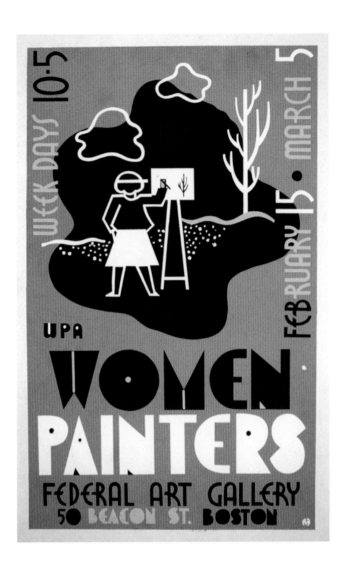

Above left
139. Monogram 'RW' (MAYBE RUSSELL W. WEST)
WPA Women Painters, Federal Art Project, Boston, MA, USA, 1938. Screenprint. Library of Congress LC-USZC2-904.

Bottom Left
140. ARTIST UNKNOWN
Keep Your Teeth Clean, Federal Art Project, Rochester, NY, USA, 1938. Screenprint. Library of Congress LC-USZC2-1016.

This unsung hero has arranged the drastically simplified essentials of the issue into a stylish and witty composition.

Above right
141. M. LEWIS JACOBS
Prevent syphilis in marriage, Federal Art Project, New York, USA, 1940. Screenprint. Library of Congress LC-USZC2-5379.

Over 40 of the WPA posters in the Library of Congress collection deal with the issue of syphilis, and the variety of styles among them reflects the diversity of the target audience. Soldiers and industrial workers are told to 'Stamp Out Syphilis' or that 'Syphilis is the Enemy' in bold designs, whereas this one, to married couples, combines its plain message with a more sensitive, almost spiritual approach to the graphics.

AL FRONT!
CNT · FAI

The Spanish Civil War

142. CARLES FONTSERÉ (1917–2007)
Al Front, C.N.T., F.A.I., Spain, 1936–37.
Lithograph, 32 x 22cm (12 x 8in.). Courtesy:
Southworth Collection, University of California,
San Diego.

The head of a Republican soldier is skilfully
rendered in a dramatic red light. His upward
gaze and the line of his shoulders follow the
same rising angle as the short text, 'To The
Front' – seven letters in a compact, stylish
design, locking the figure into its frame. With
these simple elements the artist, Carles
Fontseré, conveys strength, commitment and an
urgent call to action.

The CNT was the largest workers'
organisation in Spain at the time of the Civil
War. The FAI, the Federación Anarquista Ibérica,
formed in Valencia in 1927, was considered to
be the radical ultra-left inner core of the CNT,
committed to creating a Soviet-style revolution,
and opposed to any form of accommodation
with the less extreme parties of the left.

Following the agrarian and anti-clerical reforms introduced by the government of
the Second Spanish Republic in 1932, the political system in Spain began to fall
apart. Despite the good intentions of some of the reforms, such as universal
suffrage and the alleviation of the absolute poverty suffered by millions of
landless peasants, a powerful minority - the landed gentry, clerics, monarchists
and conservatives - strongly opposed them, particularly the punitive measures
imposed on the Church. Amid the universal gloom of the Great Depression and
the rise of Fascism in neighbouring states, a culture of confrontation and violence
settled over public life in Spain and began to drive the country towards open
conflict. Two elections, in 1933 and 1936, failed to improve the situation. Radical
groups on both sides became openly aggressive, and against a background of
strikes, civil disorder and assassination, a group of right-wing army officers
launched a long-contemplated military coup against the government on 17 July
1936. The resulting civil war completed the process of political polarisation in the
country. No common ground remained between two irreconcilable factions which
would fight to the death to produce either a fascist military dictatorship or a
socialist republic.

Initially the rebels gained control of about a third of the country but were
resisted elsewhere, particularly in the cities, where radical trade unions had
organised and armed popular militia forces. With the government paralysed and
the armed forces mostly lost to the rebels, these revolutionary socialist
organisations effectively took control of the Republican-held areas. But there was
no coherent plan and not even a common goal among them. The more extreme
organisations, notably the anarcho-syndicalists of the CNT (Confederación
Nacional de Trabajo), had no intention of restoring the current government but
saw the war as an opportunity to pursue their own aims of total revolution. The
Communist Party (PCE), in contrast, was more prepared to work within the
system and concentrate its efforts on beating the fascists. This lack of basic
solidarity, and the internal conflicts which it generated, would significantly
damage the Republican cause.

The volatile and confused situation in the early days of the war generated an
urgent need for all parties to communicate with the civil population - to support
the revolution (CNT), to join the fight against the fascist rebels (PCE), and to

Above
143. JOSEP RENAU (1907–1982)
Today more than ever, Victory, SubPro. Graf.
Ultra, SA, Córcega, 220, Barcelona, 1937.
Lithograph, 99 x 138cm (39 x 54in.). Courtesy:
Southworth Collection, University of California,
San Diego.

Issued in Barcelona late in the war, perhaps to
revive the flagging morale of the population of
the city, which was being heavily bombed by
the fascists at the time, this image shows the
Republican air force in symbolic V formation.
The air force, which largely remained loyal to
the Republic throughout the war, and
depended on the Soviet Union for equipment
and training, was known to have strong
communist sympathies.

Josep Renau was a prominent figure in the
world of art and politics in Republican Spain. A
communist, he was named Director General of
Fine Art in the government of 1936 and in that
capacity was responsible for the evacuation of
artistic treasures from the Prado Museum in
Madrid to relative safety in Valencia. He is also
credited with having secured the services of
Pablo Picasso to paint a mural for the Spanish
Pavilion in the Paris International Exhibition of
1937, which resulted in the creation of the
Guernica. Renau was a successful artist himself.
An admirer of the German John Heartfield, who
also dedicated his artistic career to political
causes, Renau probably picked up the technique
of photomontage from him and introduced it to
Spain. After the war he found refuge in Mexico
where he collaborated with the great Mexican
muralist Alfredo Siquieros on a mural for the
Union of Electricians in Mexico City.

Below
144. GIRÓN
Evacuate Madrid, Junta Delegada de Defensa de
Madrid, Delegación de Propaganda y Prensa.
1936–37. Lithograph, 100 x 69cm (39 x 27in.).
Courtesy: Southworth Collection, University of
California, San Diego.

When Madrid was first attacked by rebel forces
in November 1936, about a quarter of a million
of its citizens fled to safety in the east, most to
Valencia. Despite this, the capital city became
dangerously overcrowded by the influx of
refugees fleeing the conflict in the south.
Fearing high civilian casualties from the
frequent aerial bombardments, and conscious
that the front line of the ground war was never
far from the city, the Republican authorities
launched a propaganda campaign to encourage
people to leave. Remarkably few did, despite
the death and destruction which surrounded
them, and the constant shortages of food and
fuel.

Here a panic-stricken mother and child look
skyward before a shattered urban landscape.
The full message is, 'Don't let your family
experience the drama of war. The evacuation of
Madrid contributes to the final victory.'

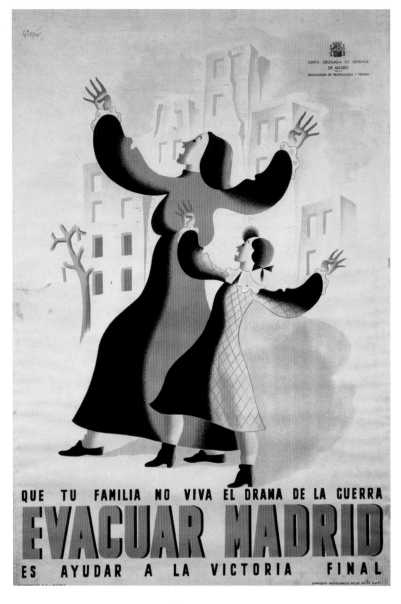

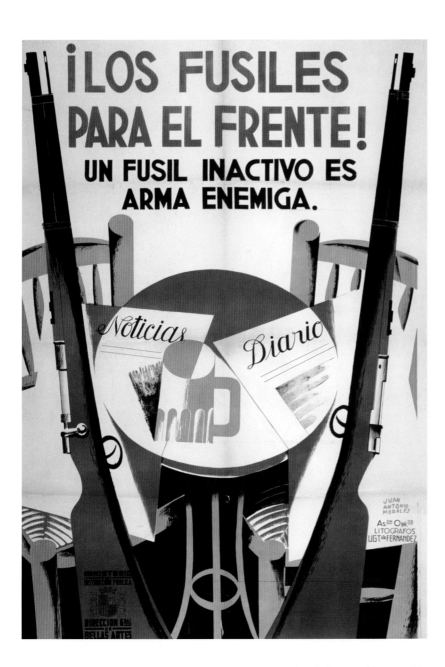

145. JUAN ANTONIO MORALES (1912–1984)
Los fusiles para el frente, Ministerio de Instrucción Pública, Spain, 1936. Lithograph, 100 x 70cm (39 x 27in.). Courtesy: Southworth Collection, University of California, San Diego.

We are in a café, a familiar feature of Spanish daily life, yet instead of patrons sitting at the table we find two rifles, two German Gewehr 98s. By putting the tools of war where they should not be, the artist captures our attention and constructs a disturbing metaphor for the particular intimate horror of a civil war.
This poster deals with a specific problem facing the Republican authorities at the time. Early in the conflict the government had distributed arms to the civilian population in an attempt to contain the fascist military rebellion. This desperate measure put some guns into the wrong hands and many more into idle ones. Hence the message, 'An unused gun is an enemy weapon.'
 The tabletop view, shown in flattened perspective and multiple viewpoints, owes something to Cubism, a movement in which Spanish artists played a prominent role. Pablo Picasso was its co-inventor, and Juan Grís is remembered as one of its most dedicated practitioners.

prepare the defence of key positions. Radio and the press played an important part in this propaganda drive, but the key medium for the spontaneous defiance of the people was the poster, examples of which sprung up in their hundreds on city streets throughout the country. (Figs. 142-144)

As it became clear that the coup was not going to succeed immediately and that a lengthy war was in prospect, the propaganda began to reflect longer-term needs: to improve productivity in the fields and factories, to practise frugality in household management, or to contribute to charitable causes. The radical socialists also produced propaganda which addressed the ideological preparation of the people, and if some of this material did not meet with the approval of all the various factions fighting in the Republican cause, one topic was sure to unite them. Everyone could join in the vilification of the enemy. (Figs. 145-147)

From the outset this very brutal war put the civil population in the front line. Atrocities were routinely carried out by both sides. With the help of their German

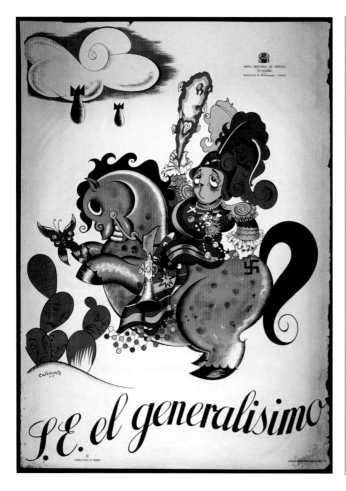

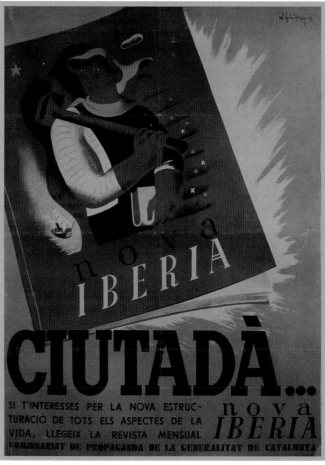

Left
146. ANTONIO CAÑAVATE
El Generalissimo, Delegación de Propaganda y
Prensa, Madrid, 1936. Lithograph, 112 x 80cm
(44 x 31in.). Courtesy: Southworth Collection,
University of California, San Diego.

Caricature is not a common device in posters
from the Spanish Civil War, but this is a good
example of it. Laden with symbols and literary
references, it lampoons the leader of the fascist
forces, and later dictator, Francisco Franco. The
Generalissimo is portrayed as a fat, effeminate
little creature, in a comic-opera military outfit,
trying to impress but looking ridiculous. He is
sitting on an equally fat little horse which is
about to trample some cactus bearing the faces
of his enemies.
 Making a horse reflect the character of its
rider is not unknown in Spanish literature.
Cervantes did it brilliantly with Don Quixote
and Rocinante, and here the artist uses the toy
horse, grinning madly while trampling, to
remind us that all is not well in the nursery, a
feeling reinforced by the swastika on his rump
and the falling bombs.
 The design of the club in Franco's hand
suggests a Spanish playing card, El Caballo de
Bastos (the Jack of Clubs), and may also refer to
a card from the Lower Arcana of the Tarot, The
Knight of Wands, which, according to some
interpretations, represents a figure full of
misdirected energy who wishes to consume the
world.

and Italian allies, the Nationalists showed no hesitation in attacking civilian areas.
Madrid was systematically bombed, and the wholesale destruction of the Basque
town of Guernica by the bombers of the Nazi Condor Legion shocked the world
and gave it a grim foretaste of what was to come in the Second World War. It
also provoked the creation of the most enduring image of the war, and arguably
the most famous example of propaganda art ever produced.

 By the end of 1936 it was clear that without help from outside, Spain would
fall to the fascists. The Paris World Fair planned for the following year offered a
unique opportunity to draw international attention to the situation, and the
organisers of the Spanish Pavilion, conscious of the need to do something
special, approached Pablo Picasso, by then the most famous living artist in the
world, to paint a mural for it. In January 1937 he agreed, but it was not until the
bombing of Guernica, a target of no military significance and the spiritual home
of the Basque people, that Picasso found the inspiration, the outrage, that he
would need. In the five weeks following 27 April, he produced the enormous
canvas, the culmination of his life's work, in time for the inauguration.

 Between 1500 and 2000 posters were created on the Republican side in the
course of the war, mostly lithographs in editions of 3000 to 5000. The
Nationalists produced fewer, and these were generally of inferior quality, which is
probably a reflection of the fact that the artistic community was more inclined to
support the Left and that for most of the war the centres of design and print

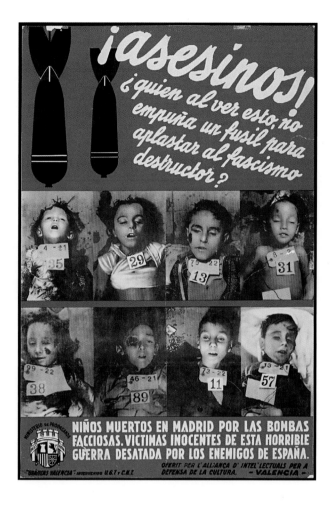

Opposite right
147. RAMON FÁBREGAS (1915–1981)
Nova Iberia, Comissariat de Propaganda de la
Generalitat de Catalunya, c.1937. Lithograph,
100 x 70cm (39 x 27in.). Courtesy: John Gilmour
Collection.

This is an advertising poster for the magazine
Nova Iberia, a literary periodical published by
the Department of Propaganda of the state
legislature of Catalunya during the civil war
period. A high-quality publication, printed in
four languages and distributed internationally,
it was an important part of the Republican
effort to generate international support. While
this poster itself was designed by Fábregas, the
illustration on the cover of the magazine (the
first issue) was the work of another Catalan
artist, Antoni Clavé. The full text reads, 'If you
are interested in the new structure of every
aspect of life, read the monthly magazine *Nova
Iberia*'.

Right
148. ARTIST UNKNOWN
The Children of Madrid, Ministerio de
Propaganda, Valencia, 1937. Lithograph. Private
collection

The propagandists of the 20th century learned
that when dealing with atrocity subjects such as
this, maximum impact is obtained through the
shocking reality and 'eyewitness' veracity of the
photographic image. The consequences of
indiscriminate aerial bombardment could hardly
be more painfully portrayed than by these
matter-of-fact records. The full text reads,
'Assassins! On seeing this, who would not pick
up a gun to crush the fascist destroyer?' And,
'Children killed in Madrid by fascist bombs.
Innocent victims of this horrible war unleashed
by the enemies of Spain.'

production were in Republican hands. In artistic quality and visual impact the best
of the Spanish Civil War posters are as good as anything produced in the 20th
century. As might be expected, much of the Republican design shows the
influence of the Soviet Constructivists. Powerful, simple, often employing dynamic
and diagonal compositions and photomontage, they capture the same sense of
heroic ideological optimism as the work of the young Russian artists some 20
years earlier. (Fig. 147)

Towards the end of the war production began to tail off. Paper and ink were
becoming scarce and many of the artists had gone off to the front. By the end of
1938 the Republican cause was on its last legs. The signal failure of the western
democracies to come to the aid of the legitimate Spanish Government and the
contrasting eagerness of the fascist states to help the rebels provided the latter
with a winning advantage. Barcelona fell on 25 January 1939 and Madrid on 28
March after resisting heroically for two years on the front line. General Franco
proclaimed victory for the Nationalists on 1 April and ruled over a bitterly divided
country for the next 36 years. (Fig. 148)

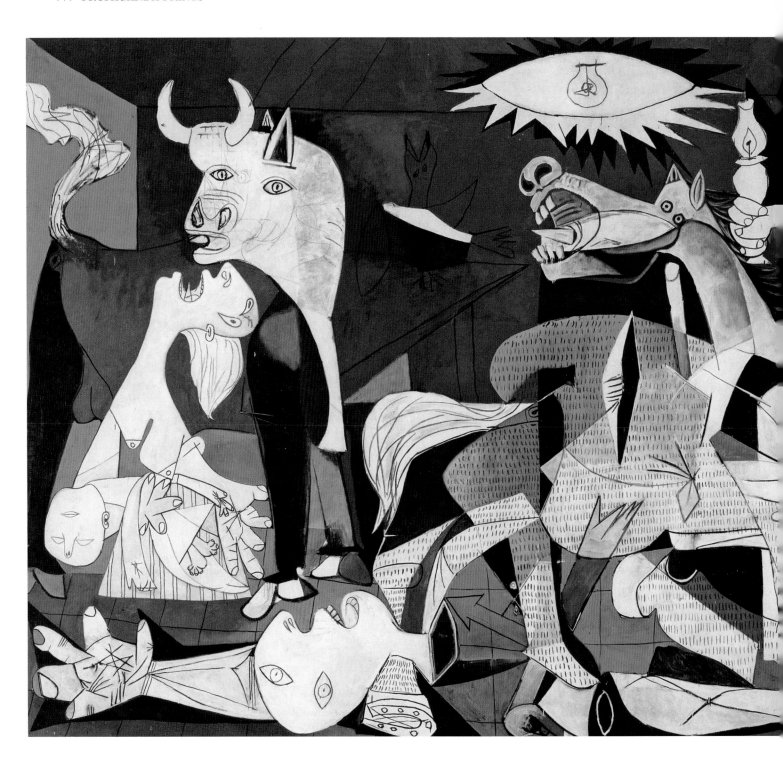

149. PABLO PICASSO (1881–1973)
Guernica, Spain, 1937. Oil on canvas,
349.3 x 776.6cm (11ft 6in. x 25ft 6in.). Museo
Nacional Centro de Arte Reina Sophia, Madrid

During the month of May 1937 Picasso
ransacked his store of symbols and characters,
emptying himself out in response to the
greatest challenge of his artistic life. The
bullfight, the life of the Minotaur and the
Crucifixion are there, as are pain and death and,
in common with every great work of art, beauty
and consolation. After it left his studio *Guernica*
took on a life of its own, becoming a symbol of
peace and the folly of war. It travelled the
world, to be seen by millions and in the process
become one of the most familiar images ever
made. But, as Gijs van Hensbergen concludes in
his fine biography of the picture, '*Guernica*'s
power to shock has, despite the millions of
reproductions, never gone away. Its rejection of
human barbarity and its cry for liberty and
peace remain as insistent today as the day
Picasso put down his brush back in 1937.'

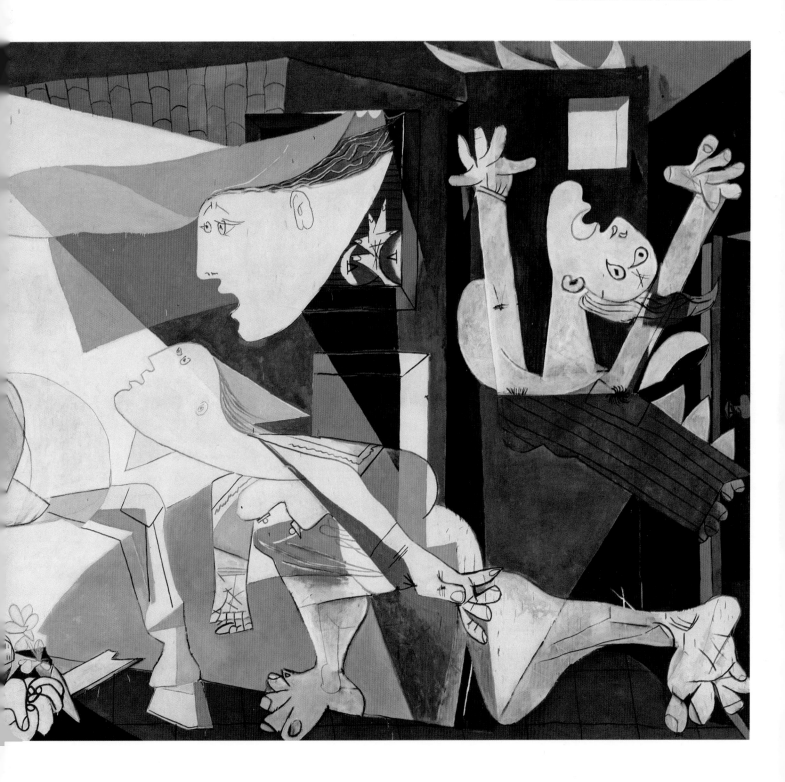

The Nazis

Hitler's vision of a Third Reich which included all
ethnic Germans prescribed a foreign policy of
aggressive expansion. The Rhineland was
reoccupied in 1936 and Austria was absorbed by
means of the *Anschluss* of 1938. It was not until
the Nazis began to invade territories occupied
by non-German peoples, Czechoslovakia and
Poland, that the western powers realised that
war was inevitable.

 This simple and effective image of the Führer
in profile against a red background neatly
expresses the cult of personality which
surrounded him.

This portrait draws on chivalric iconography to
depict the Führer as the leader and champion of
the German people. The work was first
displayed at the Great German Art Exhibition in
Munich in 1937 and later reproduced in
postcard and poster form. It was seized along
with around 10,000 other works of Nazi
propaganda art by the US Army as part of the
drive to 'de-nazify' German society after the
war, and remains in American custody today.
The damage to the face was caused by the
bayonet of an American soldier.

The miserable living conditions endured by the German people after the end of
the First World War, which were aggravated by the punitive demands of the Treaty
of Versailles, created a perfect environment for the cultivation of extreme political
views. While many Germans embraced socialist and communist principles, another
very different political force emerged in the post-war period. Promising to restore
the country to its former greatness, to its ancient racial purity, and to challenge
the right of its former enemies to exact a prolonged retribution, the charismatic
Nazi leader, Adolf Hitler, offered hope, a better life and the promise of self-
determination to a broken and demoralised people. (Fig. 152)

 Hitler, who had observed the effectiveness of British propaganda as a soldier in
the war, was convinced of its importance. In fact two whole chapters of his book
Mein Kampf are dedicated to propaganda, in which Hitler offers five principles
for its effective management.

i	Avoid abstract ideas and appeal instead to the emotions. (This is the opposite of the Marxist view.)
ii	Employ constant repetition of just a few ideas, using stereotyped phrases and avoiding objectivity.
iii	Put forth only one side of the argument.
iv	Constantly criticise enemies of the state.
v	Identify one enemy for special vilification.

(Jowett and O'Donnell, p.230)

So consistently were these principles applied that they played a fundamental role in
the growth of National Socialism, and Hitler himself based his entire career on
carefully planned propaganda, a characteristic which he shares with other great
propagandists in history such as Julius Caesar and Napoleon. Like them, too, he
was a brilliant communicator with a natural ability to inspire loyalty and exploit the
media. He believed, tragically for the world, that the masses were weak and
malleable and that the effectiveness of propaganda could be greatly enhanced if
supported by terror and intimidation. He also insisted - perhaps a legacy of his
training in art as a young man - that visual presentation was of fundamental
importance. So it was that Nazism, as brutal and depraved a regime as the world
has ever seen, was provided with one of the most effective corporate identities ever

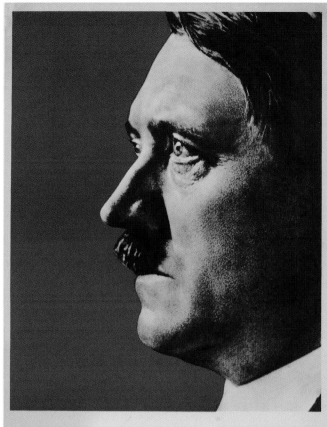

Ein Volk - ein Reich - ein Führer!

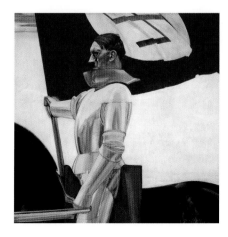

devised. Laden with symbols - eagles, swastikas, flags - and emotive gestures - the Heil salute, the goosestep walk - Nazism drew freely on Imperial Rome, ancient Aryan mythology and esoteric references to produce a compelling militaristic cult at the heart of which was the figure of Hitler himself, the Führer, the charismatic leader who could do no wrong. (Figs. 150, 151)

Joseph Goebbels, who became Hitler's propaganda minister, and the chief executive of the Nazi propaganda operation, believed that through the faithful implementation of the Führer's ideas anything was possible. According to him 'It would not be impossible to prove with sufficient repetition and psychological understanding of the people concerned that a square is in fact a circle. What after all are a square and a circle? They are mere words and words can be moulded until they clothe ideas in disguise.' (Goebbels's own words, quoted in Philip M. Thomson, p.111)

By 1925 the Nazis had gained control of much of the German press, and through such organs as Volkische Beobachter and Das Reich spread Nazi ideas - particularly anti-Semitism and anti-Communism - and reported on the activities of the party. But the written word was not adequate to transmit the unique emotional appeal of Hitler's extraordinary ranting speeches, or the constantly repeated Nazi slogans and music. That function was fulfilled by the radio, the new mass medium which the Nazis were to make their own and which was to play a critical role in the moulding of German public opinion before and during the Second World War. So committed were the Nazis to the use of radio that they developed a cheap, single-wavelength receiver for mass distribution. The 'people's receiver', the Volksempfänger, was promoted intensively and the installation of radio was made compulsory in many public places. By 1939, 70% of all German households had a radio, the highest ratio in Europe.

After 1933, when the Nazis took power in Germany, all effective political opposition was eliminated. Anti-Semitism and anti-Communism were stepped up in one of the most intense domestic propaganda campaigns ever undertaken. Every possible medium was exploited, including the poster, which was used

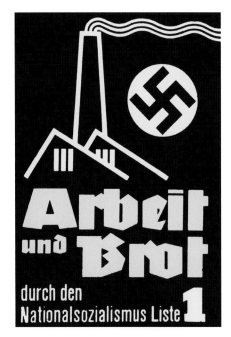

Above top
152. ARTIST UNKNOWN
Work and bread through National Socialism,
Nationalsozialstische Deutsche Arbeiter-Partei,
Germany, 1932. Lithograph. Private collection

This poster was produced for the elections held
in November 1932. The basic promise of work
and bread gives some indication of the troubled
state of the economy at the time.

Above bottom
153. ARTIST UNKNOWN
*The German Pavilion at the Paris World Fair of
1937*, Paris, France, 1937. Photographic
postcard. Private collection

Designed by Albert Speer, the German pavilion
stood opposite the Soviet pavilion, an uncannily
similar monument to the totalitarian ideal. The
Germans intended that the pavilion should
remain after the exhibition as a permanent
'sacred piece of German earth', a prospect
which may not have thrilled the people of Paris.

extensively throughout the Nazi period. So rich in colour and symbol was the
Nazi visual identity that designers had no trouble in producing powerful graphic
images, and free rein was given to the vilification of the enemies of the regime.
In the arts, only officially sanctioned styles were tolerated. Modern art, needless
to say, was vigorously proscribed. (Figs. 154-156)

Perhaps the most characteristic propaganda device of the Nazi era was the
spectacle, the mass rally attended by tens of thousands of members of Nazi
organisations and the armed forces. Under the direction of Albert Speer, Hitler's
chief architect, these were carefully controlled media events designed to
showcase the new Nazi Germany and provide a context for the cult of
personality surrounding Adolf Hitler. The annual rallies held at Nuremberg, the
symbolic heartland of the Nazi movement, were enormous events lasting a week
or more, and drawing in participants from all over the country. Goebbels
recognised their propagandistic importance, referring in several of his speeches to
the value of taking part, not only as a means of demonstrating support for the
regime but as a substitute for participation in the process of government.

Hitler always took a lively interest in architecture, and encouraged Speer in the
development of his megalomaniac schemes to prepare Berlin and the rest of the
world for the Thousand Year Reich. The approved style, a ruthlessly stripped neo-
classicism, was designed to impress, which at its best it does. At its worst, bombastic
and inhumane, it fills the viewer with a feeling not unlike despair. (Fig. 152)

The Nazi vision was eventually extinguished in the Second World War but it is
remarkable that even now, over 65 years later, interest in the Nazis and
particularly in the personality of Adolf Hitler is undiminished. Clearly the regime
left its mark not only on the minds of the German people, but on those who
were called on to oppose it and the descendants of both. We routinely celebrate
the defeat of the Nazis in battle, but we are less inclined, perhaps in fear of its
repetition, to acknowledge their unqualified success in the propaganda war
which swept them to power.

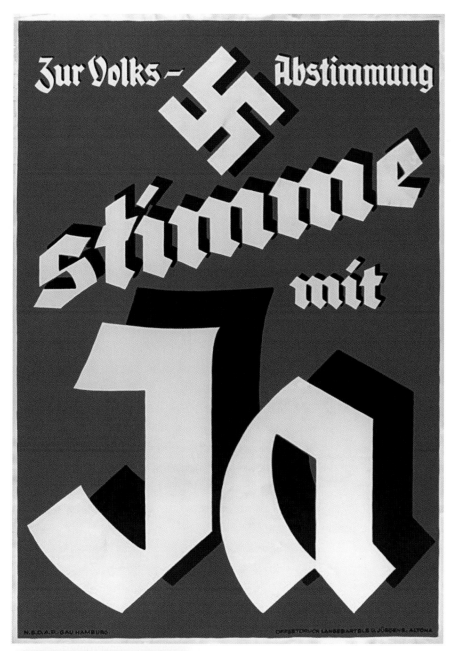

Opposite right
154. ARTIST UNKNOWN
Degenerate art, Munich, Germany, 1937.
Lithograph. Courtesy: Prof. Randolph Bytwerk.

This poster announces the celebrated exhibition of 'degenerate art', i.e. modern art, which the Nazis staged in Munich in 1937. Bringing together a magnificent collection of modern masters confiscated from various sources, the exhibition was a huge success, somewhat to the embarrassment of the regime.

The boorish and oppressive attitude of the Nazis towards modern art led to the flight of many of Germany's finest artists to other countries – Max Beckmann, for example, spent most of the war in Holland before emigrating to America. For those who remained, forbidden to work and thus deprived of their livelihood, life was hard. Some, like Emil Nolde, retired from public life altogether and continued with their work in secret, on a small scale and in perpetual fear of discovery.

Left
155. ARTIST UNKNOWN
In the people's referendum – Vote YES,
Nationalsozialistische Deutsche Arbeiter-Partei, Germany, 1930s. Lithograph. Courtesy: Prof. Randolph Bytwerk

This poster for one of the many referenda carried out in Germany in the 1930s is a good example of the powerful graphic language developed by the Nazis. The combination of black, white and red colours, one of the most effective in graphic art, was frequently used in Nazi propaganda, insignia and flags. In the 1930s the regime promoted the use of the traditional German letterform known as Fractur Blackletter in their propaganda, as seen here. But later, in the early war years, they abandoned it in favour of Roman faces, perhaps because they thought that Fractur, which foreigners had trouble reading, would interfere with their plans for world domination.

Left
156. ARTIST UNKNOWN
The Bolshevik Jew, Nazi-occupied USSR, 1943.
Lithograph. Library of Congress, Prints and Photographs Division, Washington, DC.

This poster was produced by the Nazis for distribution in the Ukraine while they occupied it during the Russian campaign of 1943. It refers to the exhumation, carried out by the Nazis, of the mass grave of over 9000 citizens of the Ukranian town of Vinnitsa, who had been executed by Stalin's secret police during the Great Purge of 1936–38. Intending to stir up both anti-Soviet and anti-Semitic sentiment in the occupied territories, it brings together the two objects of Nazi hatred – the Jew and the Communist – in one menacing but unlikely figure, the 'Jewish Bolshevik Commissar'.

The Second World War

After the experience of the First World War, all parties facing the prospect of this new conflict were well aware of the importance of propaganda. But in the intervening quarter of a century, the means of its application had changed as the revolution in communications had continued. As early as 1922 Radio Moscow was broadcasting with the most powerful transmitter in the world. Three years later it pioneered the use of short-wave transmission, and was busy targeting British workers engaged in the General Strike of 1926 until the government jammed the signals. In 1927 the British Broadcasting Company changed its name to the British Broadcasting Corporation and, inspired by its mission statement, 'Nation shall speak unto Nation', it rapidly developed its Empire Service to allow constant and worldwide communication with the people of the empire. In the USA, General Electric, Westinghouse and RCA bought AT&T's rival network operations in 1926 and reorganised them to form the National Broadcasting Company, a national radio network financially supported by advertising. All over the world in the 1920s and '30s radio brought people and their governments into closer contact than ever before, and the example of the Nazis demonstrated vividly the potential of the new medium to manipulate public opinion.

In 1927 the first 'talking picture', *The Jazz Singer*, thrilled audiences worldwide, and as it grew steadily throughout the next decade the cinema emerged as potentially the most potent of all propaganda media. Both the Soviets and the Nazis made full use of it for that purpose between the wars. In 1928 alone, Sovkino, the Soviet state production company, produced 123 films virtually all of which had propagandistic content and played to huge audiences. In Germany the Nazi film programme produced a number of notable works, such as Leni Riefenstahl's *Triumph of the Will* in 1935, but is best remembered for a vicious anti-Semitic film entitled *The Eternal Jew*, produced by Franz Hippler, the head of the Nazi film unit, and released, it appears, to coincide with the start of the programme of genocide in 1940.

However, though the impact of this film was considerable, evidence exists to suggest that propaganda material needed to be carefully handled in a cinematic context. German people, like people everywhere, went to the cinema to be entertained and to escape from reality, and understandably their appetite for feature-length propaganda, especially of the gruesome sort, had its limits.

157. ARTIST UNKNOWN
Let us go forward together, J. Weiner Ltd,
London, 1940. Lithograph. 76 x 51cm (30 x
20in.). Private collection

In the field of documentary and newsreel
production, on the other hand, German film-makers
of the period had greater success. In the early years
of the war, when the Nazi war machine was
rampaging through Europe, carrying all before it, the
stirring material coming back from the front was
skilfully processed into short films of considerable
propaganda value, the *Deutsche Wochenschau*.

So it was a far more connected world which in the
summer of 1939 stood on the brink of another war.
National and international radio broadcasting, talking
movies, and print media capable of reaching millions
of readers on a daily basis were all ready to be
deployed in the service of irreconcilable ideologies.
Moreover, the indiscriminate bombing of civilians by
the fascists in Spain and the Japanese in Manchuria
admitted no further doubt that this conflict would involve whole populations in a
total war, a struggle for survival in which propaganda would play a greater role
than ever before and would be required to address, literally, everyone.

With the end of the First World War the British had dismantled their impressive
propaganda apparatus, apparently believing that they would find no use for it in
peacetime. But as the war clouds gathered again they reconsidered, and as early
as 1935 work began on the creation of a new organisation, the Ministry of
Information (MOI), which when war began in 1939 was, like most other aspects
of the country's fighting capacity, not ready. They muddled along until Lord Reith,
legendary Director General of the BBC, took over the MOI for a few months and
got it organised. His background in broadcasting gave him a profound respect for
the news, and his attitude was summed up in what was to become the MOI
motto: 'The truth, nothing but the truth and, as near as possible, the whole truth'.
Clearly, the operative phrase there is 'as near as possible'. Most people probably
realised that the MOI might have to be 'economical' with the truth and even tell
lies for the good of the country if it came to it. But this motto was a good idea,
the MOI propagandising on its own behalf, and for the rest of the war its activities

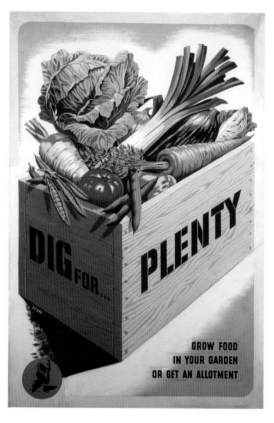

attracted remarkably little public criticism.

Its reliance on pre-censorship also proved effective. Learning from experience gained in the First World War it censored all news at source, from the news agencies, and then passed it on for distribution by the news media, who were allowed to present it in their own way. This not only hid censorship from the public view but permitted a degree of autonomy to the media sufficient to guarantee their cooperation.

Supplanted by the mass media, the poster was not the key propaganda medium it had been in the First World War, but it was an important asset which offered the propagandist the opportunity to engage with the public in situations less accessible to the mass media - the street, public transport and the workplace. This time there was no urgent need to promote enlistment, as conscription had been introduced early in 1939. The key issue for the British at the beginning of the Second World War was morale. Throughout the thirties people everywhere had become aware of the threat posed by aerial bombardment. Widespread anxiety was reflected in contemporary books and films, and the authorities were afraid that panic would lead to a breakdown in public order when the bombers appeared. So some of the first war posters to appear in Britain were straightforward textual messages attempting to fortify people's resolve, like the famous Churchill series, 'Let us go forward together' and 'We're going to see it through'. (Fig. 157)

As the nation urgently mobilised, government agencies coordinated by the MOI commissioned poster designs dealing with a range of topics: production, security, solidarity with the Allies, and domestic issues from health to austerity. (Figs. 158, 159)

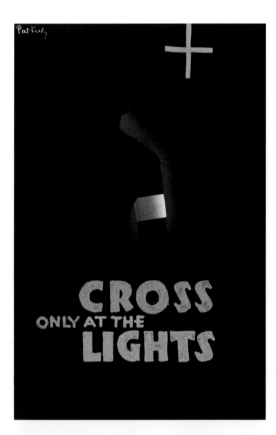

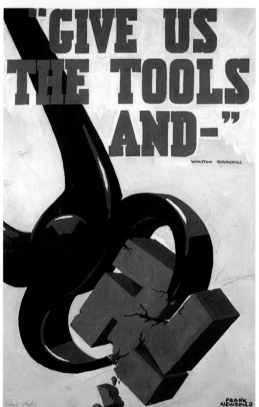

Left
160. PAT KEELEY (D.1970)
Cross at the lights, Britain, c.1941. Original artwork –
gouache on paper. © UK National Archives.

Below left
161. FRANK NEWBOULD (1887–1951)
Give us the tools, Britain, 1940. Original artwork –
gouache on paper. © UK National Archives.

Fortunately, the redeployment of industrial capacity to war work produced a downturn in the need for commercial advertising, allowing advertising agencies to redirect their free capacity to the production of government-sponsored propaganda. In the two decades since the end of the Great War, the advertising industry had grown in size and sophistication, and the commercial artists who worked in it were now professionally trained in the arts of persuasion. They grasped the opportunity to support the war effort. Leading designers like Pat Keeley and Frank Newbould showed that the modernist approach which they had developed in their commercial work before the war was well suited to the needs of the new common cause. (Figs. 160, 161)

In winning the 'People's War', the people would discover their rights to a more pluralistic and cosmopolitan way of life which, in the post-war period, would lead to a socialist government, the welfare state and the consumer society. And using the now familiar techniques of visual ambiguity, photomontage and expressive typography, artists not only communicated effectively, but established an appropriate visual language to express the shift in social attitudes which was taking place even as the war went on.

In 1942, meanwhile, the war was far from won. The Battle of the Atlantic had turned into a deadly war of attrition between the British merchant fleet and the U-boats. Singapore fell to the Japanese with the catastrophic loss of 60,000 men taken prisoner. There seemed to be no good news at all, and the MOI was in need of a morale-boosting campaign. Again, tone of voice was critical. It was clear that the American comic-book approach, with free use of exclamation marks and energetic exhortation, was not going to work on the British. One solution was drawn from the pre-war travel poster campaigns run by Jack Beddington at Shell and Frank Pick at London Transport, both of whom served at the MOI during the war. These new posters presented

Below
162. TOM ECKERSLEY (1914–1995)
Get first aid at once, Royal Society for the
Prevention of Accidents, Britain, printed by
Loxley Bros, 1939–45. Offset,
76 x 50cm (30 x 19in.). © RoSPA, image courtesy
of the Eckersley Archive, University of the Arts
London.

Bottom
163. TOM ECKERSLEY (1914–1995)
Replace covers, prevent falls, Royal Society for
the Prevention of Accidents, Britain, printed by
Loxley Bros, 1939–45. Offset, 76 x 50cm (30 x
19in.). © RoSPA, image courtesy of the Eckersley
Archive, University of the Arts London.

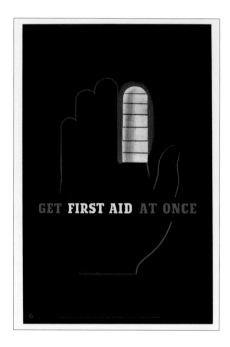

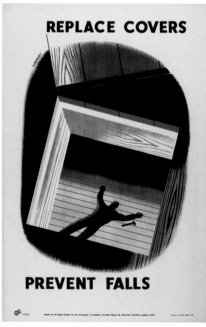

an idealised view of the British landscape and suggested, not that it should be visited, but that it should be saved from the Nazi tyranny, a challenge summed up in the main slogan of the campaign, 'Your Britain, Fight for it now.' Others in the series showed not only the ideal present but the catastrophic future which would result should the public fail to rise to the occasion.

Early in the war the issue of safety in the workplace came up. In the words of Lord McGowan, President of the National Safety First Association (NSFA), 'an accident in the works is as much a gain to the enemy as a casualty in the armed forces'. Recognising the need to maintain the productive capacity and morale of the thousands of new and inexperienced workers, including women, who were flooding into the factories, the government put the safety issue in the hands of Ernest Bevin at the Ministry of Labour. A trade unionist, Bevin had a natural sympathy with the cause of workers' welfare and no doubt saw the safety issue as part of the wider programme to redefine the relationship between workers and capital to which he and his colleagues in the Labour Party were committed. He charged The NSFA, renamed the Royal Society for the Prevention of Accidents (RoSPA), with the production and distribution of propaganda material to subscribing factories and workshops, and set about putting together a group to carry it out.

Bevin was a personal friend of Frank Pick, whose leadership at London Underground had done so much to promote the work of modernist designers, and who shared his vision of a socialist Britain.

The selection and appointment of artists and technical advisers to RoSPA clearly reflects Pick's influence, and just as clearly benefited from it. Under fearsome financial and time constraints, not to mention the inconvenience of total war, the new team produced a series of accident prevention posters which represent some of the best British graphic art of the 20th century. As Paul Rennie put it in his article 'Social Vision' for *Eye* magazine:

Such safety posters give visual expression to the hopes expressed by Walter Benjamin for a socially progressive, politically engaged, mass-produced and widely distributed form of graphic communication as a significant evolution of the Modernist project. Their messages recognise the radical potential of ordinary people to effect social change - something that was identified by Antonio

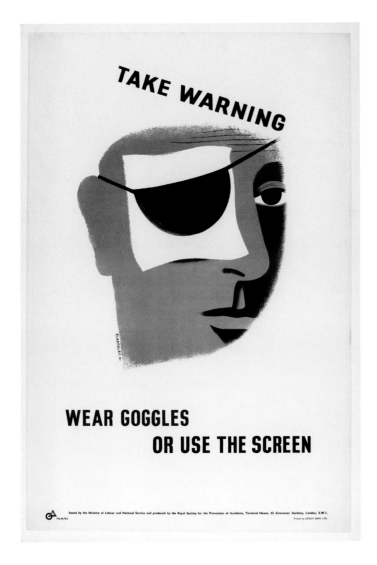

TAKE WARNING

WEAR GOGGLES
OR USE THE SCREEN

Opposite
164. TOM ECKERSLEY (1914–1995)
Wear goggles, Royal Society for the Prevention
of Accidents, Britain, printed by Loxley Bros,
1939–45. Offset 76 x 50cm (30 x 19in.). © RoSPA,
image courtesy of the Eckersley Archive,
University of the Arts London.

*Gramsci during the 1920s and 30s, and then espoused
by George Orwell in 1941 as a necessary, but
insufficient, condition of victory.*

As persuasive art the RoSPA posters reject
aggression, nationalism and the banal realism of both
conservative advertising and totalitarian propaganda,
and while they share an egalitarian optimism with the
American WPA safety posters which we have already
looked at, their technical sophistication sets them apart.

A long roster of artists contributed to the series. A
long roster of artists contributed to the series. Here are
some examples of the work of one of them, the typical
and exemplary Tom Eckersley. (Figs. 162-164)

Public criticism of the American Government's moral
and material support of the British war effort ceased
immediately with the attack on Pearl Harbor in December 1941. The fighting
alliance between the two countries was renewed, as was the propaganda
relationship which had worked so well in the First World War. America set up
two new organisations to deal with propaganda. One, the Office of Strategic
Services (OSS), had responsibility for covert operations directed at the enemy. This
was 'black' propaganda, the true source of which was hidden from the audience.
'White' propaganda, i.e. material which reveals its true source, was the
responsibility of the Office of War Information (OWI).

By far the most powerful propaganda weapon available to America was its
film industry, which had enjoyed an overwhelming dominance for 30 years, not
only at home but all over the world. In France in 1923, for example, 85% of the
films shown were American. In Britain in 1925, 98% of films were American. To
quote Professor Taylor:

*Even by 1939, after years of attempts by foreign governments to combat the
Americanisation of the national film industries, the USA owned about 40% of
the world-wide total of cinemas. During the war itself, more than 80 million*

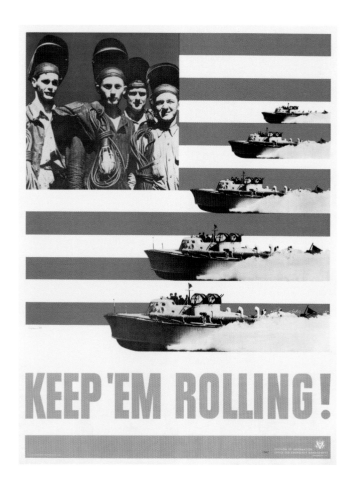

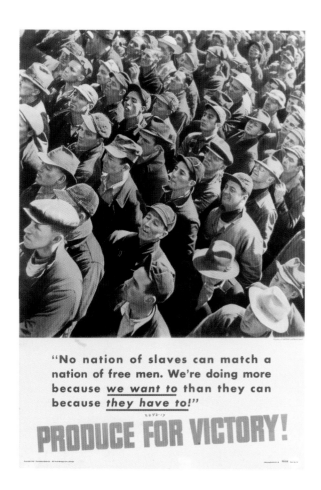

Americans went to the cinema every week, whilst the world-wide audience for American films was measured in the hundreds of millions. What has been described as the classic Hollywood style proved to be a universal formula with universal appeal. (Philip M. Taylor, p.227)

Fortunately for the Allies, in the pre-war period and in the two years before the USA entered the war, Hollywood was enthusiastically pro-British and emphatically anti-Nazi, and after America entered the war its film industry was a key asset in the propaganda war.

In February 1942, the War Advertising Council (now known as the Ad Council) was set up to mobilise the advertising industry in support of the war effort. In collaboration with the OWI it set up a committee of prominent art directors to oversee poster campaigns dealing with the sale of war bonds, labour, security and food production. These posters were produced in enormous numbers, at least 1.5 million of each, and were distributed all over the country. (Figs. 165-168)

As in Britain, the role of women both in the services and the factories was publicised, and good reasons were offered for the war against Germany, a country which, as in the Great War, lacked the means to threaten the USA directly. In this regard President Roosevelt's State of the Union Address in 1941 introduced the Four Freedoms: freedom of expression, freedom of worship, freedom from want and freedom from fear. Easy to understand and difficult to

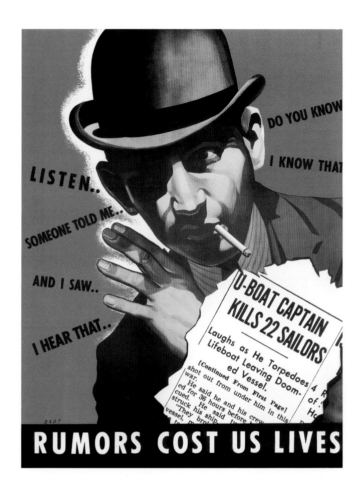

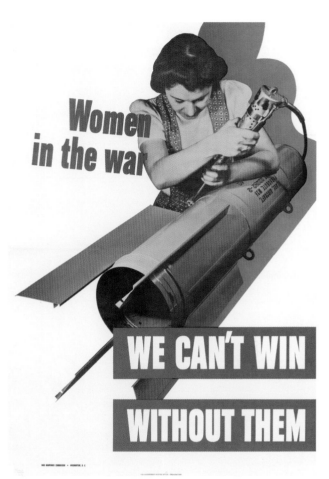

Above left
167. ARTIST UNKNOWN
Rumors cost us lives, possibly RCA, USA,
1941–45. Lithograph, 66 x 51cm (26 x 20in.).
Courtesy: University of North Texas.

Above right
168. ARTIST UNKNOWN
Women in the war, War Manpower
Commission, 1942. Lithograph, 101 x 71cm (39 x
28in.). Courtesy: University of North Texas.

argue with, these ideas formed the basis of a successful campaign which not
only justified action against the Nazis and the Japanese but later supplied the
basis of an ideology to counter the threat from any totalitarian state.

In contrast to the modernist work produced in Britain, the poster styles
prescribed by the OWI tended to follow the typical formulae used in commercial
advertising at the time. Themes were treated as campaigns, with usually emotive
slogans supported by realistic artwork or photography. The modernist approaches
essayed earlier by the WPA artists disappeared entirely once the OWI became
involved.

Hitler invaded Russia in June 1941, beginning what the Russians to this day
refer to as the Great Patriotic War. Patriotism, rather than revolutionary ideology,
was the theme adopted by Stalin and his newly created Soviet Information
Bureau to unite the Russian people against the aggressor. Despite the disruption
caused by the rapid German advance, the Soviet propaganda machine produced
a series of campaigns to rally the nation over the next two years. Every medium
was exploited, but as in the West it was the cinema which proved most effective
in uniting the widely dispersed population behind the war effort. Unlike their
western colleagues, however, the Soviet film-makers did not produce any escapist
entertainments. The studios, which were evacuated east from Moscow to escape
the rapidly advancing German Army, produced patriotic films - many with
historical themes - and newsreels, some of which were made remarkably quickly

169. EDWARD T. GRIGWARE
Alaska, Death-Trap for the Jap, Federal Art
Project, Washington, USA, 1941–43. Screenprint.
Library of Congress LC-USZC2-985.
The buck-toothed and myopic fanatic favoured
by American propagandists during World War II,
when called upon to portray the Japanese, is
here transformed into a rat slavering blood for
good measure.

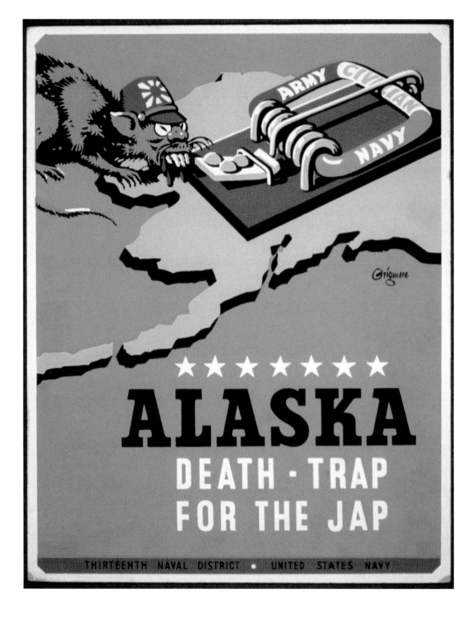

into popular feature-length films.
Stalingrad (1943), a documentary
featuring the desperate street fighting
in the beleaguered city and the
surrender of the German commander,
Field Marshal Paulus, was released
only six weeks after the surrender of
the Germans. Once again the
Agitprop trains carried the news to
remote areas, and in the towns
posters appeared in the old ROSTA
(now TASS) window format. Solidarity
with the Red Army and industrial
production provided the main themes.
(Fig. 170)

The attack on Pearl Harbor so
enraged the American people that
they needed little persuasion to go to
war against Japan. Admiral William
Halsey, for example, who became
commander of the US South Pacific
forces, made famous the slogan 'Kill
Japs, kill Japs, kill more Japs'. Some
American propaganda aimed to
dehumanise the Japanese, just as it
had done to the 'Hun' in the First
World War. They were habitually
referred to as the 'yellow peril' or
'yellow rats', and depicted as rats or
monkeys in cartoons and posters. (Fig.
169)

Japanese graphic art and literature
also demonised the enemy at times

170. EL LISSITSKY (1890–1941)
Give us more tanks ..., USSR, 1942. Lithograph,
89 x 59cm (35 x 23in.). Courtesy: Brown
University Library.

The full text is, 'Give us more tanks, anti-tank
weapons, guns, small arms, artillery, mines,
bombs, machine guns, rifles! Everything for the
front! Everything for the victory!'

and frequently excoriated the imperial activities of the western powers in Asia. Curiously, however, Japanese cinema tended not to concentrate on the enemy, but on the spiritual purity of the hero, and on the value of self-sacrifice for the collective good. As a result, the best of these films achieve a deep emotional impact. Frank Capra, author of the celebrated series of American propaganda documentaries entitled *Why We Fight*, had a high regard for the Japanese film-makers. After seeing the famous *Chocolate and Soldiers* (1938) he remarked, 'We can't beat this kind of thing. We make a film like that maybe once in a decade. We haven't got the actors.'

At least partly due to the effectiveness of domestic propaganda, the morale of the Japanese people did not give way, even when it was clear that defeat was certain, even after the first atomic bomb was dropped. But Japanese international propaganda, despite using a sophisticated radio network, was less effective. The neighbouring countries subdued by Japan in the name of its 'Greater East Asian Co-Prosperity Sphere', could not be convinced that it was a good idea, and though Tokyo Rose could make the young Americans fighting in the Pacific homesick, she could offer no excuse or justification for Pearl Harbor.

The simple fact is that a war cannot be won by propaganda alone, no matter how well directed it is. After coming to power in 1933, Nazi Germany, the ultimate propaganda state, manipulated the German people for six years to prepare them for war, but when it came they were neither prepared for it nor wanted it. Not until after Stalingrad and the intensive Allied bombing of German cities did the German people fully identify with the Nazi leadership. And this was not in response to Dr Goebbels's rage against the 'Jewish-Bolshevik Murder System', but an assertion of national pride and the desperate solidarity of a people whose world was falling apart.

6

The modern world

1993

Cola logo redesigned by "Trio" Sarajevo

The Cold War

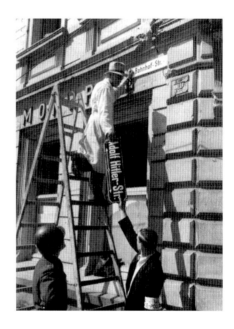

172. ARTIST UNKNOWN
An exchange of street signs, US Dept. of Defence, Germany, c.1946. Photograph. Private collection

The de-nazification of Germany in the post-war period entailed the removal of every trace of the Nazi regime from public life. Supervised by an American GI two German officials replace the street name Adolf Hitler-Strasse with Bahnhof-Strasse.

Opposite above
173. JAKUB EROL AND PAWEL UDOROWIEKI
Leninizm, Poland, 1974. Offset, 67 x 98cm (26 x 38in.). http://www.theartofposter.com

Opposite below
174. KEN GARLAND
Aldermaston to London. Easter 1962, Campaign for Nuclear Disarmament, Britain, 1962. Offset. Courtesy of the artist.

In the aftermath of the war, the victorious Allied powers were concerned to 'rehabilitate' the peoples of the defeated Axis, to purge them of the fascist contagion with which their discredited (and destroyed) governments had presumably infected them. In West Germany the process of political re-education consisted of a complete restructuring of public values - new constitution, new system of government, new school curriculum - and a propaganda campaign involving every medium, all designed, in Lord Vansittart's words, to 'rescue the world from Germany, and Germany from herself'. (Fig. 172)

In the wider post-war context, new democratic institutions were established, such as the Charter of the United Nations and the Declaration of Human Rights, while behind the Iron Curtain the Soviets made a series of communist states out of the countries overrun by the Red Army in the war. Almost before the armistice was signed the world had been realigned into two blocs, separated by irreconcilable ideologies and sustained by mutual distrust. For the next 40 years they would fight a new kind of war, a 'cold war' in which propaganda did not merely support the use of weapons; it was the weapon, in a struggle to draw the peoples of the world into one sphere of influence or the other. (Fig. 173)

For a world recently delivered from the greatest conflict in history this would have been distressing enough, but with the appearance of nuclear weapons humanity entered a terrifying new era of ideological confrontation, a war of words driven by fear and the cold military logic of 'mutually assured destruction'.

In order to justify the huge expense of maintaining these doomsday weapons, the people on both sides had to be convinced, and periodically reminded, of the wicked intentions of the other side. In America the idea of the 'Red Menace' got out of hand. Virulent anti-Soviet propaganda spread fear and mistrust throughout society, culminating in the vindictive and ultimately degrading McCarthyite witch-hunts of the early 1950s. (Fig. 175, 176)

During this period TV played a significant role in propaganda for the first time, though in the West it would not achieve majority penetration till the 1960s and most people in the Soviet bloc would not gain access to it till the 1970s. Consequently, in the early years of the Cold War, radio and film remained the principal propaganda media.

Each side strove to exploit the other's weaknesses. American propagandists

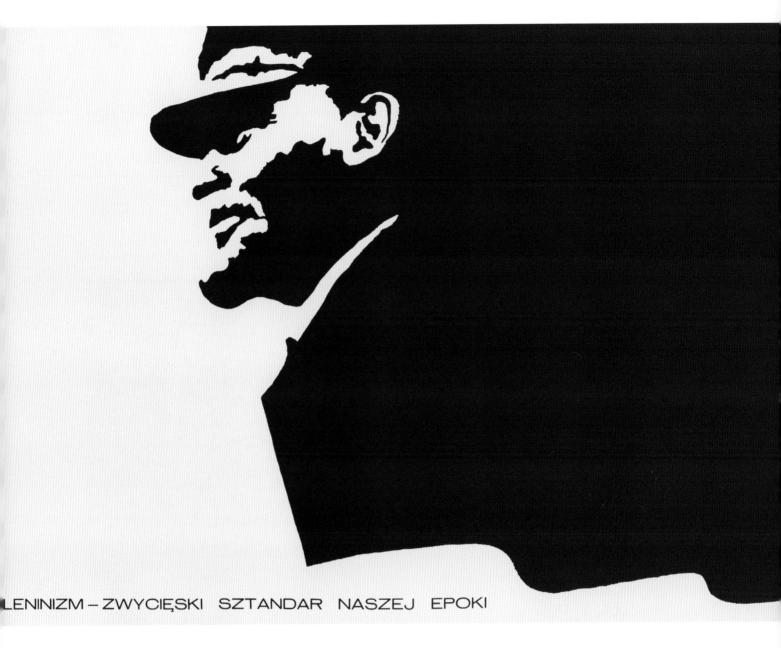

LENINIZM – ZWYCIĘSKI SZTANDAR NASZEJ EPOKI

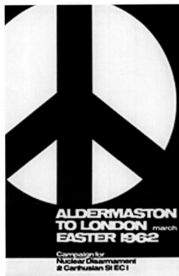

criticised the Soviet regime's denial of basic freedoms to its people - freedom of speech, freedom of movement, etc.; while the Soviets highlighted the iniquities of the capitalist system - debt and unemployment at home, imperialist exploitation abroad. (Fig. 177)

Science, the arts, sport, the exploration of space - everything was exploited by both sides in the attempt to demonstrate the superiority of their own system. Completed in 1962, the Berlin Wall became the universal symbol of a divided world, the physical manifestation of the Iron Curtain. No doubt the Soviets followed this policy of isolation to protect their people from the malevolent influence of the West, and it did allow them to present a modified view of life outside, at least until it was penetrated by the new media in the 1970s and '80s. But the Iron Curtain also presented the West not only with a symbol of Soviet oppression, but with the opportunity to present a false picture to their own people of the Soviets and their intentions.

CHILDREN'S CRUSADE AGAINST COMMUNISM

39. Soviet Rocket Fighter

What kind of planes would the Soviet Union be able to throw against us if another world war should come? We know about their MIG-15s. The Chinese Reds have used them in Korea. Then there is the Me-163 rocket fighter, shown in the picture. The Russians captured it from the nazis. This warplane, even in its earlier models, could climb 50,000 feet in 3½ minutes. The Reds are reported making improved Me-163s in large numbers. The free world, to remain free, is forced to match Red might, including air power.

 FIGHT THE RED MENACE

175. ARTIST UNKNOWN
Children's crusade against Communism. Fight the Red Menace. 39. Soviet rocket fighter, USA, 1950s. Offset. Courtesy: Dr. J. Fred McDonald, thehistoryshoppe.com

What more effective means of reaching children than bubblegum cards? Inspired by American militarism and a hatred of the Soviets, these cards are a potent reminder of the paranoia which characterised the Cold War period.

Right
176. ARTIST UNKNOWN
Children's crusade against Communism. Fight the red menace. 47. War-Maker, USA, 1950s. Offset. Courtesy: Dr. J. Fred McDonald, thehistoryshoppe.com

Here we are informed that Chairman Mao, rendered in an alarming and unwholesome green, 'delights in war'. Note the monstrous ape-like creature, presumably a communist, wielding a bloodstained sword behind him.

CHILDREN'S CRUSADE AGAINST COMMUNISM

47. War-Maker

Mao Tse-tung is the leader of the Chinese Reds who attacked the United Nations forces in Korea. His army was built up, in the first place, with the help of outlaws. Later the Russian Reds supplied him with arms and advisers. He captured the China mainland in three years of savage warfare against the Nationalist government. Mao delights in war. History, he says, "is written in blood and iron." The free world must find a way to keep war-makers like Mao Tse-tung from shedding the blood of innocent people.

 FIGHT THE RED MENACE

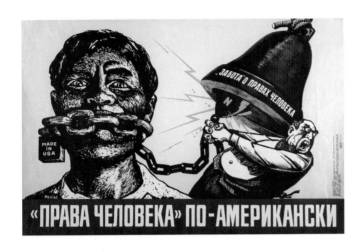

177. J. KERSIN
Rights of Man, American-style, USSR, 1978. Lithograph, 44 x 67cm (17 x 26in.). Courtesy: Brown University.

This image of the chain and 'made in USA' padlock around a man's mouth, was originally created by Mexican artist Adolfo Mexiac (b.1927) and used in the student uprising in Mexico City during the Olympic Games of 1968. The mad businessman ringing the Liberty Bell was added by Kersin.

Below
178. VILEN KARAKASHEV
Peace to the world, USSR, c.1965. Offset. Courtesy: John Gilmour Collection.

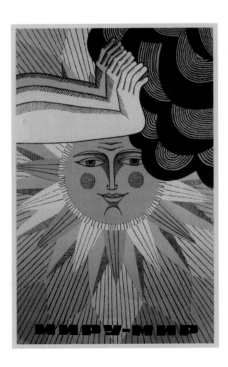

As the tension rose, and the nuclear arsenals grew, the balance of terror became ever more precarious. Each side accused the other of being a threat to world peace. In 1962 the Cuban Missile Crisis brought the world to the very brink of war, and as international peace movements grew out of the fear of it, the Soviets launched a massive 'peace' campaign. Relatively ineffective in the West generally, this campaign did influence the intellectual Left in Western Europe and less sceptical people in the developing world. (Figs. 174, 178)

Complementary to their activities involving conventional propaganda the western powers employed an approach often referred to as 'cultural diplomacy'. Designed to promote western cultural achievement and foster understanding between nations, this involved cultural missions to other, particularly developing, countries to organise activities such as language schools, arts events and student exchange schemes. The British had been doing this through the British Council since before the war, but the American policy was usually to leave international cultural activity in the hands of commercial or 'philanthropic' organisations. No wonder. It would be difficult to overstate the influence of Hollywood films, American popular music and American branded consumer goods such as Coca-Cola, Ford or Frigidaire. In fact, in the long term, these may represent the most potent propaganda resources available to the USA throughout the entire Cold War period. Of course, for those less well disposed towards the west, the same brands stood for all that is undesirable in the capitalist system, and their subversion has become a feature of modern oppositional propaganda. (Fig. 171)

By 1989 the Soviet system was nearing collapse. Without the support of the Soviet military, the communist regimes in the countries of the Warsaw Pact were losing their grip on power, and in the space of a few months a wave of political change swept through Eastern Europe.

The Cold War ended with the collapse of the Soviet Union in 1991. Although propaganda had played a greater part in it than in any conflict in history, the Soviets did not lose because their propaganda was inferior. It was not. They lost because the Soviet economy could no longer compete with the capitalist system, and because access to the new media allowed the people living inside the Eastern bloc to see and want the material wealth of the west.

Post-war Britain

179. JOHN FARLEIGH (1900–1965)
Underground cable, Post Office, Britain, 1935.
Lithograph, 76 x 51cm (30 x 20in.). © Royal Mail.

'Traditional values lost much of their force. Other values took their place. Imperial greatness was on the way out; the welfare state was on the way in. The British Empire declined; the condition of the people improved. Few now sang "Land of Hope and Glory". Few even sang "England Arise". England had arisen all the same.' (A.J.P. Taylor, Oxford History of England, Volume XV, 1914-1945.)

The thousands of young men and women who came back from winning the 'People's War' in 1945 did so with a sense of purpose. They were fed up of taking orders, fed up of a class system that held them back, and impatient to build a better world. In the general election of that year they returned the Labour Party to government with a huge majority and a mandate for change. It would not be easy. But despite an exhausted economy, worn-out industry, and an acute shortage of housing and everything else, the new administration began a programme of reconstruction and social reform greater than any ever attempted in the long history of the country. In 1946 the National Insurance Act provided a

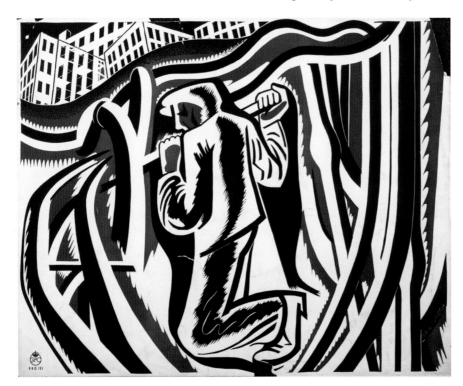

full range of benefits for workers. In 1948 the National Health Service was introduced to provide free medical services for all - free spectacles, free dental treatment, maternity and child welfare; orange juice, cod-liver oil and cheap school dinners. Drawing on proposals put forward by economist William Beverage to provide 'cradle to grave' social welfare, these initiatives formed the basis of the Welfare State.

Strict financial measures were imposed to deal with the enormous war debt, and a programme of nationalisation saw 20% of all British industry taken into public ownership by 1950. Rationing continued until 1954. But things slowly improved.

180. ALICK KNIGHT (1903–1983)
4d minimum foreign letter, Post Office, Britain,
1953. Lithograph, 74 x 92cm (29 x 36in.).
© Royal Mail.

The Marshall Plan, introduced by America in 1947 to help the recovery of the European economy, brought some relief, as did the expansion of world markets and the revival of the manufacturing industries. By 1951, when the Conservatives resumed control of the government, a new air of optimism was blowing in the country. With access to more money and leisure time, the consumer society and the rock 'n' roll generation were just around the corner.

While most American graphic design in the post-war period evolved to serve the interests of consumer capitalism, in post-war Britain the creation of the Welfare State provided the modernist designers, whose contribution to the war effort we have already looked at, with the opportunity to contribute to a social project based on the democratic and humanitarian principles which had always informed their work. Producing posters for a variety of public organisations, they established the visual style which came to be associated with the period. (Figs. 179-182)

Above left
181. TOM ECKERSLEY (1914–1995)
A safe holiday, Royal Society for the Prevention of Accidents, Britain, printed by Loxley Bros, 1947. Offset, 76 x 50cm (30 x 19in.). © RoSPA, image courtesy of the Eckersley Archive, University of the Arts London.

Right
182. F.H.K. HENRION (1914–1990)
Please pack parcels carefully, Post Office, Britain, 1955. Offset, 76 x 51cm (30 x 20in.). © Royal Mail.

Born in Nuremberg, Henrion studied graphic design with Paul Colin in Paris from 1933 to 1935. Between 1936 and 1939 he had offices in Paris and London and developed an international reputation as a designer. Upon the outbreak of war he moved permanently to London, where he produced the huge number of public information posters which made his name in Britain. An influential teacher, and respected spokesperson for his profession, Henrion lectured at the Royal College of Art and the London College of Printing in the 1960s and '70s. His firm, Henrion Ludlow & Schmidt, contributed to the establishment of corporate identity design as a distinct speciality.

The Chinese Cultural Revolution

183. LU XUN ART COLLEGE ARTISTS
Chairman Mao is the reddest reddest red sun in our hearts, Jilin, 1967. Offset, 109 x 79cm (43 x 31in.). Courtesy: University of Westminster Chinese Poster Collection.

This image shows a group of the 'Mao Zedong Thought Red Guard', with their characteristic red armbands, neckerchiefs and little red books. Convention required that Mao should be depicted as the source of light in this sort of picture.

For over a thousand years the Chinese have been using woodblock print techniques to illustrate religious texts and literary works, as well as in the production of fine art and popular prints. Traditionally, print production was a collaborative process, the separate tasks of designing, block-cutting and printing carried out by different individuals, none of whom was credited with authorship of the work. In the 1930s, however, creative printmaking, in which the whole process was performed by a single artist, was introduced to China as part of a wider movement of cultural modernisation and, inspired by Western printmakers such as Käthe Kollwitz, artists in China developed the woodblock print as a means of furthering political change. This new tradition joined the much older one in which all the arts were used to propagate correct behaviour and thought. Literature, poetry, painting, stage plays, songs and other forms of artistic expression were produced to entertain, but they were also given an important didactic function: to educate the people in the conventional morality of the day. These traditions provided the context in which the massive propaganda campaigns of Chinese Communism were deployed.

The Great Proletarian Cultural Revolution, often referred to simply as the Cultural Revolution, was launched in 1966 by Chinese Communist Party (CCP) Chairman Mao Zedong in an attempt to reverse what he perceived to have been a drift away from socialist principles since the creation of the People's Republic of China in 1949, by curbing bureaucratic privilege and eliminating the 'revisionism' which he saw at the root of the growing inequalities in Chinese society. Mao made an emotive appeal to the young to take responsibility for the revolution and restore its ideological focus. They heard him, and over the following three years 20 million enthusiastic young Red Guards, self-appointed and spontaneously organised groups of students, took up the task of exposing 'class enemies' and carrying the message of Chairman Mao to workers and peasants throughout the land. Between August and November 1966, Mao addressed rallies of over a million Red Guards in Tiananmen Square on eight separate occasions. An estimated 13 million young people from all over the country passed through Beijing at that time, turning the city into a crucible of political action, and a riot of propaganda, as one eye-witness recalls: 'The walls, shop windows, even the sidewalks were covered with posters, big-character slogans,

毛主席是我们心中最红最红的红太阳

Above
184. ARTIST UNKNOWN
Go to the big wave to exercise, Tianjin people's printing factory. Offset. Courtesy: University of Westminster Chinese Poster Collection.

Chairman Mao loved to swim. In 1956 he swam the Yangtze river, then wrote a poem about it. In 1966 a great 'Crossing the Yangtze' swimming event was organised in Wuhan to commemorate the event and Mao himself took part. This poster refers to that day while urging young people to keep fit in order to serve the revolution better.

and caricatures. Streets would be decorated and parades would march to the sound of gongs and drums.' (Hong Wei Bing, The Red Guards, Revolutionary Worker #966, 1998. http://rwor.org/a/v20/960-69/966/redgrd.htm).

The 'big character slogans' referred to, known as *"dazibao"* in Chinese, were a prominent and vital component of the Cultural Revolution. Handmade, and often the spontaneous result of meetings and debate, these large sheets of text bedecked the schools, factories and public places, a continuously updated record of the ebb and flow of the revolution's ideological tide. The *dazibao* were complemented by conventionally printed posters, usually containing text and images and produced in enormous editions in government printing factories. The Red Guards themselves also used small, portable presses to print up propaganda on the spot, the simple woodblocks printed in black and red which became characteristic of the Cultural Revolution, and which were sometimes adopted by the authorities and offset-printed to be sold in government stores.

The other key propaganda tool was the printed text, particularly the Quotations from Chairman Mao Zedong, the celebrated 'Little Red Book' which was printed in tens of millions of copies and distributed everywhere. A huge crowd waving the book and chanting slogans from it was to become one of the enduring images of the period. Visually, however, the dominant image of the Cultural Revolution was that of Mao himself. Endlessly repeated, the figure of Mao was rendered in every possible medium and context, and subject to strict convention. (Fig. 183)

While Soviet socialist realism continued to provide the dominant stylistic influence on Chinese propaganda, the use of different techniques drawn from Chinese tradition and the unique visual richness of its ideographic language resulted in an output which was both visually diverse and uniquely Chinese. There is also an excitement and optimism in much of the work produced during the Cultural Revolution. The early woodcuts in particular possess a raw urgency which no doubt reflects the circumstances of their creation. (Fig. 185)

Besides Chairman Mao, a number of other topics were given prominence. In accord with Mao's concept of 'continual revolution' the transcendental

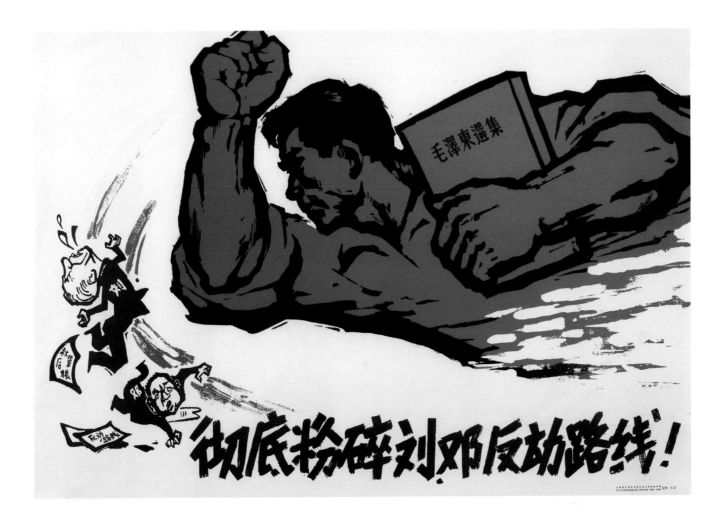

185. ARTIST UNKNOWN
Thoroughly smash the Liu-Deng anti-revolutionary line,
Hebei People's Art Publishing, Beijing, 1966–67. Offset
from original woodcut, 79 x 109cm (31 x 43in.). Courtesy:
University of Westminster Chinese Poster Collection.

This supremely energetic image refers to the purge of
party officials which took place in the early days of the
Cultural Revolution. Here Chairman Liu Shaoqui and
General Secretary Deng Xiaoping, whose pragmatic
approach to economic policy was unacceptable in the new
hard-line revolutionary climate, are vigorously cast out by
a red figure holding a copy of *The Thoughts of Chairman
Mao*. Liu was imprisoned and died shortly afterwards.
Deng, showing remarkable resilience, was eventually
rehabilitated to become leader of the country in 1978.

importance of politics in the life of the individual and group was
emphasised. Everything in the China of 1966 was either revolutionary or
revisionist. (Fig. 184)

Industrial and agricultural production, which had been energetically
promoted in the period previous to the Cultural Revolution, the so-called
Great Leap Forward, maintained its importance, not only as a vital
component of the people's welfare but as a revolutionary duty, and the
role of women in this and in military service is duly recognised. (Figs.
186, 187)

In accordance with Marxist principles, the unity of the nations
comprising the People's Republic of China, and solidarity with the
workers of the entire world, regardless of race, were enthusiastically
celebrated. (Fig. 188)

With the benefit of hindsight it may come as no surprise to us that
allowing millions of overexcited teenagers to run around the country
might lead to trouble. Though no doubt politically astringent, their
activities did not foster the social conditions necessary to sustain a large
country. In fact by the middle of 1967, after many groups of Red Guards
had armed and begun to fight amongst themselves and against units of
the PLA (People's Liberation Army), the country stood on the brink of

Right
186. DING ZHUANG, YAO ZHONGYU
Women's artillery team, Shanghai, 1975. Offset.
Courtesy: University of Westminster Chinese
Poster Collection.

Below
187. DONG ZHENGYI
(Huxian peasant painting), *The local community
fish pond,* Shanghai People's Fine Art Publishing
House, 1971. Offset from an original painting.
79 x 109cm (31 x 43in.). Courtesy: University of
Westminster Chinese Poster Collection.

女炮班

公社鱼塘

中华人民共和国万岁 世界人民大团结万岁

全国各族人民大团结万岁!

爱科学　学科学　用科学

a i k e xue　xue k e xue　yong k e xue

Above
189. LIU CHUN HUA
Love science, Study science, Use science, Shanghai
Education Publishing, 1980. Offset, 79 x 109cm (31 x 43in.).
Courtesy: University of Westminster Chinese Poster
Collection.

In the period following the Cultural Revolution much of
the propaganda addressed issues of civic duty and the
value of education. The style is more western and
'progressive'. Note the additional use of Pinyin script, a
phonetic system using Roman letters, which would help
children read the message.

Opposite
188. XUE BIN
Long live the united nationalities of China, Shanghai
People's Fine Art Publishing, c.1975. Offset from an
original photograph, 79 x 109cm (31 x 43in.). Courtesy:
University of Westminster Chinese Poster Collection.

anarchy. Eventually, in the summer of 1968, Mao ordered the Red
Guards to disband and sent 'Worker Mao Zedong Thought Propaganda
Teams', mainly military people, to the schools and campuses to restore
order. The Cultural Revolution, at least the wild Red Guard part of it,
was over.

Things slowly returned to normal, but the Cultural Revolution had far-
reaching consequences. With the death of Mao in 1976, any possibility
of establishing a truly communist society in China disappeared. In 1980
the rehabilitated Deng Xiaoping became the party leader and introduced
a series of economic reforms, notably the break-up of the People's
Commune agricultural system and measures to encourage the growth of
small enterprise, designed to cultivate a form of 'market socialism'. The
propaganda of the time, purged of the urgency and rhetoric of the
Cultural Revolution, reveals the shift in values and priorities which
occurred after it. (Fig. 189)

The Cuban Revolution

190. EDUARDO MUÑOZ BACHS (1937–2001)
Johnny's not coming home, ICAIC, Cuba, 1971.
Silkscreen, 76 x 51cm (30 x 20in.). © Lincoln
Cushing.

A classic Bachs movie poster, this one promotes
a Polish film directed by Kaveh Pur Rahnama
with Kguyen Van Quynh.

In January 1959, the US-backed government of Fulgencio Batista in Cuba was overthrown after a three-year guerrilla war by a revolutionary organisation known as the 26th of July Movement. Led by Fidel Castro, a 32-year-old Cuban law graduate, this small band of poorly equipped exiles out-thought and out-fought the massively superior forces of the Cuban Army. An unlikely outcome on the face of it, the victory of this rebellion, as of many others, may be explained by the unpopularity of the regime which it challenged.

Batista fled to the Dominican Republic on New Year's Day 1959, and the new government took up the task of building a socialist society in Cuba. From the beginning Castro made it clear that he intended to end Cuba's dependence on the United States. Programmes of land reform and literacy were followed by the nationalisation of American industrial and commercial interests on the island. The resulting break in relations and the total embargo on cultural and commercial exchange imposed by the United States effectively denied Cuba access to its natural markets and exposed its people to considerable material hardship. Castro had no option but to accept aid offered by the Soviets, and Cuba became a privileged client state of the USSR, a lone outpost of the Soviet bloc during the Cold War, a mere 200 miles from Miami.

In common with all the revolutions we have examined so far, the Cuban Revolution depended for its survival on effective propaganda. Throughout the Cold War Cuba was an important source of radio propaganda. Radio Habana Cuba (RHC) transmitted original programming around the world and relayed Radio Moscow and The Voice of Vietnam to North and South America. Cuba was also the target of both black (covert) and white radio stations, operated by the CIA and Cuban exile groups, and later of TV Martí (sponsored by the US government), which began transmission in 1990.

Perhaps the most compelling source of Cuban propaganda, however, was the arts. Since the early 1960s, the Cuban Government has encouraged not only access to but participation in

191. EDUARDO MUÑOZ BACHS (1937–2001)
The Karate Fighters (film poster), ICAIC, Cuba,
1979. Silkscreen, 76 x 51cm (30 x 20in.).
© Lincoln Cushing.

Born in Valencia in Spain, Bachs was the best-
known and most prolific of all the Cuban
Graphic artists of his time. Besides his work for
ICAIC, he did children's book illustrations, and
book covers. A great draughtsman with a fine
sense of humour, he is now considered to be
one of the best poster artists of the 20th
century.

the arts for its people, and vigorously
supported their participation in
international events, a kind of cultural
democracy which has put Cuba at the
centre of cultural activity in the
Hispanic world for a generation, a
remarkable achievement for a small
island fighting for its economic
survival. As early as 1959 a number of
state cultural institutions were
founded - the National Ballet, the
Casa de las Américas (the
International Centre for Latin
American Art and Literature) and the
National Film Institute (ICAIC), among
others - which have not only carried
Cuban culture around the world, but
have contributed significantly to the
identity of the emerging Latin
American community of the arts.

In the field of the visual arts, in
particular, the new government
pursued an enlightened policy from
the beginning. In his writings Ché
Guevara criticised both Soviet socialist
realism and the Western self-
indulgence of 'personal expression'.
Castro himself stated memorably, 'Our
enemies are capitalists and
imperialists, not abstract art', a
significant divergence of opinion from
that of Nikita Khrushchev, the Soviet
premier at the time, who condemned

Above left
192. FAUSTINO PÉREZ (B.1947)
30th anniversary of the Moncada, EP (DOR),
Cuba, 1983. Silkscreen, 75 x 50cm (29 x 19in.). ©
Lincoln Cushing.

On the night of 26 July 1953, the Moncada
Barracks in Santiago de Cuba was attacked by a
small group of revolutionaries led by Fidel
Castro. Though a failure, the attack was
adopted as the beginning of the Cuban
Revolution, and the date, 26th July, was taken
by Castro as the name of his revolutionary
movement. Castro was captured after the
attack, and released in an amnesty in 1955. He
went to Mexico where he and his fellow exiles
prepared their return.

Above right
193. DAYSI GARCÍA (1942–D. DATE UNKNOWN)
Working for the ten million, EP (for INDER),
Cuba, 1971. Silkscreen, 35 x 51cm (13 x 20in.). ©
Lincoln Cushing.

The full text reads, 'working for the ten million,
in full health with the permanent attention of
the motorised health brigade'.

all modern art as counter-revolutionary. The result has been a distinctive Cuban
art, free to engage in the contemporary developments of the western artistic
community to which it naturally belongs but committed to the socialist project of
the society which nurtures it. A major port of entry to the Americas since the
Spanish conquest, the island has always enjoyed a rich cultural and ethnic
diversity, an international outlook and an artistic heritage drawn from many
sources - pre-Columbian, Spanish Colonial, European, African, Caribbean and US
pop references are all there. This is nowhere more evident than in the visual
propaganda, the poster art of Cuba. From the early 1960s to the 1980s various
Cuban agencies produced thousands of posters which for their vitality, graphic
quality and originality have earned an international reputation.

The ICAIC, the National Film Institute, first encouraged the development of a
new Cuban poster art in the 1960s by commissioning work from a number of
young artists to support its activities. These posters frequently offer a cultural
interpretation of the film as well as simply promoting it. Conscious of their artistic
value and wide appeal, the ICAIC marketed its posters commercially and
maintained a small shop in Havana for that purpose. (Figs. 190, 191, 195)

Soon the trend extended to the output of other agencies. Editorial Política
(EP), the official publishing department of the Cuban Communist Party,
commissioned many posters on a wide range of subjects which concern the
ideological interests, economic imperatives and cultural aspirations of the Cuban
people as they struggled to establish a new society. (Figs. 192, 193, 194, 196)

Another, much smaller but still politically significant producer of posters was
the Organisation in Solidarity with the People of Africa, Asia and Latin America
(OSPAAAL). Created to reflect the activities of the Cuban Government in
providing moral, material and sometimes military assistance to countries in the
developing world, OSPAAAL published *Tricontinental*, a monthly magazine
produced in four languages and at its peak distributed in 87 countries. Many of

its issues included a poster. (Fig. 197)

Following the withdrawal of Soviet subsidies and assistance in the early 1990s, and the further tightening of the US embargo, the Cuban economy suffered badly. The poster publishing agencies, previously sustained by state sponsorship, were forced to put their activities on a commercial basis, a daunting task given the general economic climate and the chronic shortages of materials and equipment. Consequently, production of new designs has diminished considerably. However, the archive of work from the sixties to the eighties represents an important artistic legacy, a high-water mark in the world history of propaganda art, and a permanent testament to the creativity of the Cuban people and their revolution. (Fig. 198)

Above
194. JOSÉ PAPIOL
Clear the way for sugar from the mill, EP (COR),
Cuba, 1972. Silkscreen, 71 x 44cm (28 x 17in.). ©
Lincoln Cushing.

Above right
195. ANTONIO FERNANDEZ REBOIRO (B.1935)
The Discreet Charm of the Bourgeoisie, ICAIC,
Cuba, 1975. Silkscreen, 76 x 51cm (30 x 20in.).
© Lincoln Cushing.

FNL DE VIET NAM DEL SUR
9 AÑOS DE EJEMPLO Y DE VICTORIA
DICIEMBRE 20 1960-1969
Comité Cubano de Solidaridad con Viet Nam del Sur

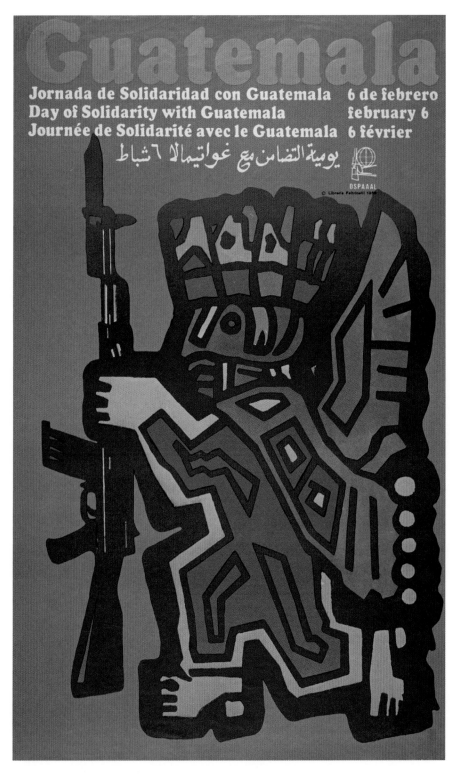

198. ALFREDO GONZALEZ ROSTGAARD (1943–2004)
Hasta la victoria siempre (film poster)
ICAIC, Cuba, 1971. Silkscreen, 76 x 51cm (30 x 20in.).

If you set yourself the task of defining the perfect 20th-century hero you would probably come up with something close to Ché Guevara: an attractive young doctor from somewhere exotic; idealistic, fearless, sensitive and charismatic; a man of action who joined the most romantic revolution of the century, triumphed, became a legend in his own lifetime and, most importantly, died for his beliefs– Christ-like credentials which he sustained even in death, resurrected in the hearts of the poor and disenfranchised of Latin America. To the protesting youth of the 1960s he was an example who encouraged them to challenge authority. To the people of the communist bloc he was a socialist hero. Nelson Mandela called him 'an inspiration for every human being who loves freedom'. The Chilean writer Ariel Dorfman called him 'a secular saint ready to die because he could not tolerate a world where the poor were eternally relegated to the margins'. In death he became a martyr, an icon, and, shed of his personality, his image has become a global brand exploited by the very forces he fought against. Now he stares out at us from posters and T-shirts, tattoos, designer bags, and products from Swatch to Smirnoff. The revolution seems as far away as ever. But as Dorfman points out, 'The powerful of the earth should take heed: deep inside that T shirt where we have tried to trap him, the eyes of Ché Guevara are still burning with impatience.' (*The Time 100 – heroes and icons*, 1999).

This poster, and all the other stuff, derive from an original photograph taken of Ché Guevara by Alberto Korda on 5 March 1960.

Opposite
196. RENÉ MEDEROS (1933–1996)
NLF (National Liberation Front) of South Vietnam – 9 years of example and victory, EP (COR), Cuba, 1969. Silkscreen and offset, 70 x 48cm (27 x 19in.). © Lincoln Cushing.

Above
197. OLIVIO MARTINEZ (B.1941)
Guatemala, OSPAAAL, Cuba, 1968. Silkscreen, 76 x 51cm (30 x 20in.). © Lincoln Cushing.

In this kind of solidarity poster the Cuban artists frequently juxtaposed elements of traditional art and culture with the paraphernalia of armed resistance – AK47, hand grenade, etc.

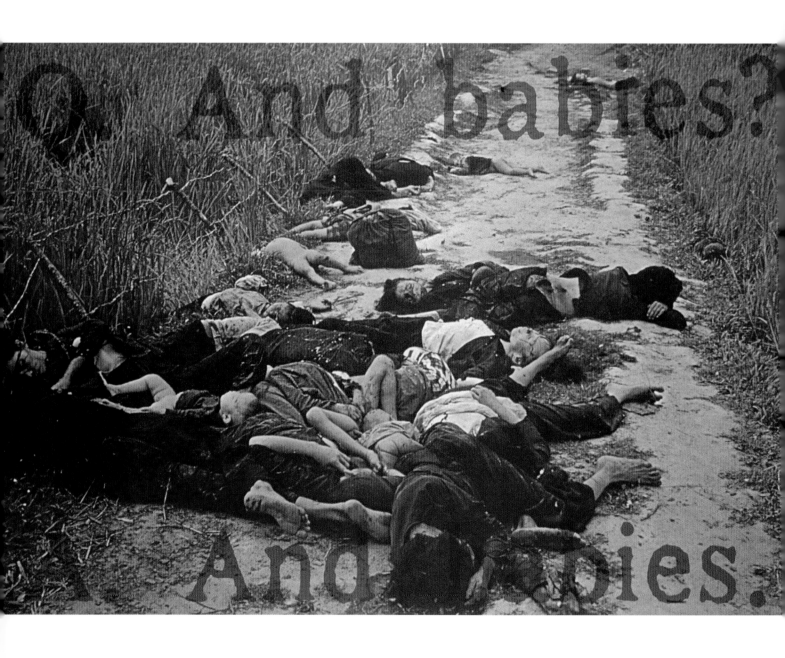

Vietnam and the art of protest

199. ART WORKERS' COALITION
Q. And babies? A. and babies, USA, 1970. Offset
62 x 95cm (24 x 37in.). Courtesy: Center for the
Study of Political Graphics, Los Angeles, USA.
Photo: © R.L. Haeberle.

On 16 March 1968, US Army forces massacred
up to 504 unarmed South Vietnamese civilians,
mostly women and children in the village of My
Lai. This photograph, taken by army
photographer Ronald Haeberle, who was court-
martialled for turning it over to the press,
brought events at My Lai to the attention of the
world, and is generally considered to have
played an important role in turning American
public opinion against the war.

'And it's one, two, three,
What are we fighting for?
Don't ask me, I don't give a damn,
Next stop is Vietnam;
And it's five, six, seven,
Open up the pearly gates.
Ain't no time to wonder why,
Whoopee! We're all gonna die.'

Country Joe and the Fish, Fixin' to Die Rag (1965)

The history of the Vietnamese people is largely one of resistance to foreign invasion. Invaded by the Chinese and the Mongols long ago, colonised by the French in the 19th century, invaded by the Japanese in World War II, and reoccupied by the French after it, they resisted as they had always done. During the Japanese occupation the Vietnamese Communist Party conducted a campaign which sought, successfully, to link nationalist sentiment with anti-colonial and anti-capitalist ideas. They blamed the imperialist invaders for the country's problems and offered a Marxist solution. After the war the communists played a leading role in the struggle to expel the French, a goal that was achieved in 1954 at the expense of a divided country: a communist North and a non-communist South. When efforts to reunite the country failed, a network of communist cadres, the Vietcong, was organised by the government in Hanoi to infiltrate and hasten the collapse of the South. This measure, while ultimately effective, would lead to a catastrophic war.

America had been involved in Vietnam since 1950, sending advisers and military assistance to the French in response to Chinese aid to the communist forces, the Viet Minh, in North Vietnam. Following the defeat of the French at Dien Bien Phu and the subsequent independence of Vietnam, Cambodia and Laos, Vietnam was temporarily partitioned at the seventeenth parallel. With American support, in 1955 the autocratic anti-communist Ngo Dinh Diem became President of the new republic of Vietnam.

From 1956 to 1960, following the creation of the National Liberation Front

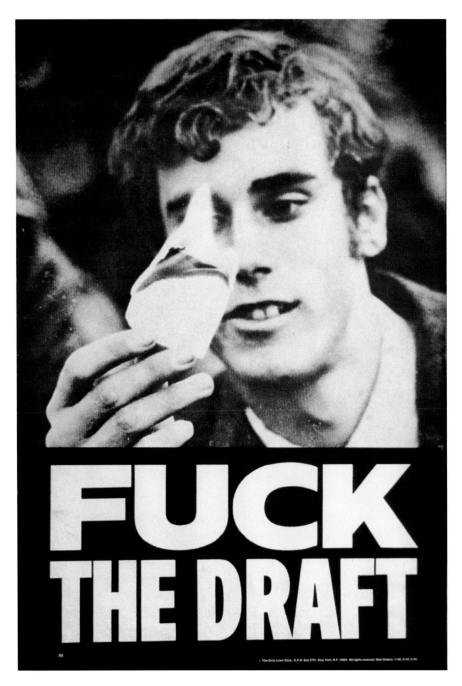

200. DIRTY LINEN CORP.
Fuck the draft, USA, late 1960s. Offset,
76 x 52cm (30 x 20in.). Courtesy: Center for the
Study of Political Graphics, Los Angeles, USA

(NLF), the Vietcong insurgency intensified as the increasingly oppressive Diem regime steadily lost popular support. Then, with American cognisance, Diem was overthrown and executed by Vietnamese army generals in 1963, and as they fought amongst themselves for power, the country entered a period of extreme political instability, a situation of which the NLF took full advantage. From the American point of view this was a mess, but the Kennedy administration, deeply entrenched in the Cold War and convinced that Vietnam was the key to maintaining democracy in South-East Asia, would not withdraw. In President Kennedy's own words, spoken at his inaugural address, he had promised to, 'pay any price, bear any burden, meet any hardship, support any friend, oppose any foe, in order to assure the survival and success of liberty'. It was in Vietnam, tragically, that he would feel obliged to keep that promise.

For the remainder of the Kennedy Presidency and throughout that of his successor, Lyndon Johnson, American involvement in Vietnam steadily increased. In 1965, American ground troops were deployed, and a massive bombing campaign began, designed in

201. VICTOR MOSCOCO (B.1936)
The Chambers Bros, Neon Rose (publisher), 1967.
Offset lithograph, 51 x 35cm (20 x 13¾in.).
Courtesy: Smithsonian Institute, Washington, USA.

the words of USAF Chief of Staff Curtis LeMay to 'bomb them (the communists) back into the Stone Age'. An equally ambitious propaganda campaign was undertaken at the same time, in an attempt to disengage the people from the Vietcong and to encourage the Vietcong to give up the fight. During its seven years in Vietnam, the United States Information Agency (USIA) dropped nearly 50 billion (yes, billion) leaflets on North and South Vietnam, and the Ho Chi Minh trail in Laos and Cambodia, easily the biggest leaflet campaign ever undertaken. But neither the bombs nor the leaflets could win the war. As soon as American forces arrived in numbers, the consistent communist propaganda appeal to 'save Vietnam from American imperialism' was offered a tangible justification which no amount of paper could counter.

At home, the US government faced a propaganda challenge of the other kind. After the Gulf of Tonkin Incident in 1965, which persuaded Congress to authorise the President to use whatever force was deemed necessary in South-East Asia, it was no longer possible to hide what was going on in Vietnam from the American people, but it was also politically vital to maintain their approval of the war. This proved difficult to do for a number of reasons. Firstly, the Americans had to be convinced to support a war against an enemy which posed no direct threat to them - as we have seen, the same dilemma they had faced in both the First and Second World Wars. But Vietnam was not the Kaiser's Germany, nor Hitler's either, but a harmless little country which was so far away that most Americans had never heard of it.

Secondly, it soon became evident that the regime which the US was supporting, a viciously corrupt military dictatorship whose only perceived virtue was its hatred of communists, hardly squared with President Kennedy's rhetoric about assuring the survival and success of liberty. Thirdly, the government had been systematically deceiving the American people about what was going on there for the best part of 20 years. Many Americans were experiencing for the

202. ARTIST UNKNOWN
For God and Ulster, 1970s. Linocut on coloured paper. Private collection

203. ATELIER POPULAIRE
May '68, the beginning of a long struggle, Paris,
France, 1968. Silkscreen, 56 x 39cm (22 x 15in.).

In May 1968 students in Paris occupied
university buildings in the first of a series
protests against the authorities which quickly
spread to the working population and led to
the largest general strike in French industrial
history. It was also the first wildcat general
strike ever, anywhere. Attempts by the
government to suppress the strikes by police
action led to violent street confrontation. After
two weeks, almost two thirds of the workforce
was involved and the government was close to
collapse. Alarmed by the extent of the disorder,
conservative elements of the labour unions and
the Communist Party began to side with the
government, the violence evaporated and the
people went back to work. Though May '68 was
a political failure, it represented a watershed in
French cultural life, a shift in moral values which
reflected the sexual liberation and the demand
for human rights and freedoms emerging
elsewhere in the western world at the time.

The Mai'68 posters were produced
collaboratively by the students of the Atelier
Populaire overnight and distributed free in the
streets of Paris and elsewhere. By employing
traditional workers' symbols like the red flag,
the clenched fist and, here, the factory building,
the students aimed to extend their protest
beyond the confines of their own bourgeois
academic world to include the working
population, a goal which they achieved
spectacularly.

first time how it feels not to trust your government.

To make things worse, the propagandists faced a new threat from
the media. This was the first war since the Crimea in which journalists
were allowed virtually free access to the combat zones, and it was the
first war ever which everybody watched, every day, on television. As
the military build-up progressed, so too did the media coverage. 'In
1963, there were 16,000 American troops and about 20 American
correspondents in Vietnam. By 1968, these figures had risen to half a
million men and 637 journalists. It was the first war fought out before
a mass television audience, and its impact upon American and world
public opinion is often said to have been decisive.' (Philip M. Taylor,
p.269.)

Nixon, who had won the Presidency in 1968 on a promise to end the war,
took that as a mandate to intensify and extend the bombing campaign into Laos
and Cambodia. Night after night the newsreels showed the pointless devastation
and young American conscripts coming home in body bags. The lack of real
evidence to support government claims that the war was being won fed a public
distrust which was confirmed by the Watergate scandal, and the anti-war
movement began to attract mainstream support.

The role of television in the defeat of America in Vietnam is still a subject of
academic debate. The American military certainly believed that they had been
stabbed in the back by the media, and would never again allow the press such
free access to a war zone. But the question of whether the media played a
decisive role must take into account what else was going on in society at the
time - and as it happens, a great deal was going on.

In the late sixties the young people of the western world were in the process
of changing the rules of engagement in the generation war, a social experiment
which would have profound cultural consequences. Emboldened by the freedoms
that their rock 'n' roll predecessors had already gained, and possessed of an
optimism and self-confidence only known to those brought up free of fear and
hunger, they began to question the conservative values of the establishment. In
America, college students in particular became a powerful and disruptive force, a
catalyst for the anti-war movement which quickly spread beyond the campuses

YOU HAVE NOT CONVERTED A MAN BECAUSE YOU HAVE SiLENCED HiM

(John, Viscount Morley, On Compromise, 1874)

Great Ideas of Western Man... one of a series [CCA] Container Corporation of America

204. BEN SHAHN (1898–1969)
*You have not converted a man because you
have silenced him*, Container Corporation of
America, 1968. Offset lithograph,
114 x 76cm (45 x 30in.). Courtesy: Smithsonian
Institute, Washington, USA.

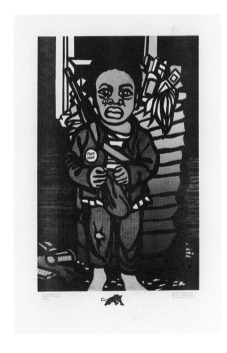

Bottom left
205. EMORY DOUGLAS
Free Huey. Black Panther Party, USA, 1970.
Offset, 57 x 38cm (22½ x 15in.). © Victoria and
Albert Museum, London.

A barefooted and ragged black child stares out
at the viewer from a litter-strewn yard. He is
weeping but carrying a gun and wearing a
badge which says 'Free Huey'. While the image
draws attention to the injustice and poverty
suffered by black people in America, the gun
provokes the kind of shock which characterises
the best of this artist's work. Emory Douglas,
the Black Panther Minister of Culture, was
responsible for most of the party's propaganda
art. With great economy of means his posters
powerfully express the Panthers'
uncompromising commitment to their cause.
 Huey P. Newton (1942–89), co-founder of the
Black Panther Party and its Minister for Self-
Defence, was jailed for manslaughter in 1967
following a gun battle with police in Oakland,
California, three years before this poster was
produced as part of a campaign to secure his
release.

to challenge the authority of the government to
prosecute what more and more people saw as an
immoral war. The anti-war propaganda, the
alternative press and posters produced at the time,
broke new ground, broke the rules, and clearly reflect
the conviction of a genuine grassroots movement.

The events at Kent State University in 1970, which left four students shot dead
by the National Guard and caused widespread shock and disbelief throughout
the country, further diminished popular support for the war. By 1973 the last US
troops were leaving Vietnam, and Saigon fell to the communists two years later.
(Figs. 199, 200)

Although the anti-war movement was related to the earlier 1950s peace
movement, which had been influenced by the American Communist Party, by the
mid-sixties it had outgrown its political origins to reflect the full diversity of the
blooming sixties counterculture. In fact a growing number of the young people
involved in the movement adopted an emphatically apolitical point of view,
believing that the whole political system was part of the problem, and offering
instead a way of life based on peace, love and community. These were the
hippies, whose alternative lifestyle would grow into a global subculture that
would alter the lives of millions of people and permanently change the social and
cultural values of the western world. Heirs to the beatnik culture of dissent, and
opposed to consumerism, the hippies advocated free love, universal brotherhood
and the conservation of the natural world. In eastern philosophy they found
support for their wish to replace material with spiritual experience, and in the use
of mind-altering substances like LSD and marijuana they found a quick way to do
it. All of this is reflected in the music, style and visual art of the hippies. (Fig. 201)

Their rejection of conventional society was not without precedent in history.

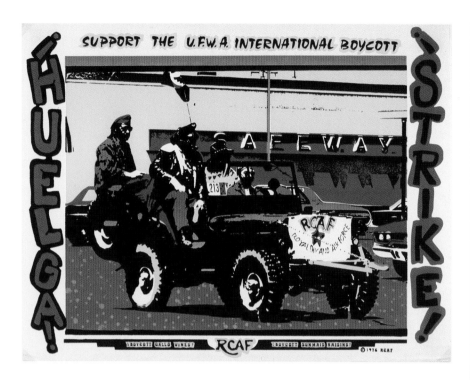

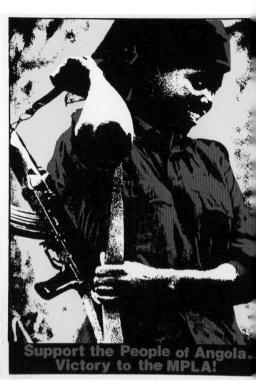

Above left
206. RICARDO FAVELA
Strike! Support the UFWA international boycott,
Royal Chicano Air Force, USA, 1976. Silkscreen.
Courtesy: Center for the Study of Political
Graphics, Los Angeles, USA.

The Royal Chicano Air Force is an artists'
collective based in Sacramento, dedicated to the
support of Chicano civil rights and the United
Farm Workers Union of America (UFWA).
Initially named the Rebel Chicano Art Front,
people started to confuse it with the Royal
Canadian Air Force, so they changed the name.

Above right
207. ARTIST UNKNOWN
*Support the people of Angola. Victory to the
MPLA*, MPLA, Angola, c.1946. Offset, 57 x 44cm
(22 x 17in.). Courtesy: Center for the Study of
Political Graphics, Los Angeles, USA.

The young European artists who took refuge in Symbolism and Art Nouveau in
flight from the squalor and inhumanity of the Industrial Revolution embraced
similar bohemian lifestyles, an affinity which is reflected in the influence of their
work on sixties and seventies hippy poster art. Another equivalent occurred in
Germany around the turn of the 20th century when a youth movement known
as Der Wandervogel ('the wandering bird') inspired thousands of young people
to get back to nature and the simple life. Under its influence, young Expressionist
artists like those of the Die Brücke group, were encouraged to study 'primitive'
cultures and to spend time painting in the countryside.

By the late 1970s much of the hippy style and attitude had been absorbed
into mainstream culture, and although the pure hippy life proved unsustainable
for most of the movement's adherents, its advocacy of sexual, religious and
cultural tolerance has left an enduring legacy in western society.

In the 1960s the hippies were not by any means the only ones to challenge
authority. Movements to promote civil rights, labour rights, women's rights, gay
rights, and the right of the environment to be protected from human
depredation all flourished in this decade. Like the British Suffragettes when faced
with a political system full of men, the activists of the sixties protest movement
refused to work within the system, adopting instead techniques of direct action -
marches, rallies, sit-ins, petitions - encouraged by the knowledge that, for the
first time, such activities would receive widespread attention through the now
universal medium of TV. This activism also stimulated a renewed interest in the
poster as a means of persuasion. For a hands-on direct-action community, the
humble handmade poster - cheap, quick and easy - still offered the solution it
had for a century or more. (Fig. 203)

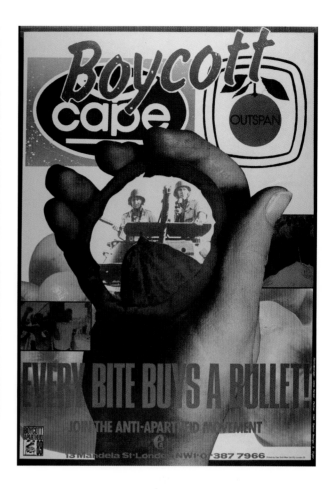

Above right
208. DOUG MINKLER
Mr. Camel's kids club, Doctors Ought to Care,
USA, 1990. Offset. Courtesy of the artist.

Above left
209. K. PIPER
*Every bite buys a bullet – boycott Cape,
Outspan,* Anti-Apartheid Movement, London,
c.1989. Offset, 60 x 40cm (23 x 15in.). © Anti-
Apartheid Movement, image courtesy of the
Bodleian Library, Oxford University.

At the other end of the spectrum the natural relationship between art and protest produced a world of material from which the individual could choose. What easier way to express one's solidarity than through the beautiful Cuban or hippy poster pinned on the bedroom wall? In fact at this time the poster broke out of the narrow confines of the world of the specialist collector to become the ubiquitous lifestyle accessory of the masses. No matter how straitened your circumstances or temporary your accommodation the poster on the wall could express your taste, your beliefs and your personality. (Figs. 204-206)

The protest movements of the 1960s and '70s fostered a renaissance in political graphics. In America, the social concern which had been virtually lost in the 1950s - Ben Shahn was a notable exception - resurfaced to be expressed again in political cartoons and a great variety of poster art. As the counterculture spread around the world, sustained by economic affluence and the rapid growth of international travel, oppositional propaganda flourished, embracing global and local issues with equal vigour. Though the involvement of the mainstream subsided in the 1980s, the international community of activists which had developed earlier remained active. The liberation struggles of ex-colonial nations in the developing world, the elimination of apartheid in South Africa, the conflict in Northern Ireland, opposition to American interference in Chile, Nicaragua, El Salvador, and a myriad local issues; all are recorded in the oppositional propaganda of the late 20th century. (Figs. 202, 207, 208, 209, 215)

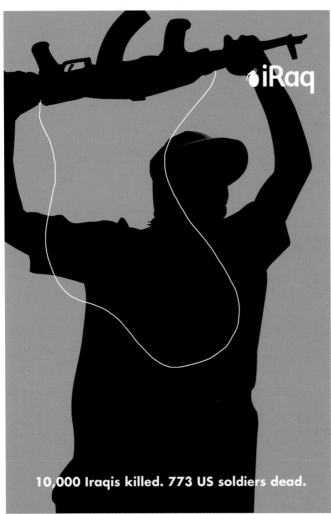

iRaq

10,000 Iraqis killed. 773 US soldiers dead.

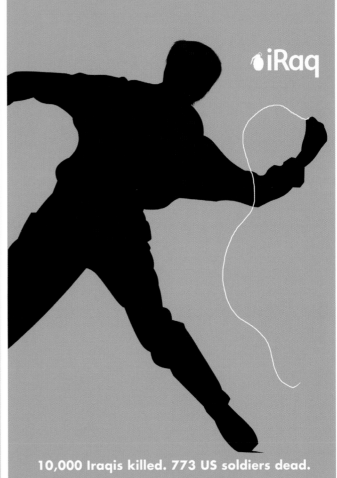

iRaq

10,000 Iraqis killed. 773 US soldiers dead.

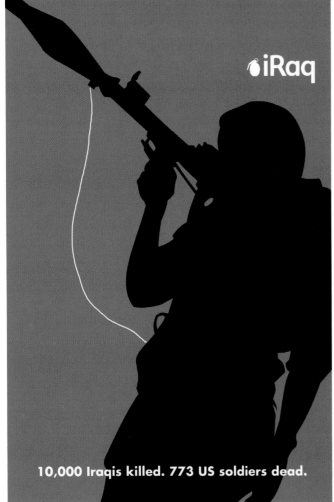

iRaq

10,000 Iraqis killed. 773 US soldiers dead.

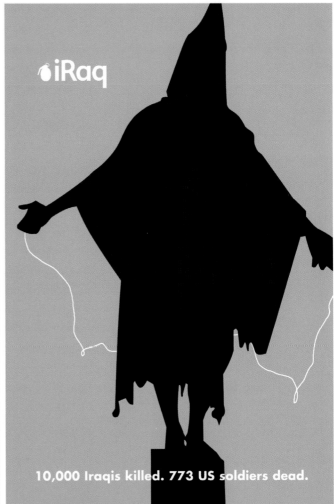

iRaq

10,000 Iraqis killed. 773 US soldiers dead.

Propaganda in the digital age

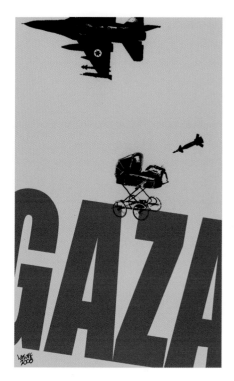

211. CARLOS LATUFF
Gaza, 2000. Digital image. Courtesy of the artist.
Download from fileflyer.com/view/Ho03ZB7

Carlos Latuff's statement: 'I'd like to beg all viewers to spread this image anywhere, as a way to expose Israeli war crimes against Palestinians. Use it on T-shirts, posters, banners. Reproduce it in zines, papers, magazines, and make it visible everywhere. Thank you in the name of every suffering Palestinian.'

Opposite
210. FORKSCREW GRAPHICS
iRaq, USA, 2001. Digital image (download from forkscrew.com). Courtesy: the artists.

Most graphic art is now produced digitally, with all the advantages of reproduction and distribution which that implies. Much of contemporary political graphics in particular is designed with the internet in mind. Now, with the steady growth of broadband connection, a full-colour poster can be created as a digital file small enough either to send by email or to download from a website set up for the purpose, and printed by the recipient in as many copies as necessary or simply passed on digitally. (Fig, 210, 211)

This in itself is a big change. Up until the Second World War only four or five companies in the whole of Britain were capable of producing full-colour lithographs in large numbers, and until recently the limited access to offset printing represented a bottleneck in the distribution of oppositional propaganda. Now artists can produce video clips, animated games, images and sound, and distribute them through pre-existing social networks, a method referred to as 'viral marketing' in the world of commercial advertising. Digital art also accommodates the micro scale of production. You can take your image file to the local store and print only one T-shirt, or one poster, free from the old 'thousand minimum order' rule. This enables more people to get involved, so a more fine-grained pattern of action can emerge.

For designers, however, perhaps the most exciting possibilities derive from the speed and ease of collaboration which the internet offers. In March 2001, the Movimiento Zapatista, formerly the Ejército Zapatista de Liberación Nacional (EZLN), a popular movement created to protect the rights of the indigenous people of the southern state of Chiapas in Mexico, organised a major demonstration in Mexico City. A group of young designers there decided to support the movement by producing and distributing graphic material to coincide with the event. Instead of posters, they chose to make small (4 x 5cm/1½ x 2in.) adhesive stickers and asked colleagues around the world to produce designs within 24 hours and email them back. Twenty-five designs were chosen and in all 75,000 stickers were produced. Distribution was carried out by making the sheets available to kids, vendors, skateboarders, all kinds of street people - and within hours the stickers were everywhere. This is 21st-century, direct propaganda action. Like the protest movement of the 1960s, it avoids established channels, and takes advantage of the networking and production capacity of the digital media. (Figs. 212-214)

212. ALEJANDRO MAGALLANES, LEONEL
SAGAHON AND OTHERS
Stickers for the Zapatista demonstration, Mexico
City, 2001, Mexico, 2001. Offset, each sticker 4 x
5cm (1 x 2in.). Courtesy of the artists.

Two groups of designers took part in this
initiative – Collectivo Fuera de Registro and
Corriente Eléctrica.

Throughout this account we have seen new technologies transform the art of propaganda. Movable type, the lithograph, the telegraph, the photograph, radio and TV have all changed the way we communicate, and though it may be too early to tell how profound its influence may be, the internet has changed our lives so much since its introduction in 1983 that we can expect it to play an increasingly significant role in the world of contemporary propaganda. But how? And should we worry about it?

In 1988 Professors Noam Chomsky and Ed Herman described in their groundbreaking book *Manufacturing Consent* how the mass media and public opinion are manipulated in a modern democracy. Many readers were shocked by the idea that respected institutions like CBS, the *New York Times* and *Time* magazine might be organs of US government propaganda, but the book's arguments were persuasive and contributed to a loss of faith in mainstream media among some liberal-minded people, a trend which has been confirmed in the light of more recent events, such as the 'weapons of mass destruction' fiasco leading up to the Second Gulf War.

213. ANDRÉS RAMIREZ
Solo es música contra el poder, Multiforo Alicia
(publisher), Mexico, 2006. Digital image.
Courtesy: the artist.

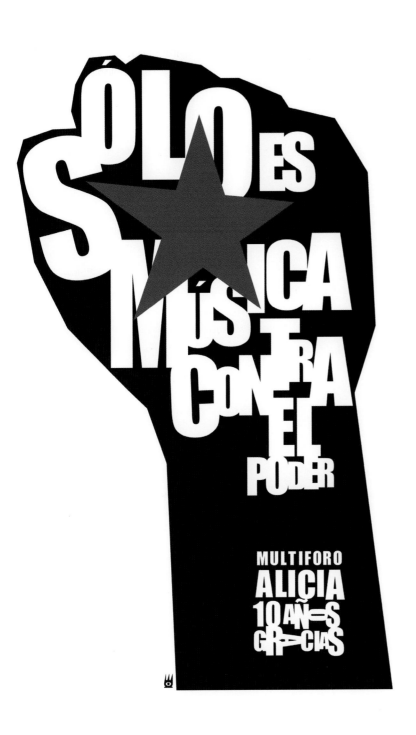

Things have changed a lot, however, since the book was written. As its title suggests, it relates to 20th-century industrial society, to the world of centrally owned and controlled mass media, where the all-seeing eye of CBS stares out and the giant radio mast of RKO Radio Pictures straddles the world, a 'hub and spokes' model to which the internet does not conform. Now, instead of a mass audience consuming media from a single source, we have multiple sources, multiple channels and multiple audiences. Every participant is potentially a sender as well as a receiver of information, and the barrier to entry is no longer the fortune required to set up a TV station or a newspaper, but the price of a PC and an internet connection.

While the mass media depend on advertising revenue, and their objectivity is a hostage to it, the internet user does not. While traditional journalism frequently relies on official sources, the internet provides access to many sources, and even the business of news gathering has itself become a universal activity as anyone with a mobile phone can take a picture or a video and have it on 'You Tube' while the event is still going on.

214. ANDRÉS RAMIREZ
Mine, mine, mine. My body is mine and I decide what happens with it. 8 March, International women's day, Multiforo Alicia (publisher), Mexico, 2008. Digital image. Courtesy: the artist.

215. SHEPARD FAIREY (B. 1970)
Obama Hope, USA, 2008. screenprint/digital print. Courtesy: Wikimedia Commons.

This stylised stencil portrait of presidential candidate Barack Obama came to epitomise his campaign. Endlessly copied, parodied and subverted in both style and content, it has become the first truly iconic piece of political graphics of this century.

Chomsky talked about anti-Communism, a concept which he believed was used at the time as a device to distract the American people from criticism of their own government. Now that the Cold War is over, that threat has gone, only to be replaced by the 'War on Terror'. It appears, then, that the internet has not changed everything. Human nature is quite the same as it was. The anonymity which protects those who protest in blogs and emails also provides an opportunity for the unscrupulous to indulge in black propaganda. The new digital media will not change the game, just the tactics.

We have seen the art of propaganda progress from the limestone stele of Naram-Sin to the animated, digital offerings of the World Wide Web, and from an audience of a few Mesopotamians to the hundreds of millions who can now access the internet. Soon to be online all the time, we are constantly exposed to propaganda. Our daily lives are punctuated by one persuasive communication after another, the vast majority of which do not involve argument or rational debate but are a one-sided exercise in the manipulation of symbols designed to engage our emotions. Some of it is inspiring, some dangerous; most of it is dull and commercially motivated but it all demands our attention. We can do our best to block it, but we cannot, indeed should not, block it all. We can, however, be aware of it, understand how it works, and question it regardless of its source. And if we learn to seek out its intentions we will disarm it.

For the propaganda artist new opportunities to create and communicate are appearing every day. All the machines are getting joined up, and so, apparently, are all the people. The new social media offer possibilities to quickly and easily form communities around shared ideas and attitudes in an environment which encourages self-expression. We are all propaganda artists now. This must, surely, be a good thing.

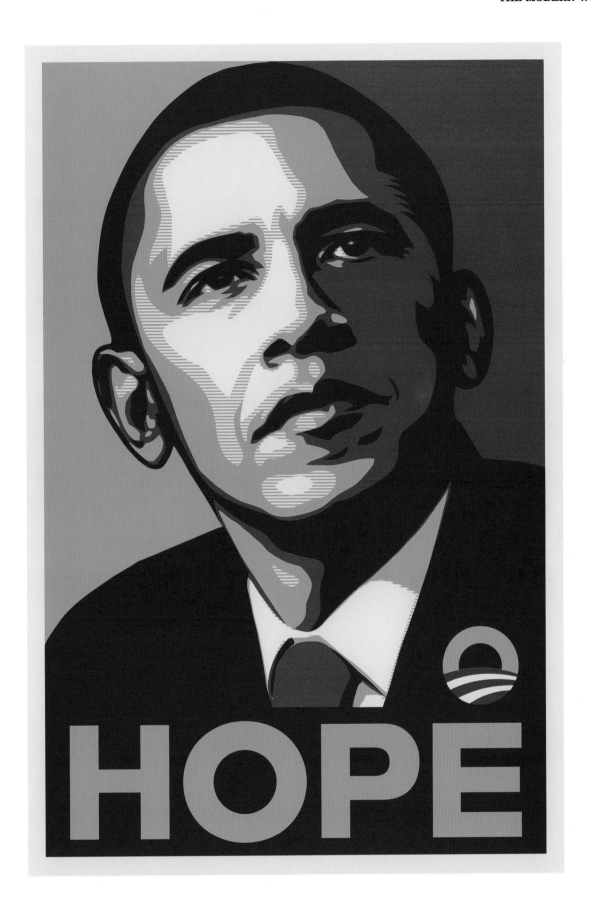

Bibliography

Ades, Dawn et al., *The 20th-Century Poster: Design of the Avant-Garde* (New York: Abbeville Press, 1984).

Anikst, Mikhail, *Soviet Commercial Design of the Twenties* (New York: Abbeville Publishers, 1987).

Aulich, James, *War Posters: Weapons of Mass Communication* (London, Thames and Hudson, 2007).

Barnicoat, John, A Concise History of Posters (London, Thames and Hudson, 1972).

Bernays, Edward, *Propaganda* (New York: Ig Publishing, 1928).

Craven, David, 'Cuban Art and Culture', an essay in *Cuba: A Different America, Wilbur A. Chaffee and Gary Prevost* (eds) (Maryland: Rowman and Littlefield, 1992).

Creel, George, *How We Advertised America* Manchester, NH, USA, Ayer Co, publisher, 1972: Kessinger Publishing, 2008).

Chomsky, Noam and Herman, Ed, *Manufacturing Consent: The Political Economy of the Mass Media* (Oxford: The Bodley Head, 2008).

Cushing, Lincoln and Tomkins, Ann, *Chinese Posters: Art from the Great Proletarian Cultural Revolution* San Francisco, USA: Chronicle Books, 2007).

Cushing, Lincoln, *Revolución! Cuban Poster Art* (San Francisco, USA: Chronicle Books, 2003).

Edwards, Mark U. Jr, *Printing, Propaganda and Martin Luther* (University of California Press, 1994).

Ellul, Jacques, *Propaganda: the Formation of Men's Attitudes* (New York: Random House USA Inc., 1963).

Farrer, Anne, *Chinese Printmaking Today* (London: The British Library, 2003).

Gentleman, David, *Hearts and Minds*, in *Baseline* magazine, 54, 2008.

Griffiths, Antony, *Prints and Printmaking* (London: British Museum Publications, 1980).

Hanley, Wayne, *The Genesis of Napoleonic Propaganda*. Electronic Book. New York: Columbia University Press. 2002.

Hensbergen, Gijs van, *Guernica: The Biography of a Twentieth-Century Icon* (London: Bloomsbury, 2005).

Heymann, Theresa Thau, *Posters American Style* (New York: Abradale Press, 1998).

Hill, Katie (ed.), *The Political Body* (London: University of Westminster Chinese Poster Collection, 2004).

Inkworks Press, *Visions of Peace and Justice* (San Francisco: Inkworks Press, 2007).

Ittmann, John (ed.), *Mexico and Modern Printmaking* (New Haven)

Jowett, Garth S. and O'Donnell, Victoria, *Propaganda and Persuasion* (California, USA: Sage Publications, 2006).

Lippmann, Walter, *Public Opinion* (New York, USA: Free Press Paperbacks, 1922).

López Casillas, Mercurio *Jose Guadalupe Posada* (Mexico City: Ediciones RM, 2003).

Müller-Brockmann, Josef and Shizuko, *History of the Poster* (New York, USA: Phaidon, 2004).

Monsiváis, Carlos et al., *Leopoldo Méndez 1902-2002* (Mexico City: Ediciones RM, 2002).

Musacchio, Humberto, *El Taller de Gráfica Popular* (Mexico City: Fondo de Cultura Económica, 2007).

O'Connell, Sheila, *The Popular Print in England* (London: British Museum Press, 1999).

Taylor, A.J.P., *Oxford History of England*, vol. XV (Oxford University Press, 1965).

Taylor, Philip M., *Munitions of the Mind* (Manchester University Press, 2003).

Thomson, O., *Mass Persuasion in History* (Edinburgh: Paul Harris, 1977).

Toman, Rolf et al., *Baroque* (Cologne: Könemann, 1998).

Toor, Frances (ed.), Las Obras de Jose Guadalupe Posada (Mexico City: Ediciones Toledo, 1991).

Tupitsyn, Margarita, *Rodchenko and Popova: Defining Constructivism* (London: Tate Publishing, 2009).

Philippe, Robert, *Political Graphics: Art as a Weapon* (London: Phaidon, 1980).

Rennie, Paul, 'Social vision, RoSPA's WWII Safety Posters', in *Eye* magazine (eyemagazine.com), 52, 2004.

Walther, Ingo F., *Picasso* (Cologne: Benedikt Taschen, 1992).

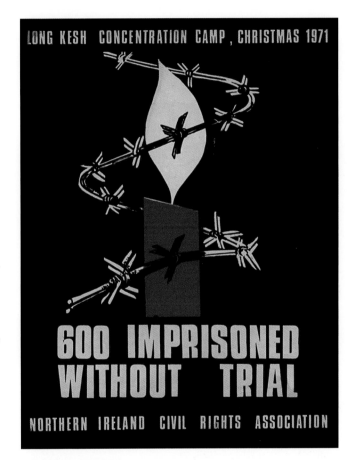

215. ARTIST UNKNOWN
Long Kesh concentration camp, Northern Ireland Civil Rights Association, 1971. Colour half-tone letterpress. Private collection

Long Kesh was the main camp used to hold individuals suspected of belonging to illegal paramilitary groups. Involving, as it did, the incarceration of people without trial, internment was a highly controversial policy. In response to it the Northern Ireland Civil Rights Association began a campaign of civil disobedience and the Social Democratic and Labour Party (SDLP), the only major Catholic political party in Northern Ireland, was forced to end cooperation with the government. Considered by many to be a counterproductive measure, internment was suspended in 1975.

This poster, published at Christmas time, makes a symbolic visual connection between the Christmas candle and the candle of the Amnesty International logo.

216. ARTIST UNKNOWN
The Adam Forepaugh and Sells Brothers,
Courier Litho, USA, 1898. Lithograph, Library of
Congress LC-USZC4-5227

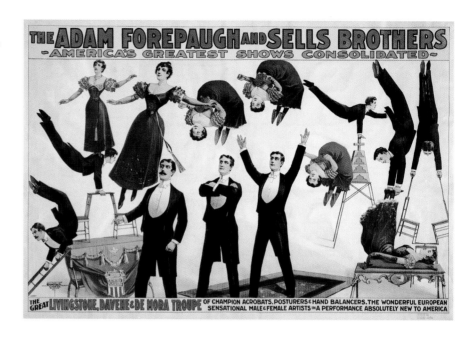

Acknowledgements

I would like to express my sincere gratitude for the support and generosity of the following people and organisations, without whose help this book would not have come about:

Barry Attoe at the British Postal Museum and Archive; Professor Randall Bytwerk at Calvin College; The British Museum; Lynda Corey Claassen of the Mandeville Special Collections Library at the University of California, San Diego; Piotr Dabrowski; Emory Douglas; Ken Garland; David Gentleman; Leslie Green at the Smithsonian Institute; Christabel Gurney of the Anti-Apartheid Movement; Hariette Hammasi at Brown University Library; Selva Hernández; Katie Hill at the University of Westminster; Starr Hoffman at the University of North Texas Library; Paul Johnson at the UK's National Archives; the Library of Congress; José Luis Lugo; Lucy McCann and Marion Lowman at the Bodleian Library, Oxford University; Alejandro Magallanes, Doug Minkler, Malaquias Montoya and Lezlie Salkowitz-Montoya; The National Gallery, London; Graham Nisbet at the Hunterian Museum, University of Glasgow; Vicky Quinn at RoSPA; Soledad de Pablo at the Museo Nacional Centro de Arte Reina Sofía in Madrid; Andrés Ramírez; Veronika Reichert at Baseline magazine, Leonel Sagahón; Vitaly P. Sitnitsky; Karyn Stuckey at London College of Communication; the Victoria and Albert Museum; Carol Wells and Joy Novak at the Centre for the Study of Political Graphics in Los Angeles.

With respect to references, I must acknowledge my debt to Philip M. Taylor and to Garth S. Jowett and Victoria O'Donnell for their works on the history of propaganda. Without the guidance of these professional historians I could easily have strayed from that long and winding path, never to be seen again. Thanks also to Leo Costello for his short but highly informative account of the WPA in *Posters American Style*, to Paul Rennie for his essay on the RoSPA posters in Eye magazine, and to the many other expert sources, in print and online, which I have used.

I am particularly grateful to Lincoln Cushing for his generosity and encouragement, to Susan James and her colleagues at A&C Black, and to John Gilmour, Danielle Eubank, James McDonald, Neil Giles, Mychael Barratt and the many friends and colleagues who have supported me in the course of this project. Lastly to my partner, Jazmín Velasco, who has patiently related to the back of my head for the last two years, *gracias nenita.*

Index

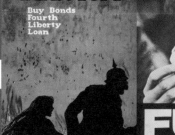

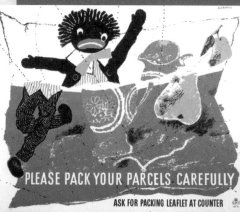
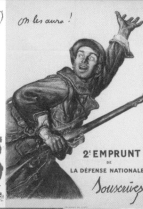

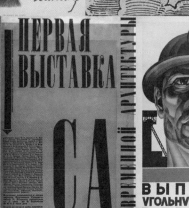